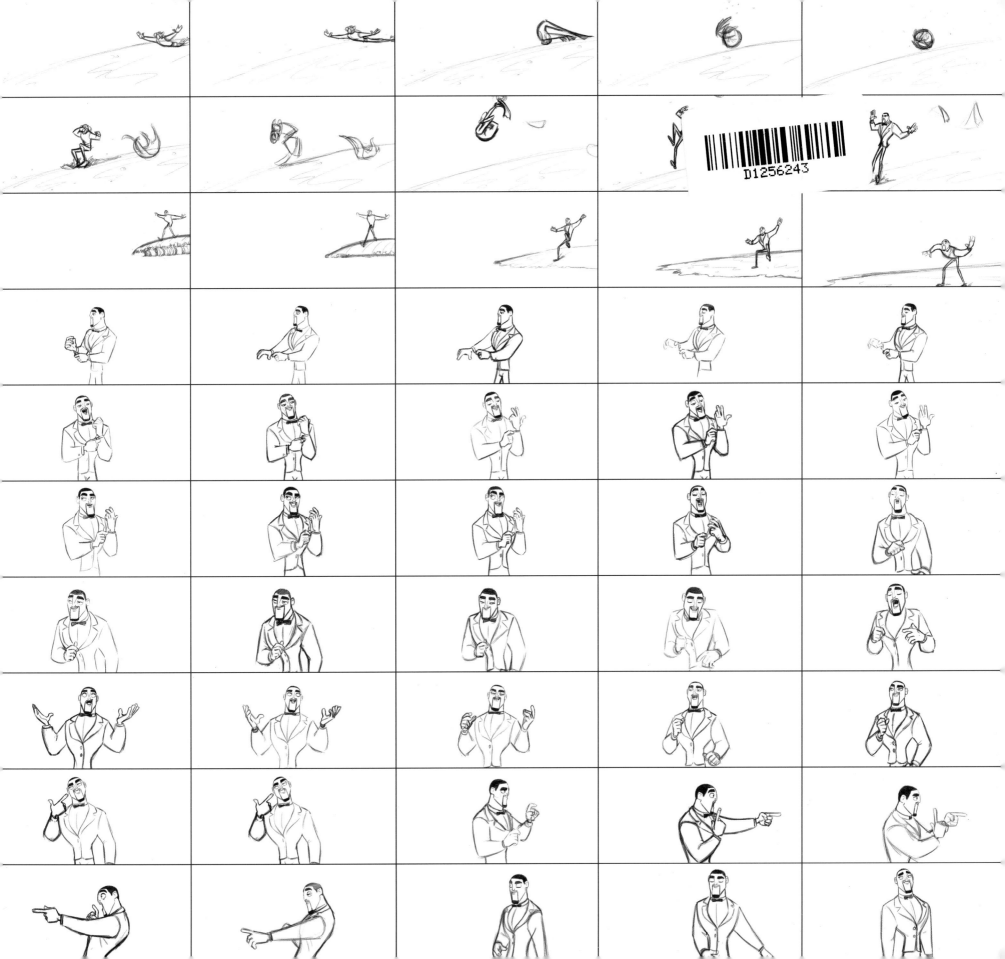

D1256243

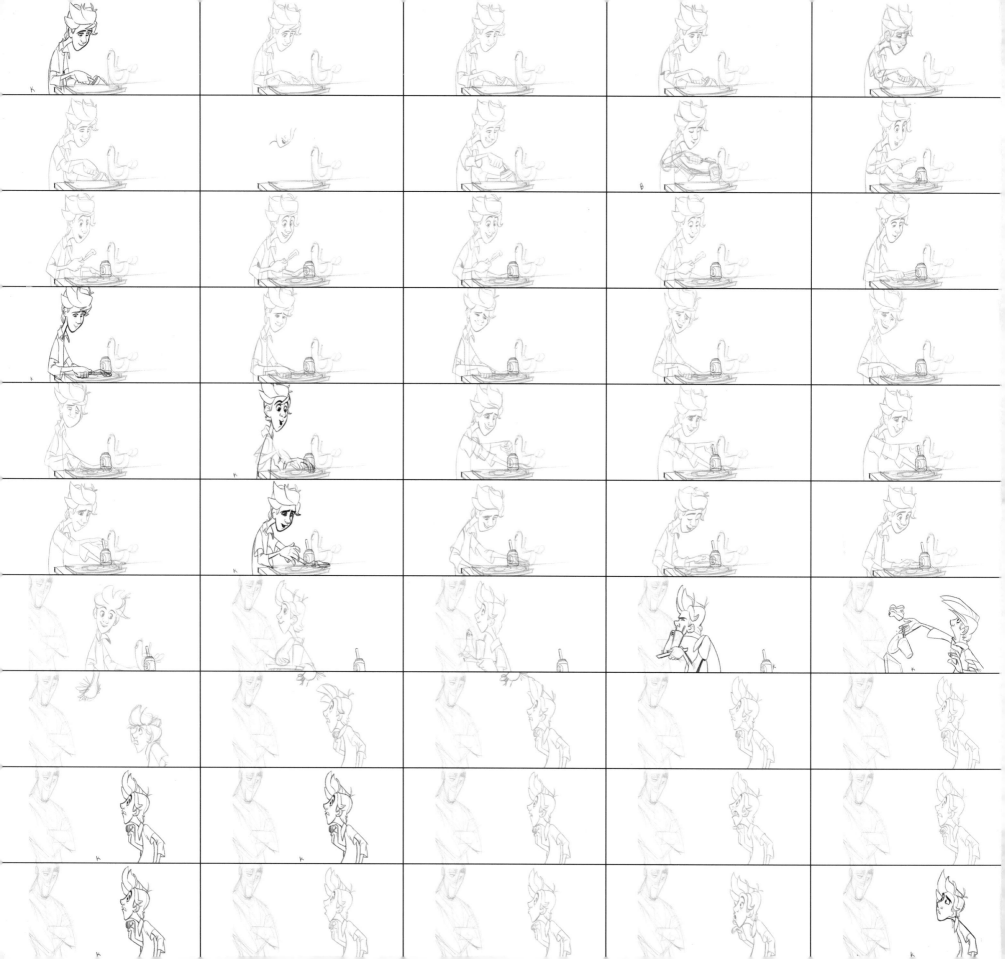

Blue Sky
STUDIOS

THE ART OF SPIES IN DISGUISE

TITAN BOOKS

CONTENTS

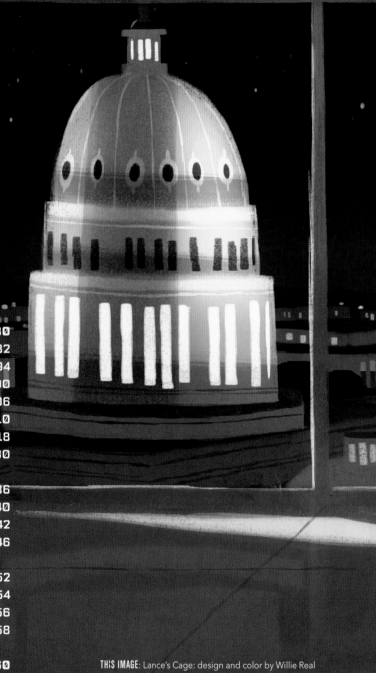

THIS IMAGE: Lance's Cage: design and color by Willie Real

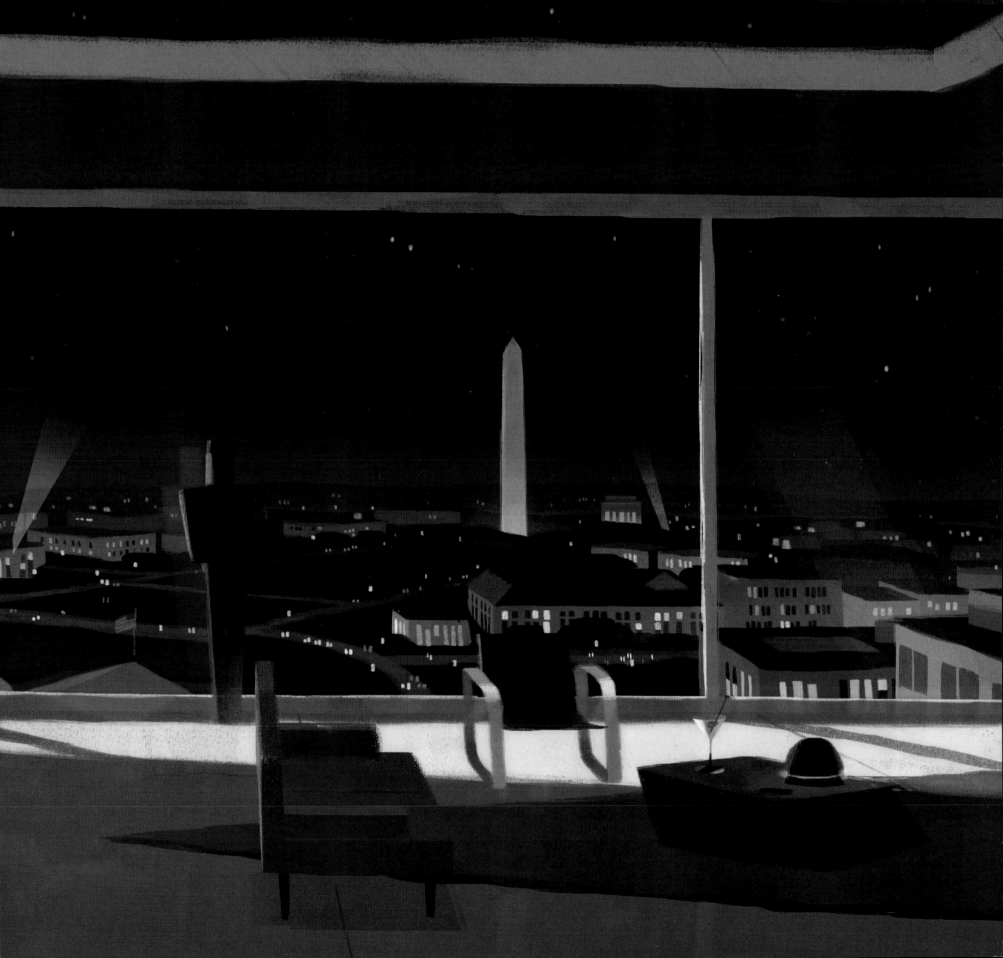

FOREWORD

BY TROY QUANE & NICK BRUNO

When offered the opportunity to make *Spies in Disguise*, we couldn't have been more excited! The spy genre is one of our personal favorites. The action, the suspense, the gadgets, and in the case of our film, the comedy. It had all of the hallmarks of the blockbusters we love, including a colorful cast of interesting characters taking us to a broad array of exotic international locations both beautiful and perilous. It's our filmmaking dream come true!

Of course, the spies that inhabit the movie world are quite a bit different from real spies. Our hero Lance Sterling, who proudly proclaims he's the world's greatest spy, because "everybody knows the name," couldn't be further from reality. The job of a real spy is to blend in and go unnoticed. If they've done their job right, you never even knew they were there.

And like real-world spies, that same philosophy applies to the hundreds of supremely talented Blue Sky artists and tech wizards who labored behind the scenes to make this movie. Artists whose unparalleled imagination brought to life unforgettable characters like Lance Sterling, Walter Beckett and Marcy Kappel, and a zany flock of pigeons, to name a few. Artists whose vision designed specialized gadgets like no other and who built a secret spy agency concealed beneath national monuments in Washington, D.C. And whose unprecedented collaboration with Audi created something never before seen in animation, the coolest spy vehicle we all dream of driving.

Which is why we love books like this. Books that celebrate the artistry and visual development that go into making animated films. It's a chance to acknowledge and highlight the passionate and dedicated team whose work went above and beyond to make this movie shine. We tasked each and every one of them with creating a larger-than-life world that was fun enough to allow a man to be turned into a pigeon, while at the same time remaining grounded enough so that you care about the emotional stakes of the story. We couldn't be more proud and thankful for the work they've done. They accomplished an impossible mission. And it's all right here in these pages for you to explore, no top-secret security clearance required.

We hope you enjoy seeing this art as much as we've enjoyed creating it! And keep your eyes peeled for those secret agents hidden amongst us. They could be the pigeons on the bench next to you.

This book will self-destruct in five, four, three, two, one...

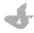

THIS PAGE: Young Walter Shows Mom His Gadgets: storyboards by Ian Abando

INTRODUCTION

Q&A WITH MICHAEL KNAPP, PRODUCTION DESIGNER

OPPOSITE: First Act Color Script: by Michael Knapp

All of Blue Sky's movies are visually distinct, while still being recognizably from the studio. How did you go about distinguishing *Spies in Disguise*?

This film took a very sculptural approach to defining its look, beginning with the characters. Their proportions are very exaggerated, and the world around them is exaggerated to match. We approached lighting the world in a way that really showcased the sculptural and graphical design choices we made to make the biggest impact on screen. We also took some time to look at how we could improve the communication of ideas between departments to ensure that when one department completed their work, the next department could take that work and make it even better. Our focus on opening up the collaboration across the entire studio led to a richer interpretation of the artwork you'll find in this book. You can really see in the finished film how much love and hard work went into building on the ideas we designed early on.

What was the inspiration for *Spies in Disguise*?

From the beginning, we set out to make a comedic international spy movie that just happened to be animated. We wanted our characters to be bold and sculptural, and the world around them rich and tangible. Visually, this meant the cameras had to be dynamic, the lighting had to be dramatic, and the aesthetic had to have a gritty filmic quality that was unlike any of our previous films at Blue Sky. We drew inspiration from the posters and title sequences of the legendary designer Saul Bass and distilled what we loved from our favorite spy movies – from the campier classics to the slicker, more action-packed films of late. As we were developing our shape language, we took cues from the polygonal designs of stealth aircraft, the minimalist sculptures of Constantin Brancusi and the bold visual economy of brutalist architecture.

> "The color themes on *Spies in Disguise* were constructed around Lance's palette. He had some common themes with Killian – our main villain – and they shared cool deep blue tones. Lance was in direct contrast with a lot of the characters associated with teamwork and trust. We assigned the Agency and its tech a distinct turquoise, and then reserved red for danger and imminent threats within the story. These color themes then gave us a framework to build the color script and color keys around. While these weren't rigid rules, they did help keep new color and lighting ideas in context as they developed."
>
> *Michael Knapp, Production Designer*

How did the idea of a spy being transformed into a pigeon develop?

There's a history of pigeons being used in espionage dating back to at least World War I, and while we take these very common birds for granted, they're actually quite remarkable. They can fly up to 90 mph, they can see the UV spectrum, and because of their size and eye positioning they have incredibly fast reflexes and see almost 360 degrees. What if a spy could do that? He or she could have all these amazing abilities while hiding in plain sight! The idea seemed both incredibly cool and pretty hilarious at the same time.

What were the themes that you wanted to emphasize in this movie?

Initially, Teamwork/Trust versus Betrayal/Isolation was the central theme that helped us start laying the groundwork of the story and the color palette of the film. Lance didn't trust anyone enough to work with as a team or partner, and this was a character flaw that our villain, Killian, was able to exploit. But the themes evolved as Walter became more central to the main narrative, and the emphasis shifted to contrasting his world view – that violence only begets violence – with that of Lance – to win at all costs, regardless of the harm done in the process.

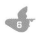

USING COLOR THEMES FOR VISUAL STORYTELLING

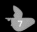

How did you go about expressing those themes visually?

We began by using color and shape to define the themes, starting with Lance. He's a strong solitary figure with a striking angular silhouette decked out in a deep blue tuxedo. We established these cool blues as a symbol of isolation and distrust, and his tall angular shape keeps him at arm's length from the world around him. Our villian, Killian, wears greys and deep blues as well. His silhouette is a more jagged version of Lance's. These are two men who have major trust issues, and we wanted to establish some similarities between them. Walter, on the other hand, is basically an s-curve with bad posture and messy hair dressed in both yellow-orange and warm browns (which we defined as the colors of Teamwork/Trust). His green shirt is a nod toward the Agency's turquoise palette. Joyless and Marcy both wear Agency colors throughout the film. Our locations echo these thematic colors as well. In addition to color, we would use all the cinematographic techniques at our disposal – lighting, composition, contrast, depth of field, etcetera – to support these themes.

How do you ensure that you hit the emotional beats of the story?

We think about what an environment says about the characters that inhabit it, and how it fits into the story. Is it a natural location or is it man-made? Is it old and dilapidated, clean, sleek and modern, or lived-in and messy? Is it lit naturally or with practical lights? Does it feel spacious or claustrophobic? We then support the emotional beats with the staging and framing of the characters in that space. We make sure the lighting, color and contrast of every shot supports the emotional beats by planning it all out in the color script. This is where we map out the peaks and valleys of the mood, color and lighting ideas that best help tell the story.

How do you make sure that all the visual elements of the film are cohesive?

One way this is achieved is by putting a style guide together, which defines the visual rules of the film. Our lead character designer, Jason Sadler, assembled the character style guide early on, and this was a great reference point for character work as well as sets and props moving forward. We also created a style guide for environments and a color/lighting style guide for not only our color artists, but for all the downstream departments to work from.

How did the process of designing pigeon Lance and human Lance work?

A lot of the discussion came down to just how few of human Lance's features we needed to carry over to pigeon Lance. One rule that we established early on in development was that the animals in this film were simply animals. Not anthropomorphized. They don't talk. Wings can't behave like hands. So we were going to bend those rules a little bit for Lance, but generally he needed to be at a complete disadvantage as a pigeon with none of his human strengths and abilities at his disposal. No fingers, hands, lips… Only his eyes and eyebrows from his human design carried over to his pigeon self. And in the few moments where his new

THIS PAGE: Color Script: by Michael Knapp

OPPOSITE TOP: Montage Concept Frames: color by Tyler Carter

OPPOSITE BOTTOM: Color Script Frames: color by Vincent Nguyen

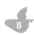

pigeon instincts kick in fully and his humanity gets buried, his eyebrows vanish and he looks just like all the other pigeons in the film. Ultimately, he's the only pigeon with eyebrows. And a little feather bow tie.

Spies in Disguise features several "real world" locations. What was your approach to depicting them in this film?

We focused more on achieving the "feel" of our locations than being slaves to the real place. This is both out of the need to be efficient from a production standpoint, but also because the designs of our locations are driven by the action in the story. That said, our research trip to Washington, DC, and a vacation I took to Venice years back were extremely helpful in distilling the unique character of those locations. We would then emphasize the color, shapes and textures that felt true to those places and reinforced the aesthetic of our film, but lay out the locations in the best way to serve the story.

Was each location designed to contrast with other locations or to compliment a character?

We always look for ways to distinguish one location from another. We think of each location as a character as we're designing them, and always consider how each location is a stage for the action and emotion of a sequence, but also how it relates to each character.

A great example of how a location is designed to say something about a character would be Walter's house. By the time we visit this location, we've already experienced the grand Mount Olympus-like halls of the Agency and the slick, cold gadget lab where he works, but at his home everything is cozy and warm and packed with family photos, memorabilia, and his experiments. The house really gives you a peek into both Walter's past and his chaotic, brilliant mind. We referred to it as Walter's "nest." The sequence wound up getting cut, but to contrast Walter's house we designed Lance's apartment to be a cold, modern, minimalist space containing no evidence of attachment to the past. Just a huge plate-glass window overlooking DC that separated him from the world. We called it Lance's "cage."

What is the rationale behind the different groups of gadgets in the film?

We broke down our approach to gadgets according to who designed them – the Agency or Walter.

Most of the Agency's gadgets have more in common with the sort of thing you'd find in classic spy films: camouflaged weapons, oil spraying from a car, exploding cufflinks, laser watches, etc. Basically, very overpowered destructive versions of the tools of tradecraft; lots of things that shoot or blow things up. In addition to that, Eyes and Ears have their specific surveillance tools – Eyes' being AR glasses and Ears' being a parabolic microphone that can be used as a sonic weapon.

Walter's gadgets, on the other hand, are designed to incapacitate foes without hurting them. His gadgets might disorient the bad guys, or put them in a state of bliss to stop them from attacking, or simply seal them inside an inflatable device that would both protect them and prevent them from hurting others. His goal is to break the cycle of violence that increasingly escalates in the field while adding an element of fun and whimsy that's unexpected, but surprisingly effective.

 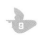

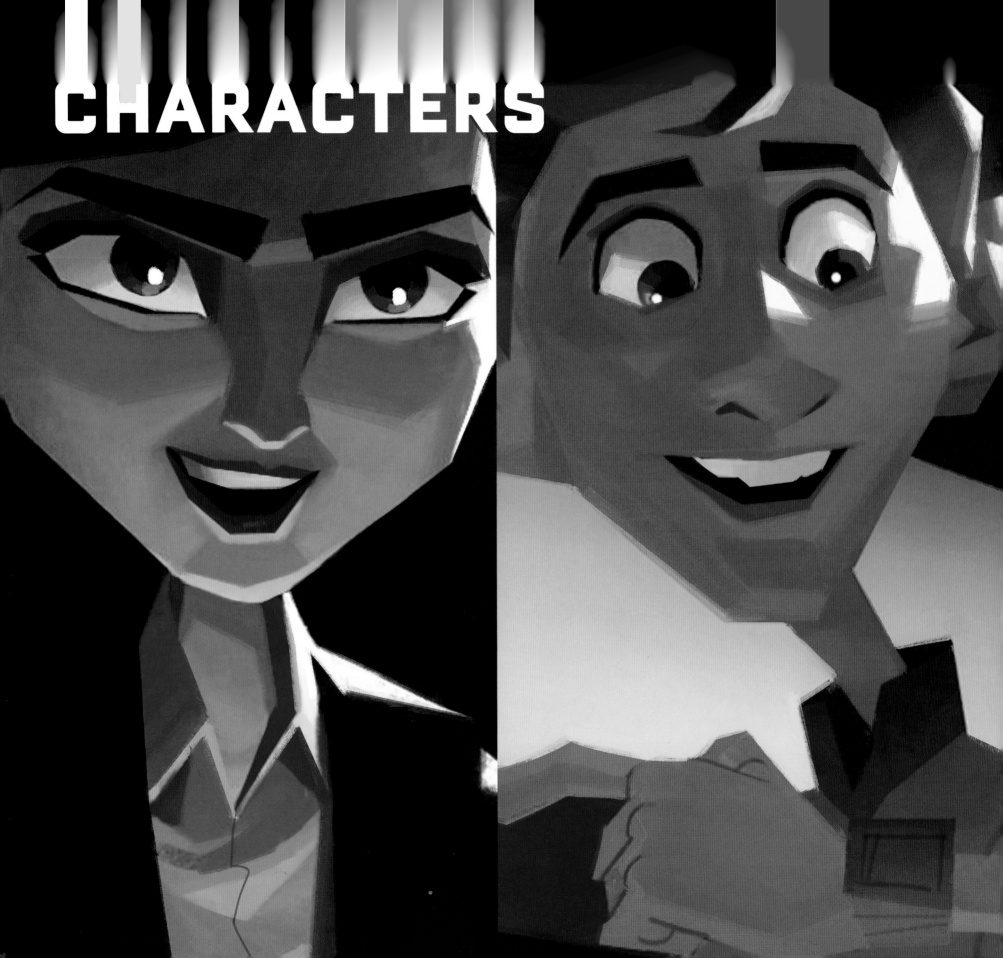

LANCE STERLING

"In collaborating with Dan Seddon to find the human Lance design, we were inspired by the clean flowing shapes and economy of detail in sculptures by Constantin Brancusi. Working over each other's drawings, we tried to refine and simplify the forms with each new iteration. The long straight lines in Lance's silhouette helped to set the tone for a general style principle of 'three straights to every one curve' that we attempted to employ throughout the film"

Jason Sadler, Lead Character Designer

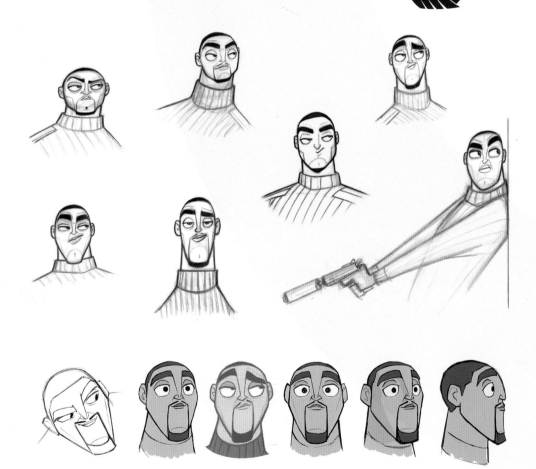

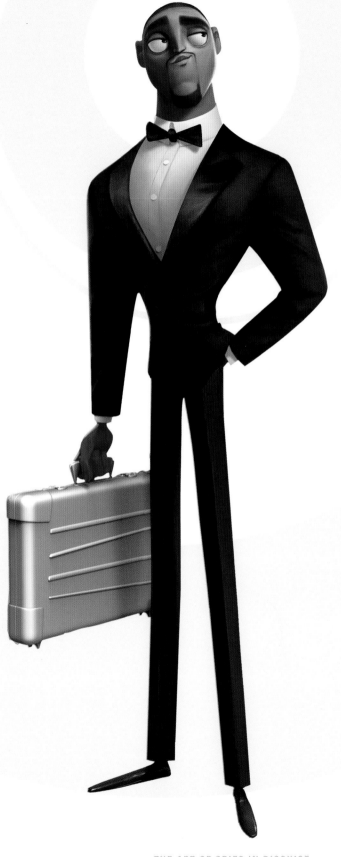

PREVIOUS SPREAD: Marcy: color by Peter Nguyen; Walter: color by Peter Nguyen; The Flock: color by Hye Sung Park; Lance: color by Hye Sung Park

TOP: Early Lance Concepts: designs by Jason Sadler

ABOVE: Lance Turnarounds: designs by BJ Crawford

RIGHT: Lance: design by Jason Sadler, color by Vincent Nguyen

OPPOSITE LEFT: Early Lance Concepts: designs by Peter de Sève

OPPOSITE RIGHT: Lance in Helicopter: color key by Hye Sung Park

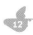

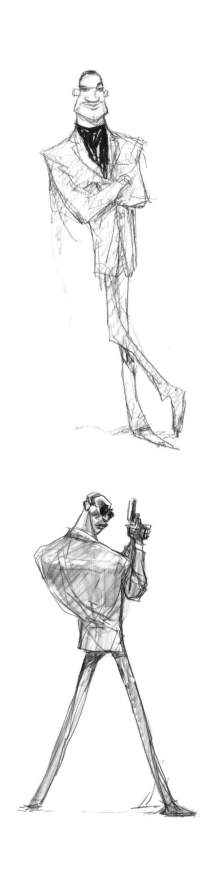

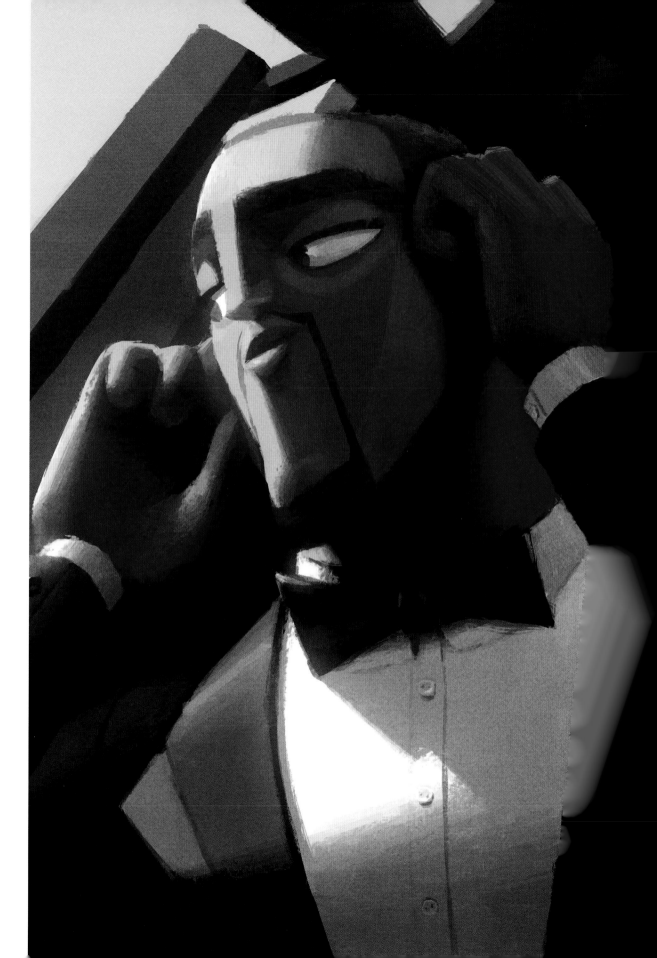

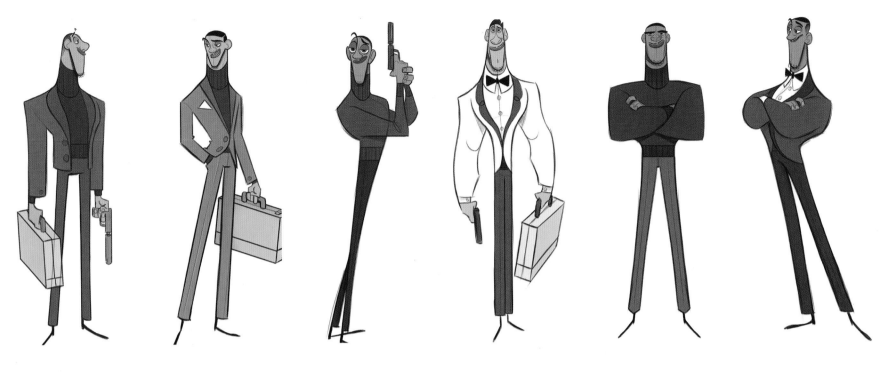

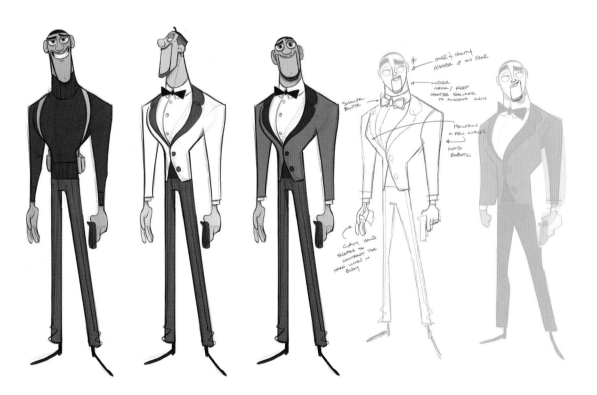

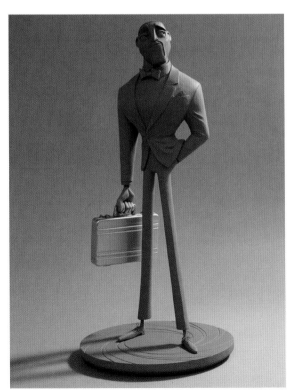

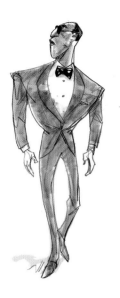

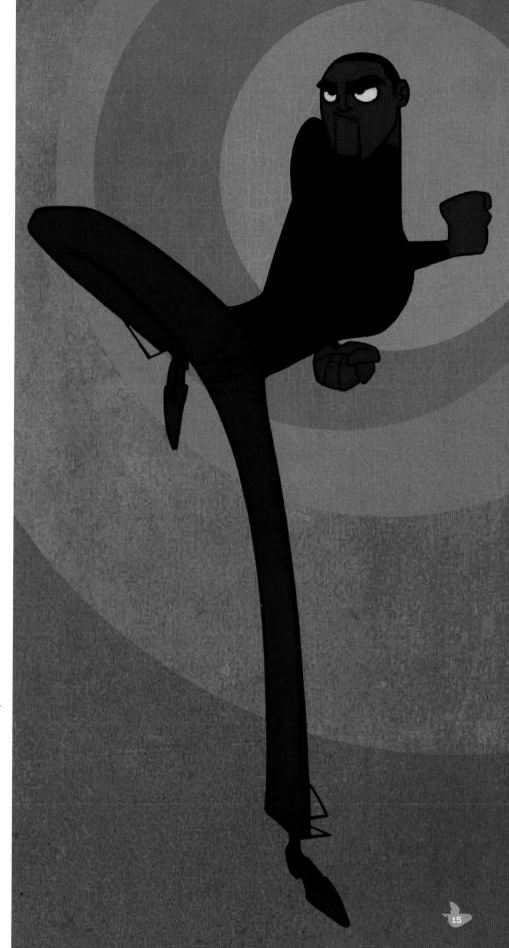

"Lance was one of the few sculpts that stayed fairly true to the original design. Pushing extremes and the contrast of his massive chest to his long, thin legs and *tiny* ankles made him a fun character to sculpt."

Vicki Saulls, Lead Sculptor

OPPOSITE TOP: Early Lance Concepts: designs by Dan Seddon

OPPOSITE BOTTOM LEFT: Early Lance Concepts: designs by Dan Seddon

OPPOSITE BOTTOM RIGHT: Lance: physical sculpt by Vicki Saulls

TOP: Early Lance Concepts: designs by Peter de Sève

ABOVE: Lance Gesture: design by Jason Sadler

RIGHT: Lance Action Poster: design by Jason Sadler

"Lance's design – like the overall style of the characters in *Spies in Disguise* – is very sculptural. To fit the 'photo-graphic' look of our style, we always light Lance in ways that emphasize the graphic shapes and planes of his form and his striking martini glass silhouette."

Michael Knapp, Production Designer

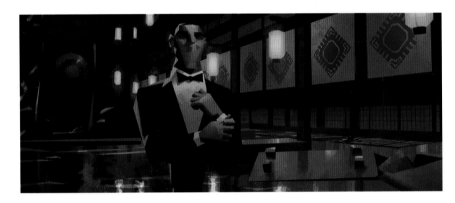

TOP LEFT: Lance Fighting Yakuza: design and color by Tyler Carter

LEFT: Lance in the Yakuza Pagoda Lair: color key by Peter Nguyen

BELOW: Lance Running from Drone Attack: color key by Hye Sung Park

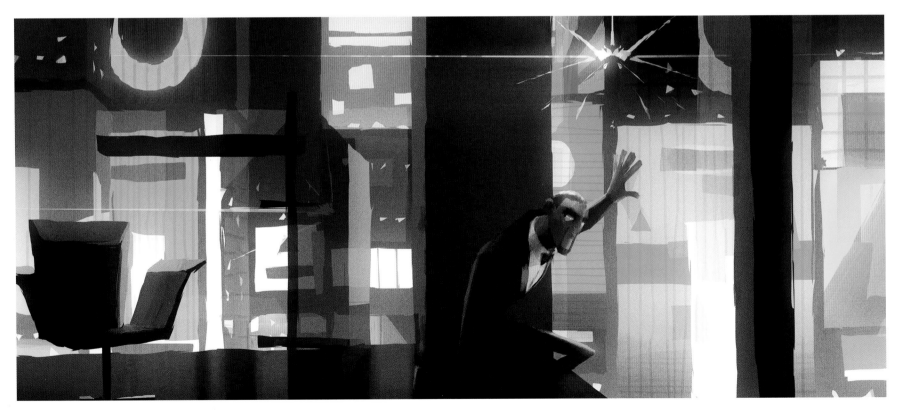

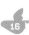

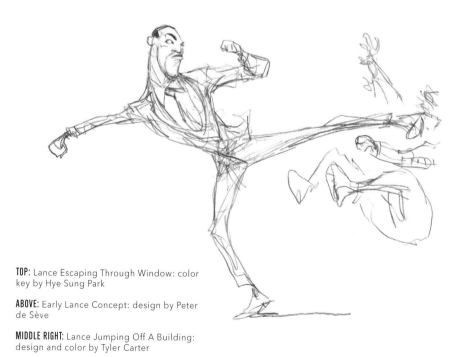

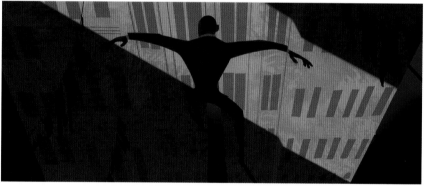

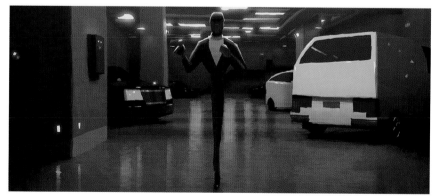

TOP: Lance Escaping Through Window: color key by Hye Sung Park

ABOVE: Early Lance Concept: design by Peter de Sève

MIDDLE RIGHT: Lance Jumping Off A Building: design and color by Tyler Carter

BOTTOM RIGHT: Lance Walking In Parking Garage: color key by Hye Sung Park

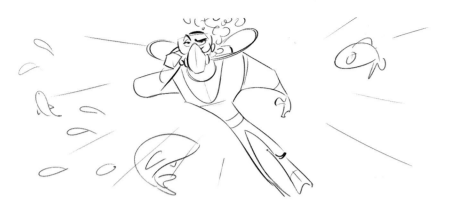

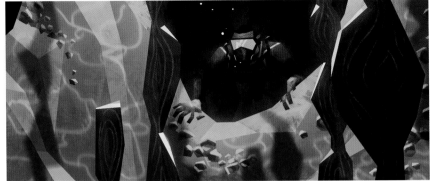

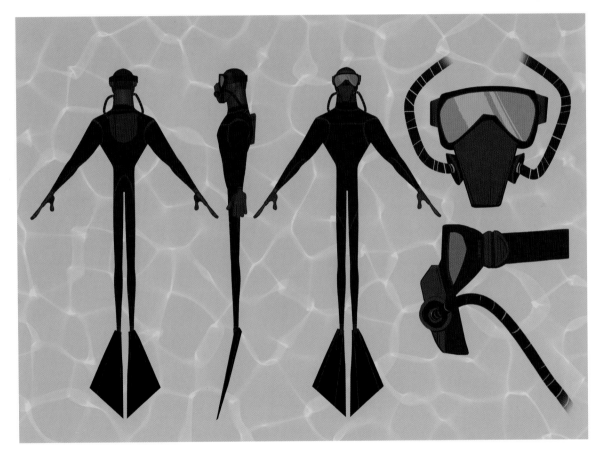

"The first ideas for the capabilities of Lance's suit began with our head of story Adam Cootes' story beat boards. Lance's tuxedo has air, sea and land capabilities built right into it."

Michael Knapp, Production Designer

TOP LEFT: Lance in Scuba Gear: storyboards by Adam Cootes, Head of Story

ABOVE: Lance in the Fish Tank: color key by Peter Nguyen

LEFT: Lance Scuba Gear: design by Tyler Carter

BOTTOM LEFT: Lance in Action: storyboards by Adam Cootes, Head of Story

BELOW: Early Lance Concepts: design by Peter de Sève

OPPOSITE: Lance and Walter Walking Through Agency: design and color by Greg Couch

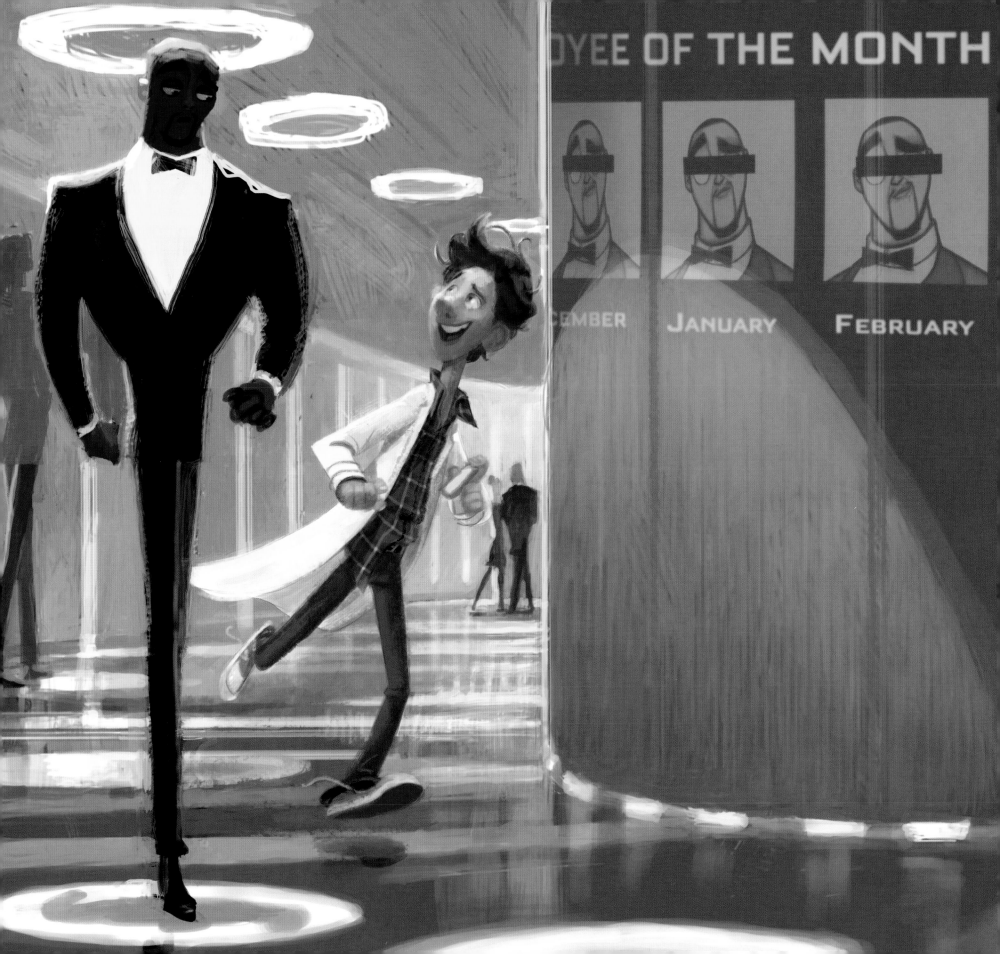

LANCE THE PIGEON

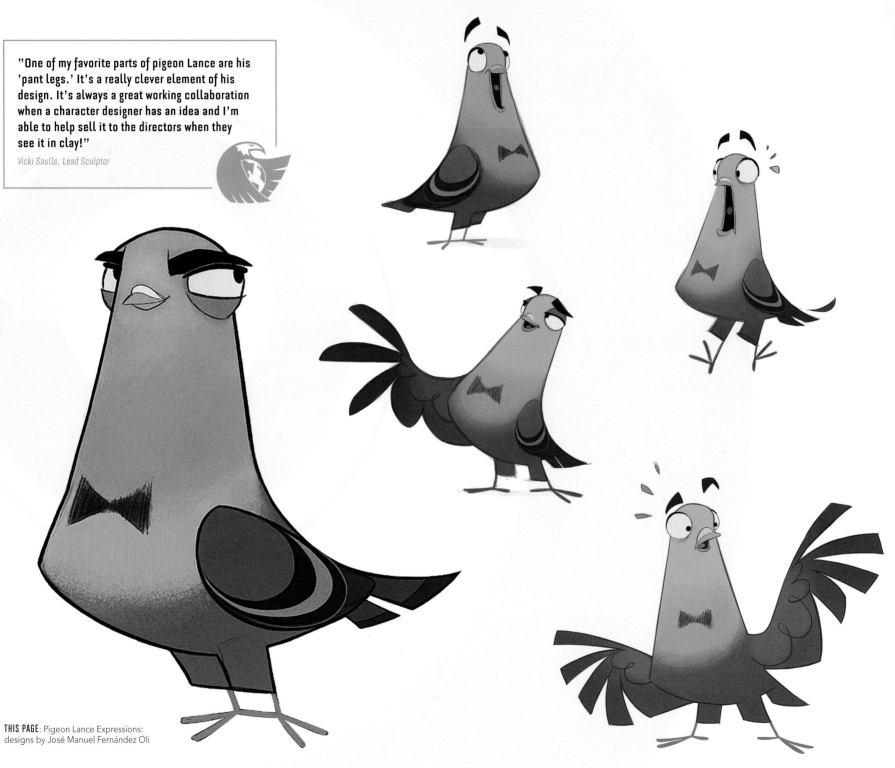

"One of my favorite parts of pigeon Lance are his 'pant legs.' It's a really clever element of his design. It's always a great working collaboration when a character designer has an idea and I'm able to help sell it to the directors when they see it in clay!"

Vicki Saulls, Lead Sculptor

THIS PAGE: Pigeon Lance Expressions: designs by José Manuel Fernández Oli

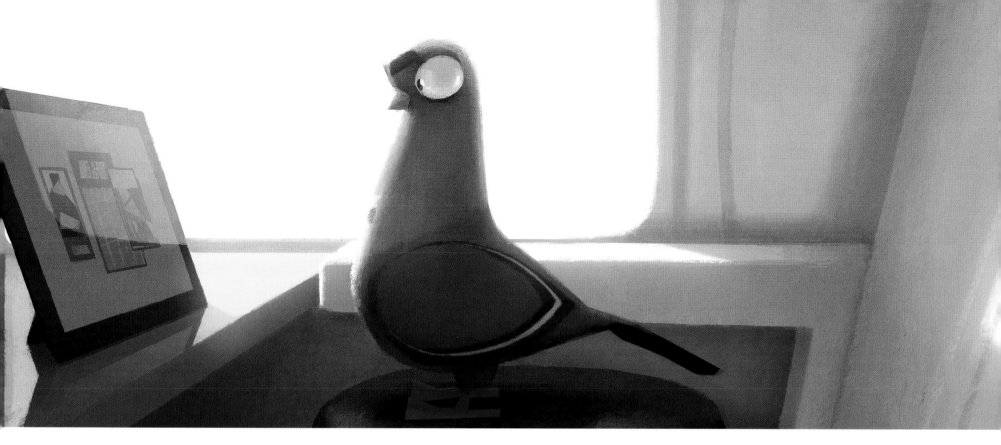

ABOVE: Pigeon Lance in Spy Plane: color key by Hye Sung Park

BELOW: Pigeon Lance Expressions: designs by Jason Sadler

RIGHT: Pigeon Lance: physical sculpt by Vicki Saulls

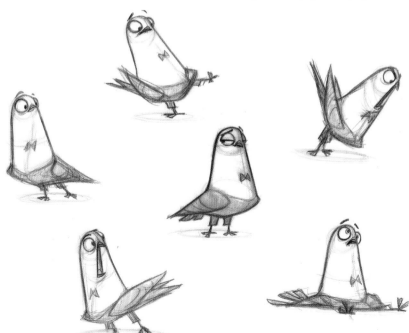

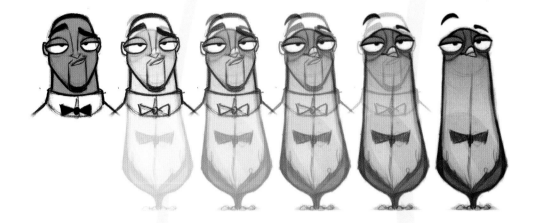

LEFT: Human and Bird Lance
Drawovers: designs by Jason Sadler

BELOW: Human Lance Expressions:
designs by BJ Crawford, Pigeon Lance
Expressions: designs by José Manuel
Fernández Oli

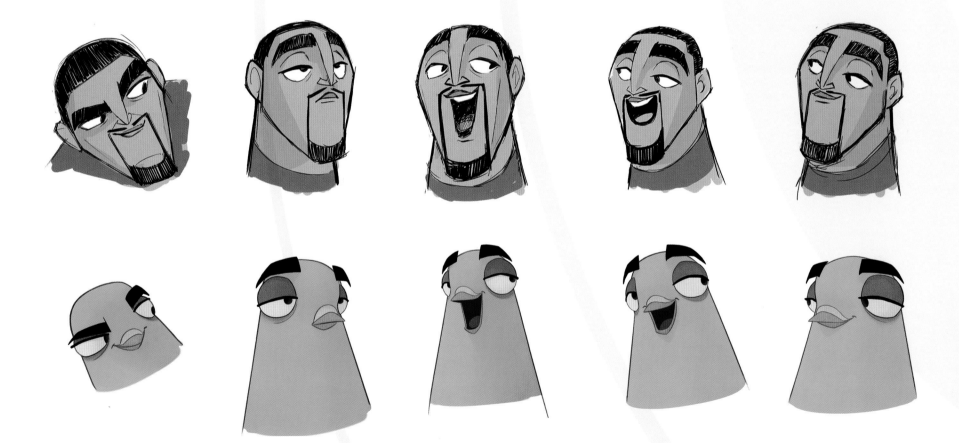

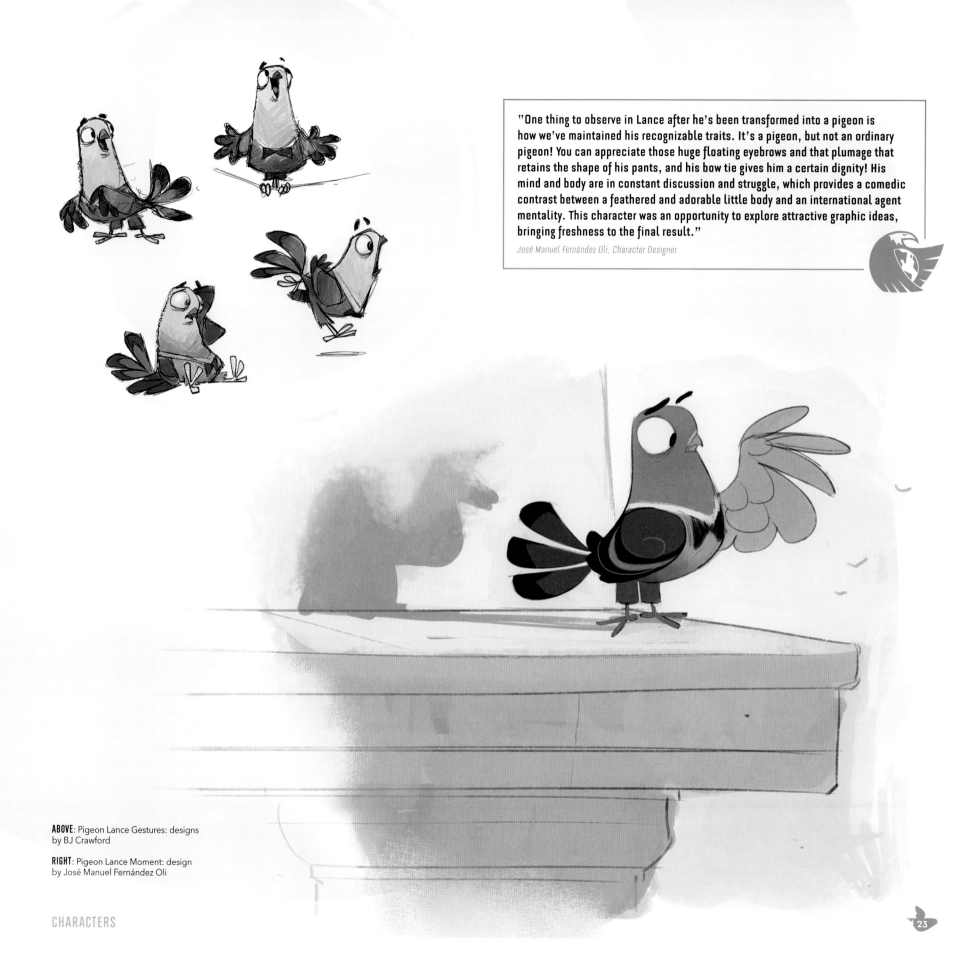

"One thing to observe in Lance after he's been transformed into a pigeon is how we've maintained his recognizable traits. It's a pigeon, but not an ordinary pigeon! You can appreciate those huge floating eyebrows and that plumage that retains the shape of his pants, and his bow tie gives him a certain dignity! His mind and body are in constant discussion and struggle, which provides a comedic contrast between a feathered and adorable little body and an international agent mentality. This character was an opportunity to explore attractive graphic ideas, bringing freshness to the final result."

José Manuel Fernández Oli, Character Designer

ABOVE: Pigeon Lance Gestures: designs by BJ Crawford

RIGHT: Pigeon Lance Moment: design by José Manuel Fernández Oli

FULL OPEN v02
T-POSE
TOPSIDE UNDERSIDE
13 FEATHERS

FULL OPEN v02
TOPSIDE UNDERSIDE
13 FEATHERS

HALF OPEN v02
TOPSIDE UNDERSIDE
13 FEATHERS

CLOSED v02
TOPSIDE UNDERSIDE
13 FEATHERS

"The graphic styling of our characters required a rethink of how we designed our birds' wings. They were a graphic interpretation of a wing that wasn't anthropomorphized in any way. It had to be graphically simple, but mechanically sound. Aidan Sugano and Jose Manuel Oli really boiled down the wing's shapes to their barest elegant essence, and then our character teams put a ton of brilliant engineering into making them work."

Michael Knapp, Production Designer

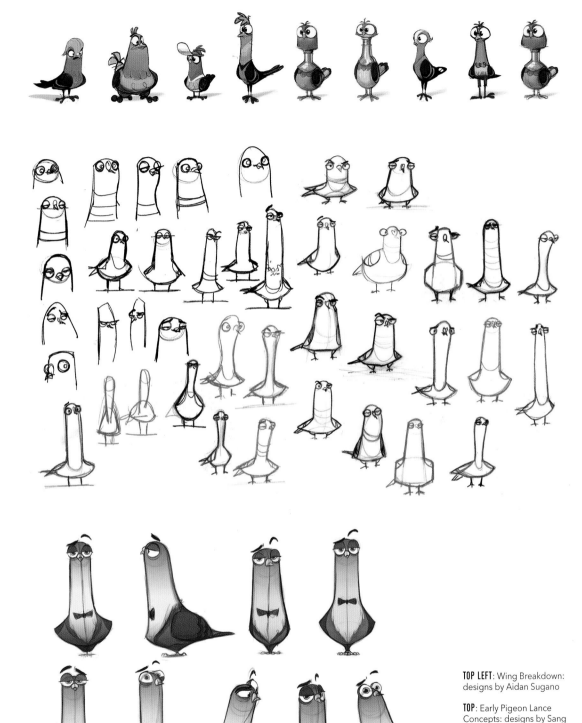

TOP LEFT: Wing Breakdown: designs by Aidan Sugano

TOP: Early Pigeon Lance Concepts: designs by Sang Jun Lee

MIDDLE: Early Pigeon Concepts: designs by Jason Sadler

LEFT: Pigeon Expressions: designs by Dan Seddon

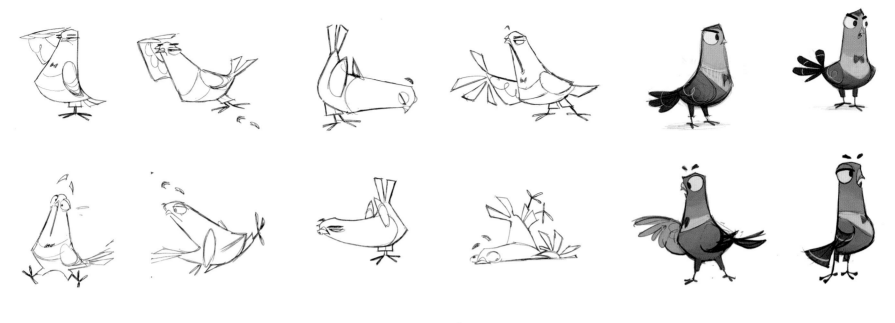

LEFT: Pigeon Lance Expressions: designs by BJ Crawford

ABOVE: Pigeon Lance Concepts: designs by José Manuel Fernández Oli

BELOW: Pigeon Lance and Walter in Spy Plane: color key by Ron DeFelice

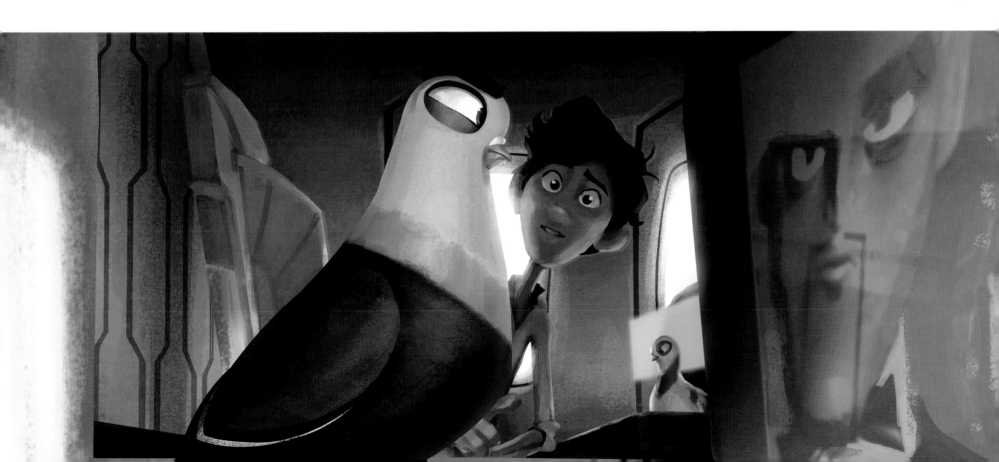

WALTER BECKETT

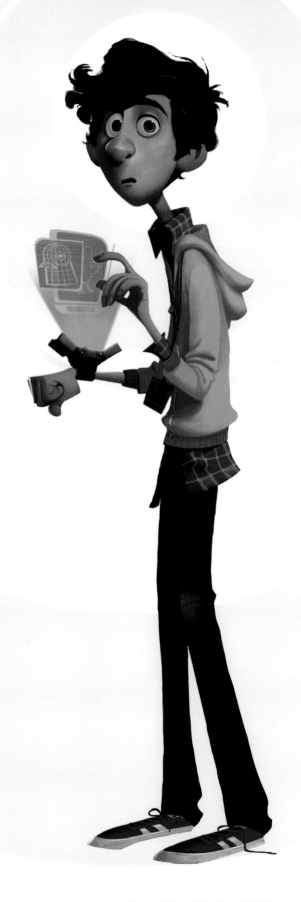

"The directors were looking for a character that could play to the comedic and more whimsical aspects of the story, but have gravitas as well, capable of showing genuine heart. I tried to think of someone who works hard and has the talent, but feels underestimated and unappreciated. Walter wanted to get out and see the world, but couldn't bring himself to, because he was so scared of the unknown. After a few takes, the directors really latched onto this drawing, where Walter had a wide-eyed, somewhat naive optimism. What I like about him is that he feels like a big kid, someone that would be fun to go on an adventure with."

Bobby Pontillas, Character Designer

RIGHT: Lance and Walter Moment: design by BJ Crawford

BELOW: Walter Gestures with Multi-Pen: designs by Bobby Pontillas

FAR RIGHT: Walter: design by Dan Seddon, color by Vincent Nguyen

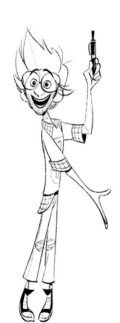

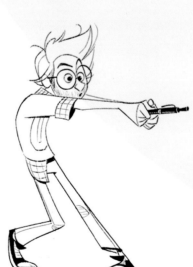

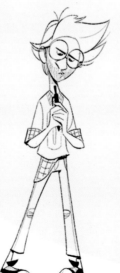

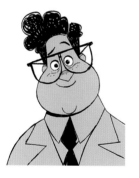 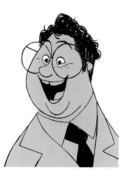 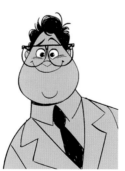 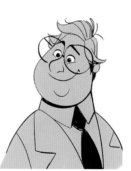

TOP: Walter and Pigeon Lance in Minisub: color key by Ron DeFelice

ABOVE: Early Walter Concepts: designs by Bobby Pontillas

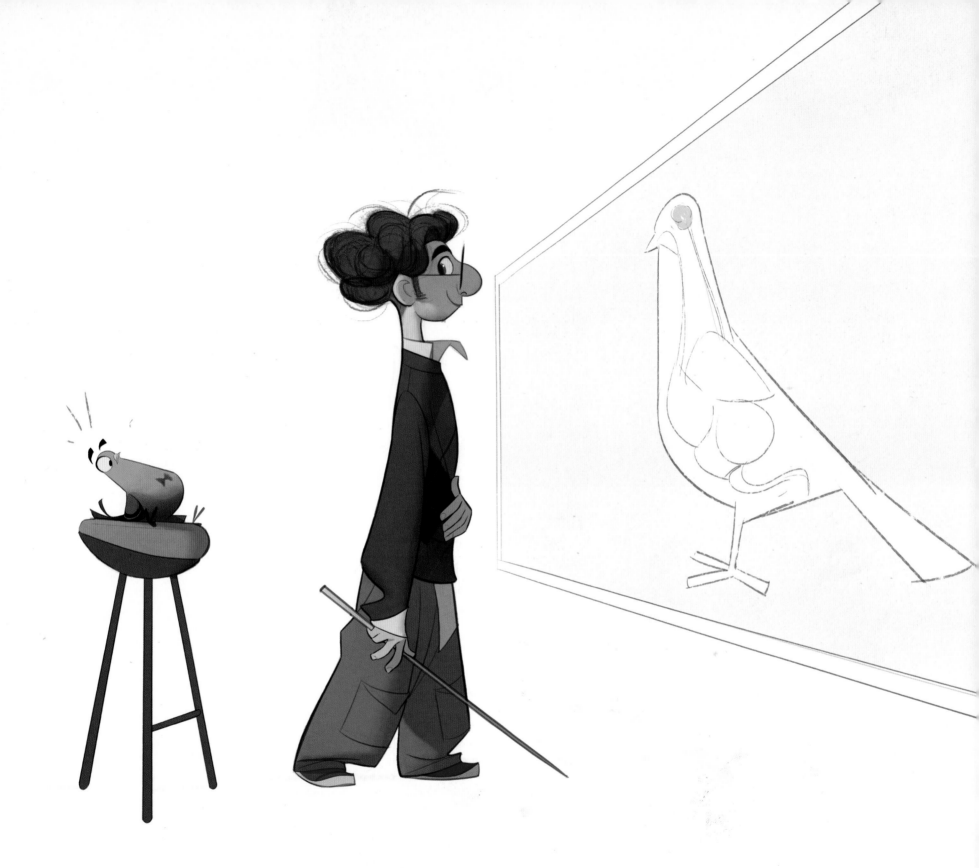

OPPOSITE: Walter and Pigeon Lance: designs by José Manuel Fernández Oli

BELOW: Early Walter Concepts: designs by José Manuel Fernández Oli

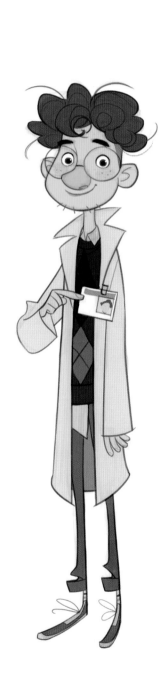

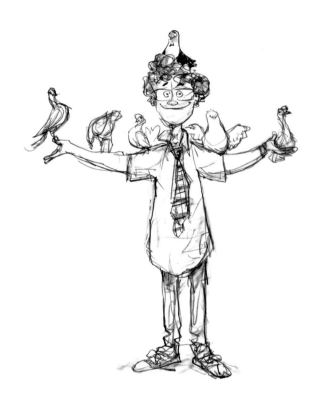

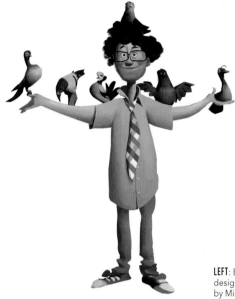

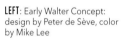

LEFT: Early Walter Concept: design by Peter de Sève, color by Mike Lee

BELOW: Early Walter Concept: design by Dan Seddon, color by Aidan Sugano

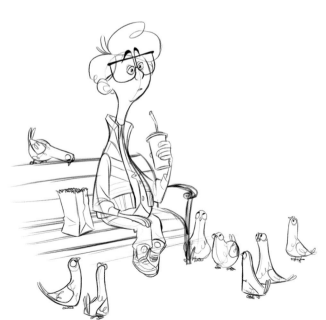

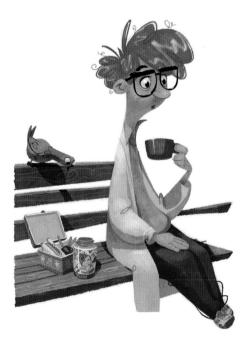

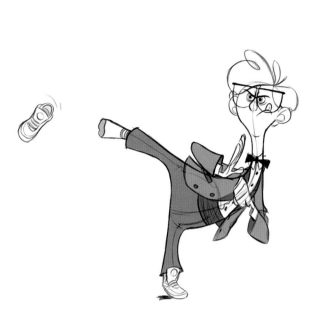

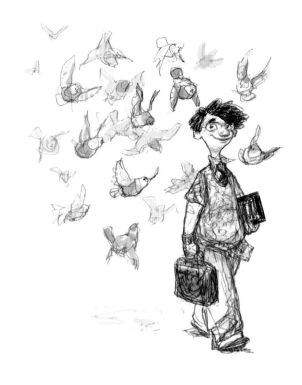

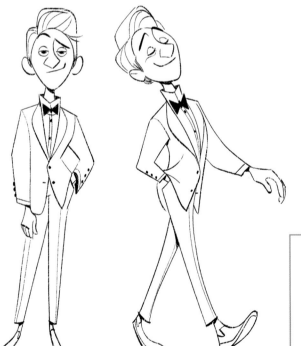

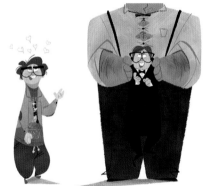

"One of the main challenges of Walter's design was creating a unique shape language that would not only contrast Lance's design, but also support it as both a human and as a bird. We ended up breaking the designs down to their simplest forms of strong sharp aggressive shapes vs soft round noodley lines."

Dan Seddon, Character Designer

TOP LEFT: Early Walter Concept: design by Dan Seddon

TOP RIGHT: Early Walter Concepts: designs by Peter de Sève

LEFT: Walter in a Tux: designs by Bobby Pontillas

ABOVE: Early Walter Concepts: designs by Aidan Sugano

OPPOSITE TOP: Early Walter Concepts: designs by Dan Seddon

OPPOSITE MIDDLE LEFT: Early Walter Concepts: designs by Jason Sadler

OPPOSITE MIDDLE: Early Walter Concept: designs by Willie Real

OPPOSITE BOTTOM LEFT: Early Walter Concepts: designs by José Manuel Fernández Oli

OPPOSITE BOTTOM RIGHT: Early Walter Concept: designs by Peter de Sève

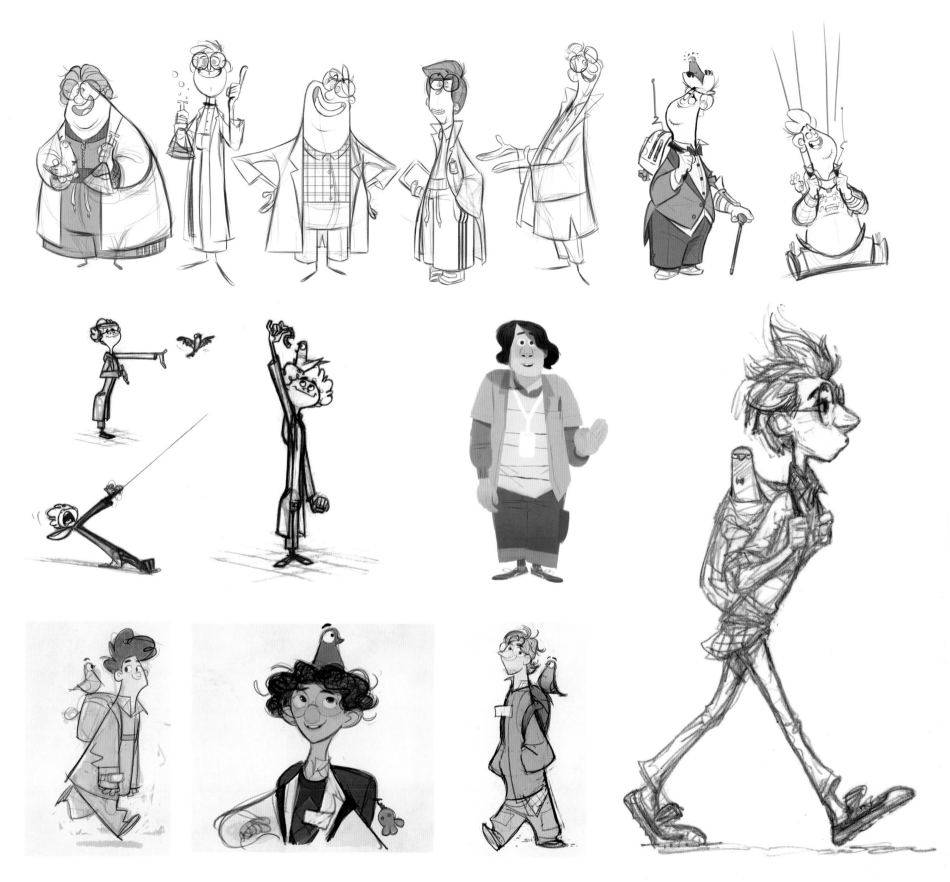

YOUNG WALTER

"The design of eight-year-old Walter needed to convey the optimism and the inclination to invent devices that would protect loved ones from harm. His mom Wendy Beckett's design needed to create a balance between compassion and tough resilience. To that end, she was given Walter's kind, expressive eyes as well as an athletic physique and strong jawline."

Jason Sadler, Lead Character Designer

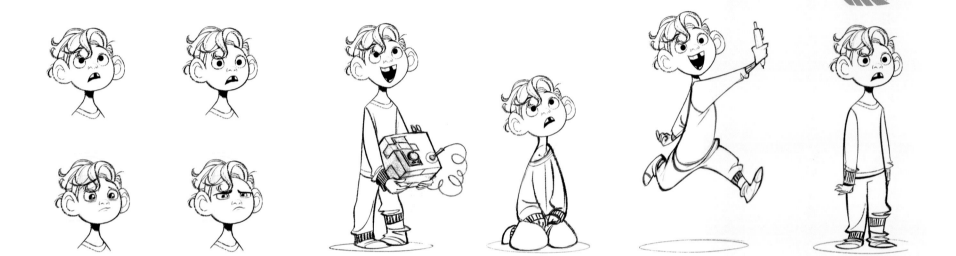

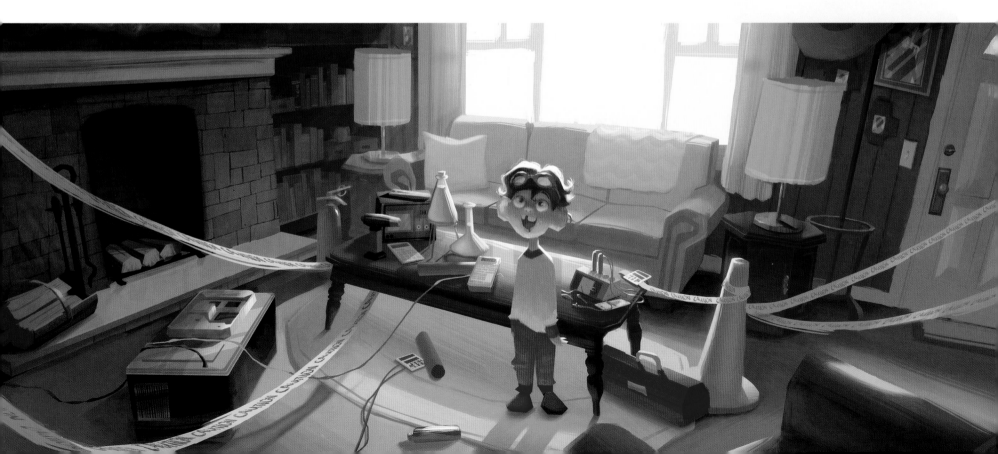

WENDY BECKETT

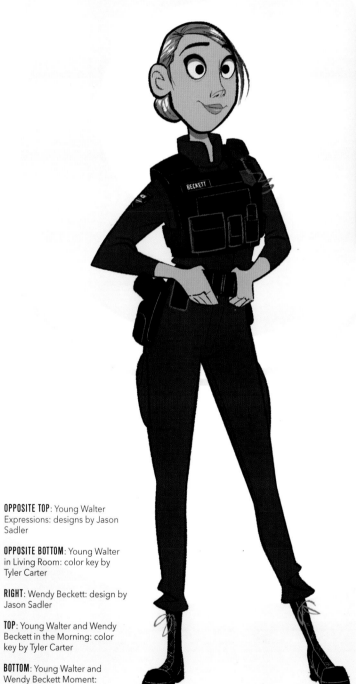

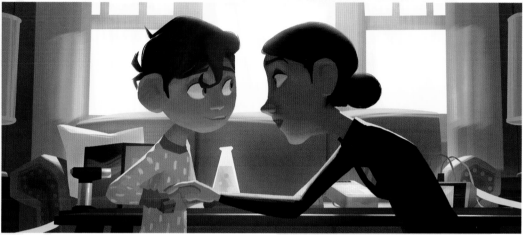

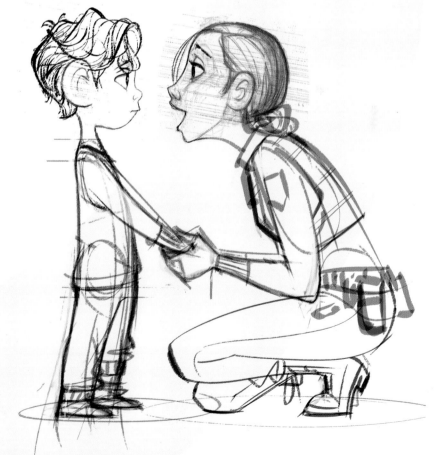

OPPOSITE TOP: Young Walter Expressions: designs by Jason Sadler

OPPOSITE BOTTOM: Young Walter in Living Room: color key by Tyler Carter

RIGHT: Wendy Beckett: design by Jason Sadler

TOP: Young Walter and Wendy Beckett in the Morning: color key by Tyler Carter

BOTTOM: Young Walter and Wendy Beckett Moment: designs by Jason Sadler

JOY "JOYLESS" JENKINS

"The filmmakers wanted Joyless to be strong as the Agency director, yet at the same time hold a soft spot for Lance. We had several early designs, but we settled on a more simplified idea. Her entire silhouette has a square shape and her nose, eyes, and mouth are contrasted to Lance."

Sang Jun Lee, Character Designer

LEFT: Early Joyless Concepts: designs by Sang Jun Lee

RIGHT: Joyless: design by Jason Sadler, color by Peter Nguyen

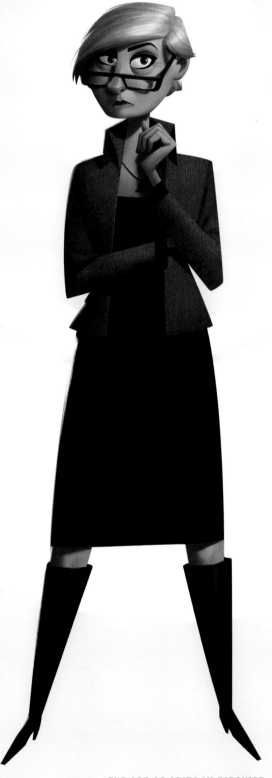

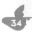

A4-ASSASSIN DRONE

A4-ASSASSIN DRONE

'A4-ASSASSIN'06

ADRONE1 SUBJECT LOCK

AGENCY DRONESCAN

SPEECH RECOGNITION

DRONE FE

AGENT STE

CUFF-LINK DRONE FEED_001

AGENCY **DRONEVIEW DO1**
DRONE FEED_001

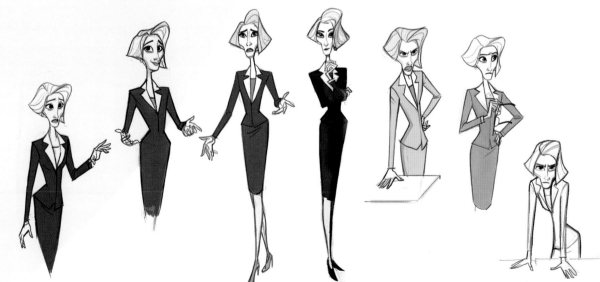

ABOVE: Joyless in Agency War
Room: color key by Peter
Nguyen

RIGHT: Early Joyless Expressions:
designs by Sang Jun Lee

CHARACTERS

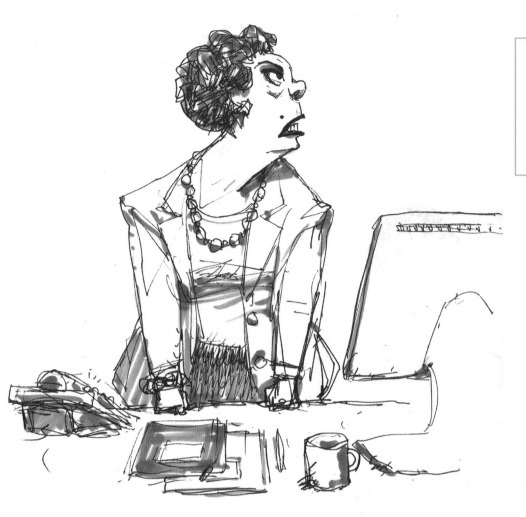

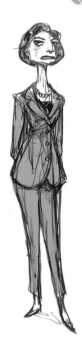

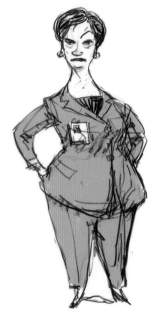

"Joyless was such an enjoyable and intriguing character to work on. Like Lance, she was given a silhouette with long straight lines, a well-tailored suit and a powerful wide stance. Heavily lidded, calculating eyes, strong cheekbones and jawline were designed to convey a strong presence. It also seemed fitting that this no-nonsense character would have a fashionable, minimal-maintenance hairstyle."

Jason Sadler, Lead Character Designer

ABOVE: Early Joyless Concepts: design by Peter de Sève

TOP RIGHT: Early Joyless Concepts: designs by Peter de Sève

RIGHT: Early Joyless Concepts: designs by Sang Jun Lee

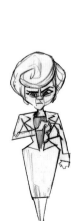
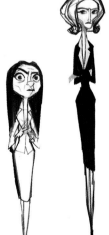
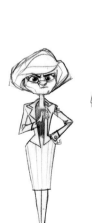
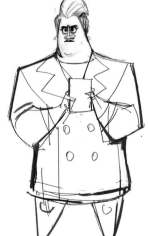
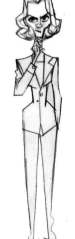
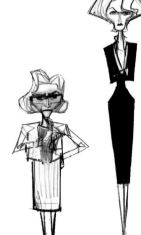
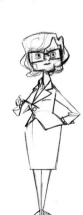

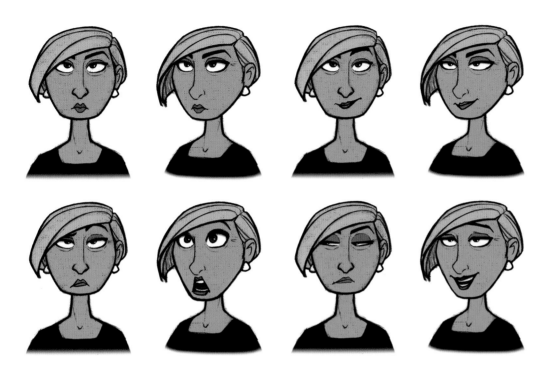

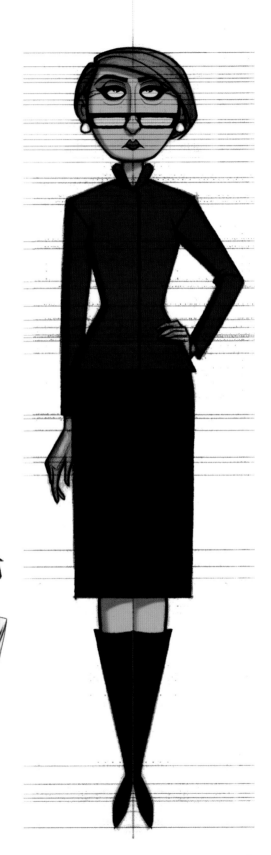

ABOVE & RIGHT: Joyless
Expressions and Pose: designs
by Jason Sadler

BELOW: Early Joyless Concepts:
designs by Sang Jun Lee

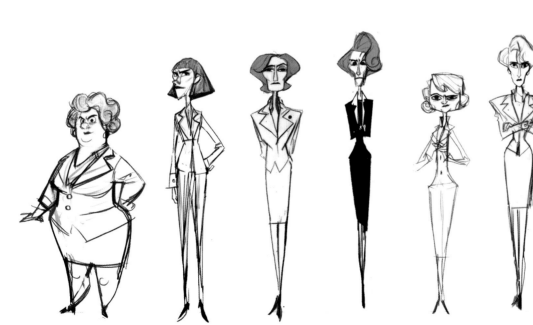

KATSU KIMURA

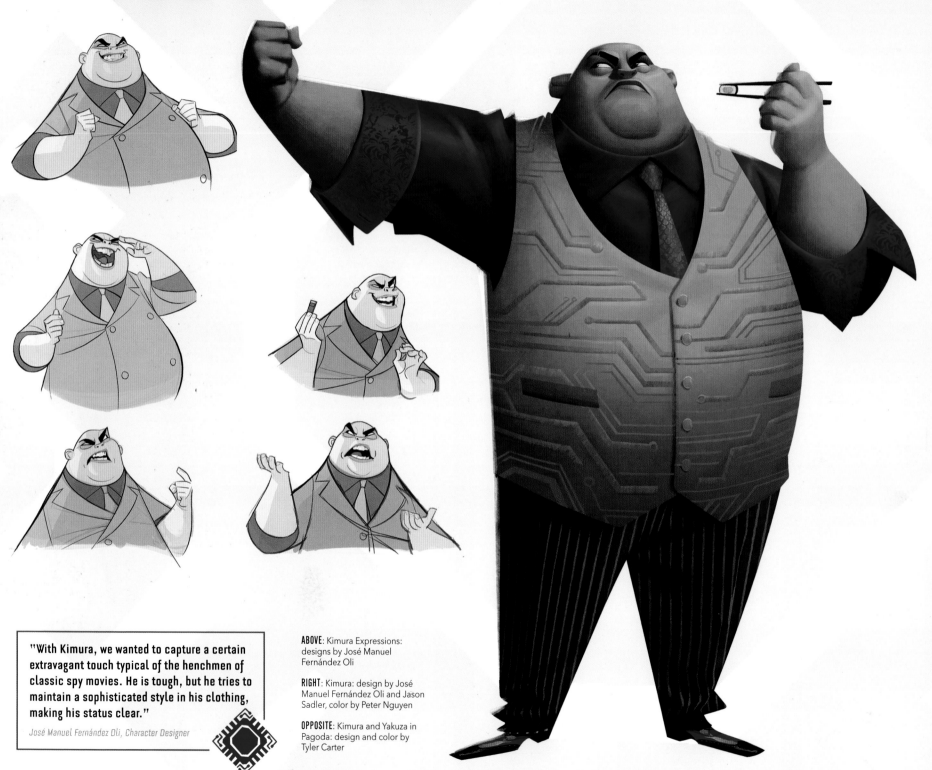

"With Kimura, we wanted to capture a certain extravagant touch typical of the henchmen of classic spy movies. He is tough, but he tries to maintain a sophisticated style in his clothing, making his status clear."

José Manuel Fernández Oli, Character Designer

ABOVE: Kimura Expressions: designs by José Manuel Fernández Oli

RIGHT: Kimura: design by José Manuel Fernández Oli and Jason Sadler, color by Peter Nguyen

OPPOSITE: Kimura and Yakuza in Pagoda: design and color by Tyler Carter

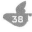

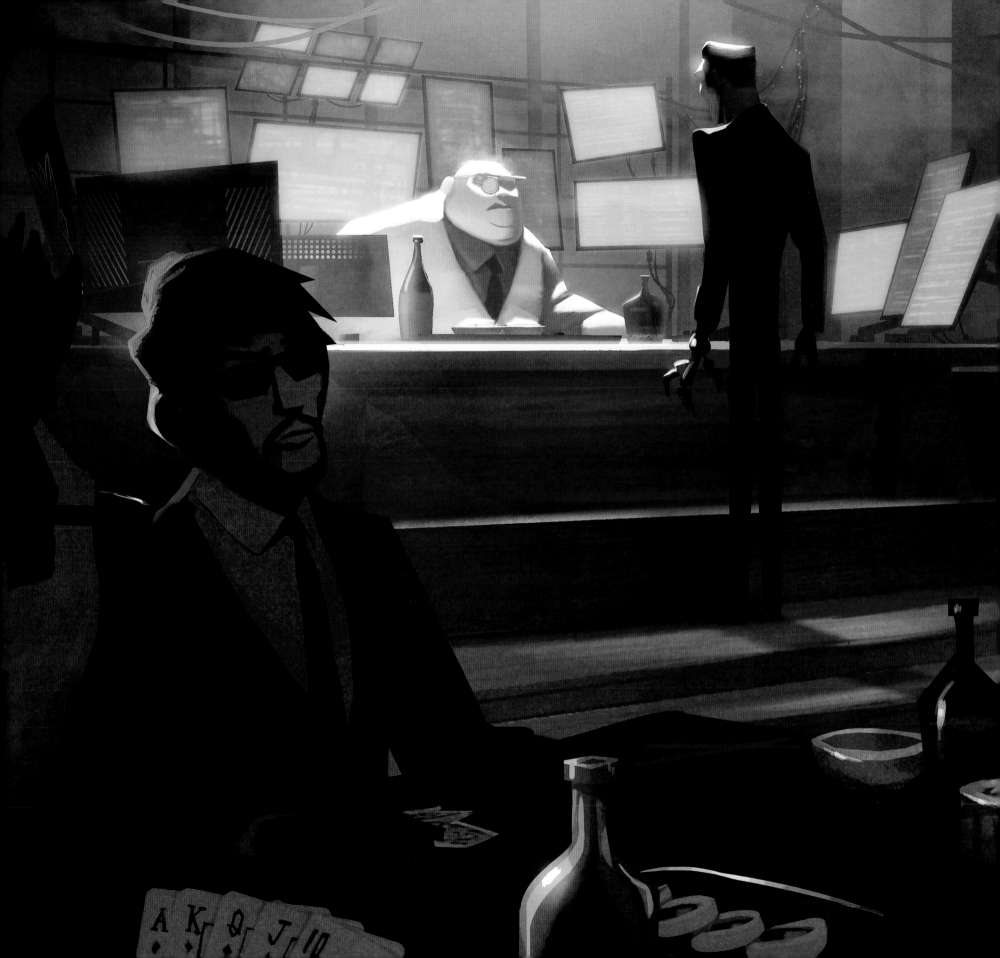

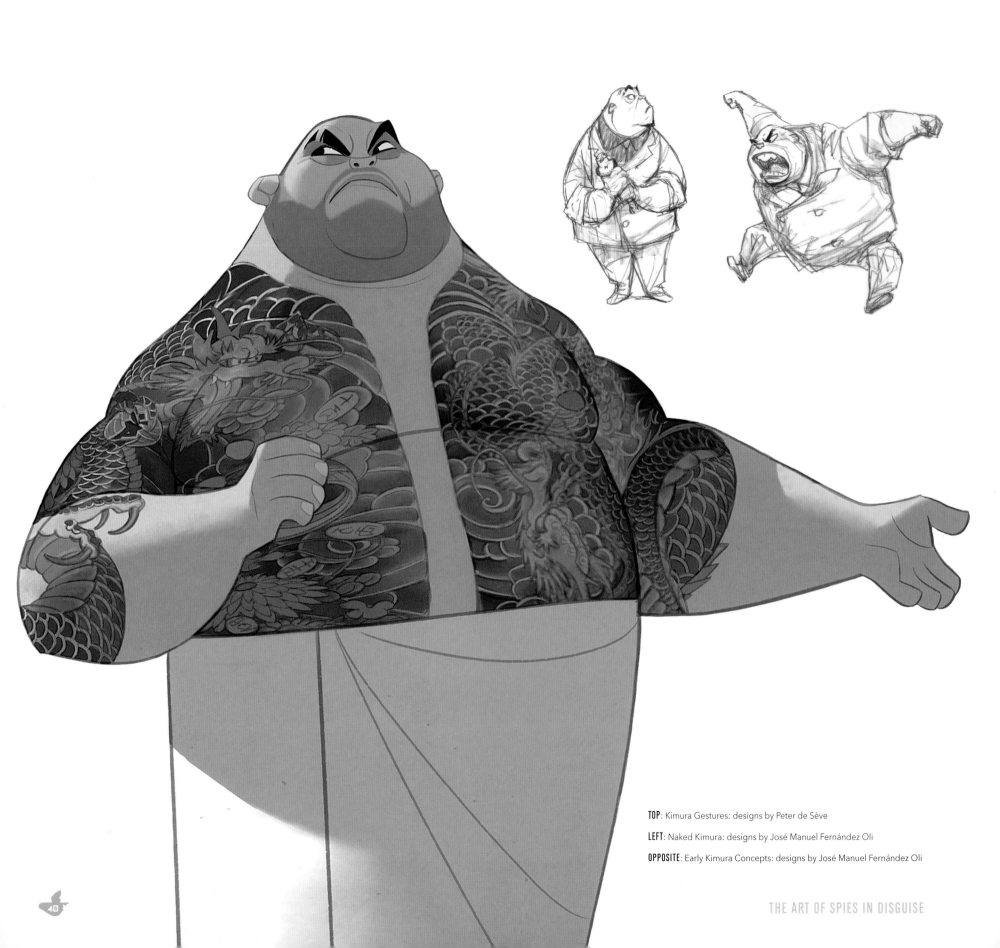

TOP: Kimura Gestures: designs by Peter de Sève

LEFT: Naked Kimura: designs by José Manuel Fernández Oli

OPPOSITE: Early Kimura Concepts: designs by José Manuel Fernández Oli

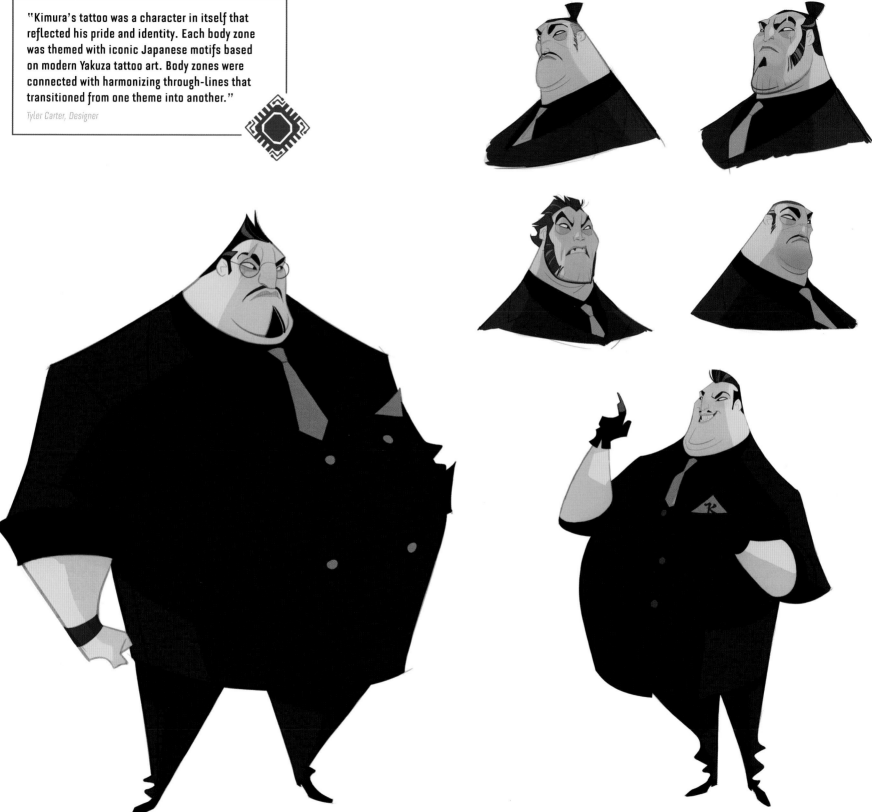

"Kimura's tattoo was a character in itself that reflected his pride and identity. Each body zone was themed with iconic Japanese motifs based on modern Yakuza tattoo art. Body zones were connected with harmonizing through-lines that transitioned from one theme into another."

Tyler Carter, Designer

KILLIAN

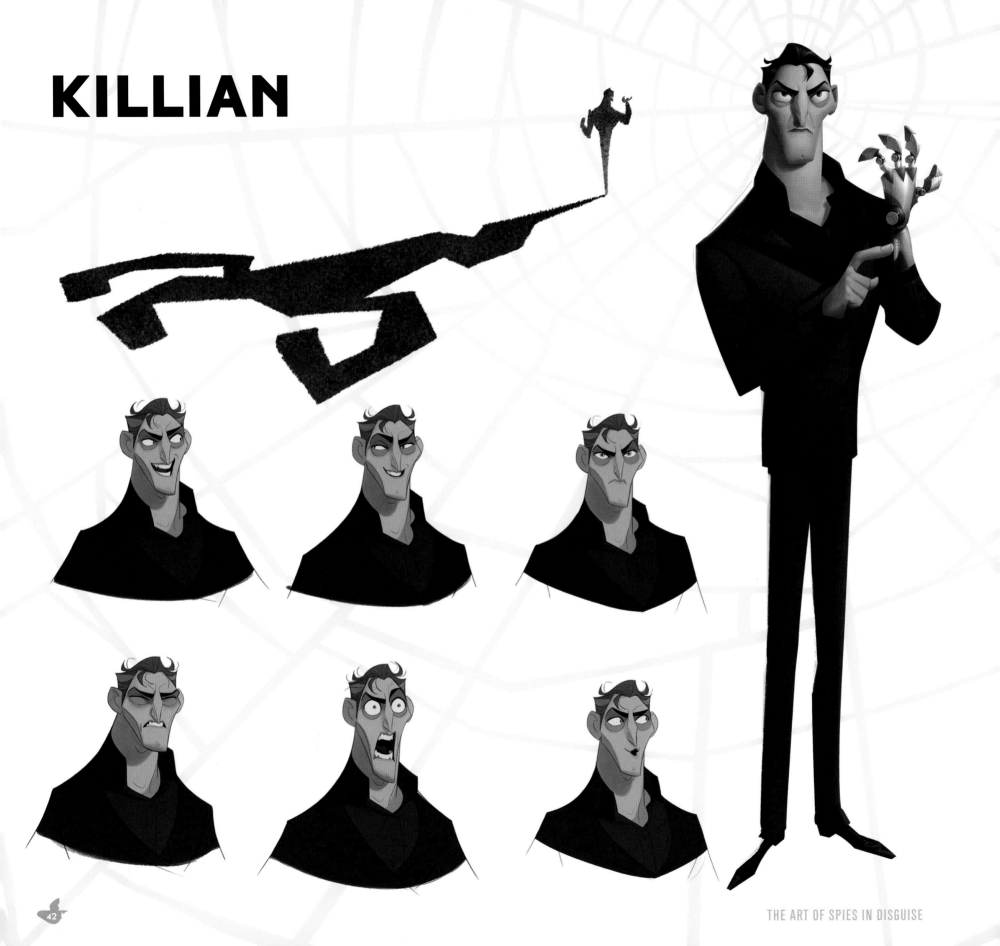

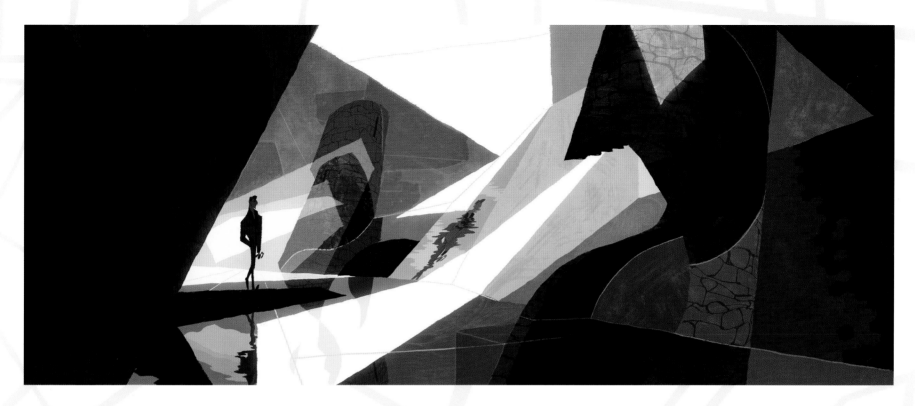

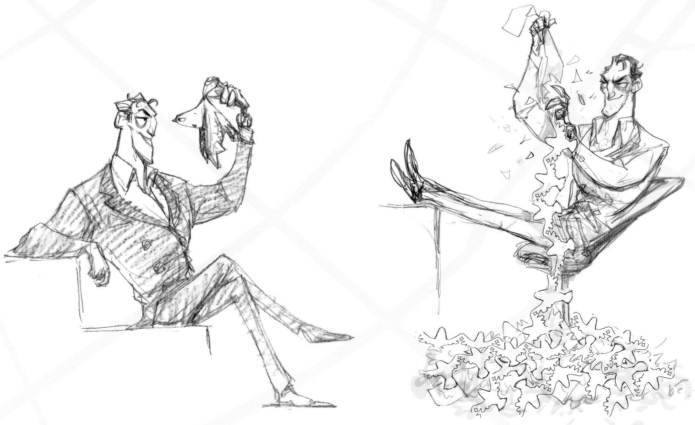

OPPOSITE TOP LEFT: Killian and Shadow: design by Aidan Sugano

OPPOSITE BOTTOM LEFT: Killian Expressions: designs by José Manuel Fernández Oli

OPPOSITE RIGHT: Killian: designs by José Manuel Fernández Oli , color by Peter Nguyen

ABOVE: Killian Walking in His Lair: design and color by Aidan Sugano

LEFT: Killian Gestures: designs by Peter de Sève

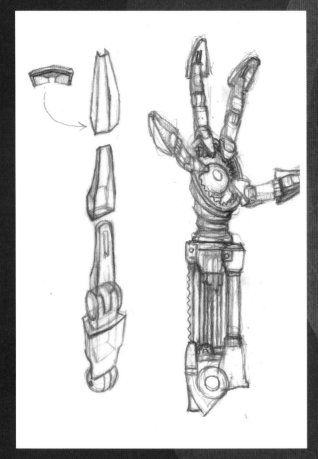

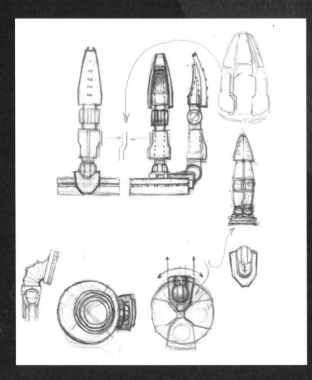

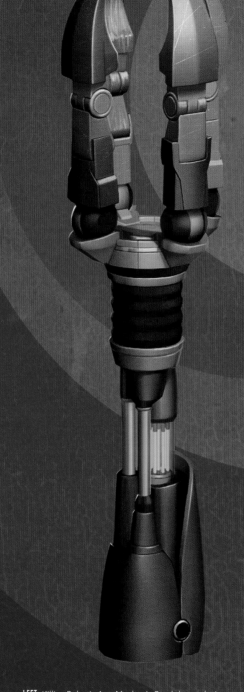

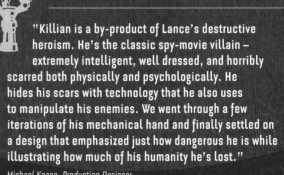

LEFT: Killian Robotic Arm Mechanic Breakdown: design by Greg Couch

ABOVE: Killian Robotic Arm: design by Greg Couch, color by Peter Nguyen

ABOVE RIGHT: Killian Scarred Face: design by José Manuel Fernández Oli , color by Peter Nguyen

"Killian is a by-product of Lance's destructive heroism. He's the classic spy-movie villain — extremely intelligent, well dressed, and horribly scarred both physically and psychologically. He hides his scars with technology that he also uses to manipulate his enemies. We went through a few iterations of his mechanical hand and finally settled on a design that emphasized just how dangerous he is while illustrating how much of his humanity he's lost."

Michael Knapp, Production Designer

BELOW: Killian Gestures: designs by José Manuel Fernández Oli

BOTTOM: Killian and Lance Face Off in Pagoda: color key by Peter Nguyen

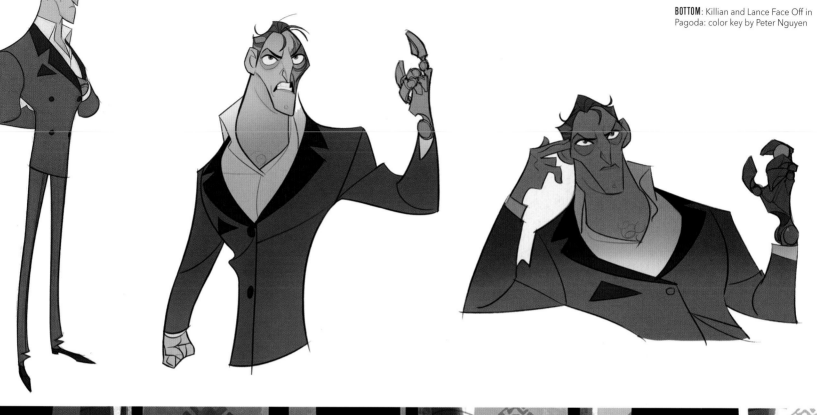

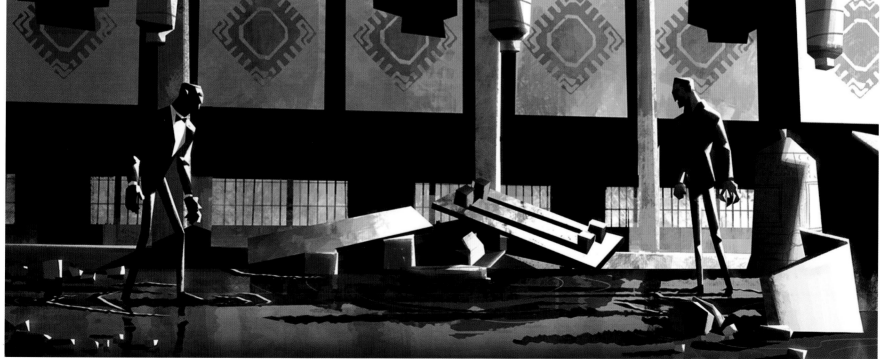

MARCY KAPPEL

"Marcy's character is in complete opposition to Lance's and her asymmetrical hair shape and overall silhouette were designed to reflect that contrast. Like Lance, though, she is capable of working in the field and her athletic physique was designed to be similar to that of a mountain climber or gymnast."

Jason Sadler, Lead Character Designer

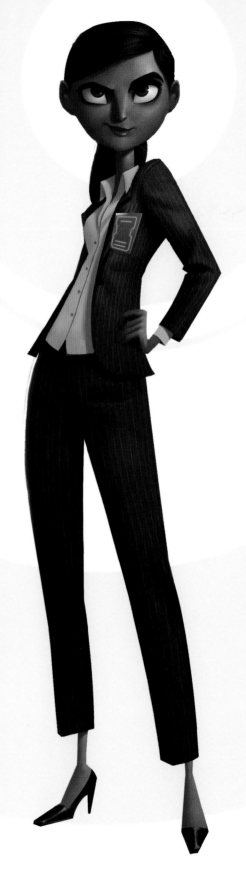

ABOVE: Early Marcy Expressions: drawings by Jason Sadler

RIGHT: Marcy: drawing by Jason Sadler, painting by Peter Nguyen

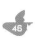

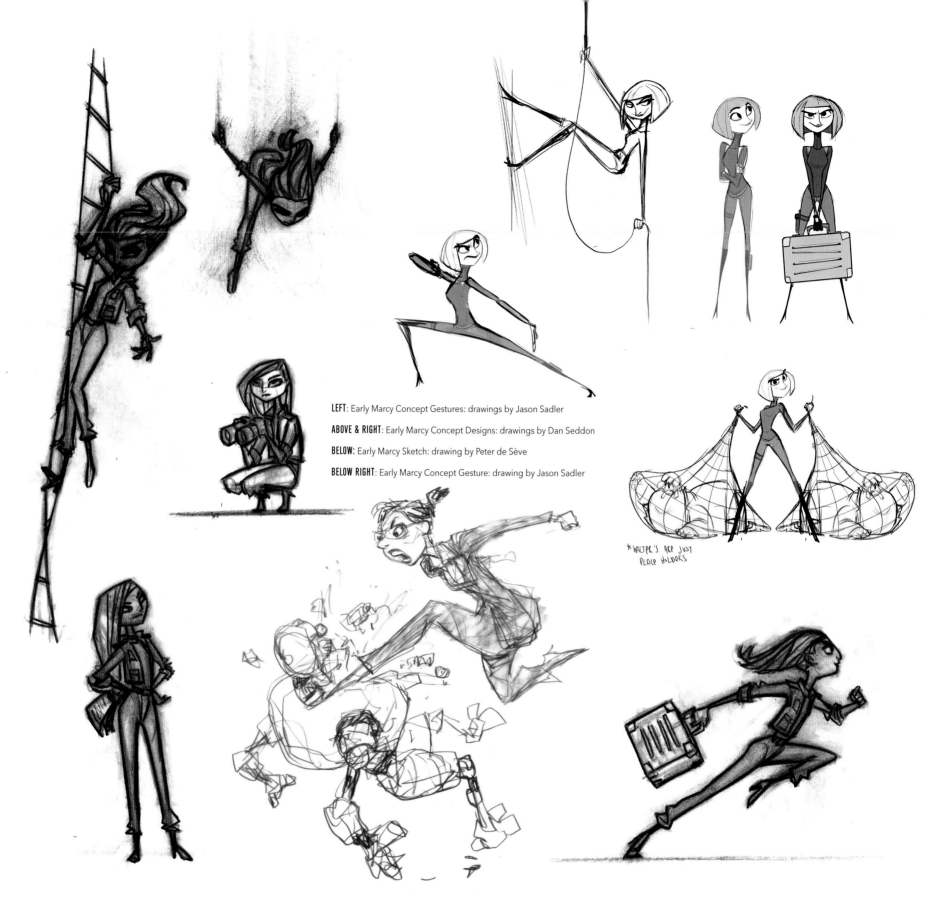

LEFT: Early Marcy Concept Gestures: drawings by Jason Sadler

ABOVE & RIGHT: Early Marcy Concept Designs: drawings by Dan Seddon

BELOW: Early Marcy Sketch: drawing by Peter de Sève

BELOW RIGHT: Early Marcy Concept Gesture: drawing by Jason Sadler

*WALTER'S ARE JUST PLACE HOLDERS

BELOW: Marcy Hair Breakdown: design by Jason Sadler

RIGHT: Marcy Sitting: design by Jason Sadler, color by Peter Nguyen

FAR RIGHT: Early Marcy Concept: design by Jason Sadler, color by Mike Lee

BOTTOM RIGHT: Early Marcy Concepts: designs by Dan Seddon

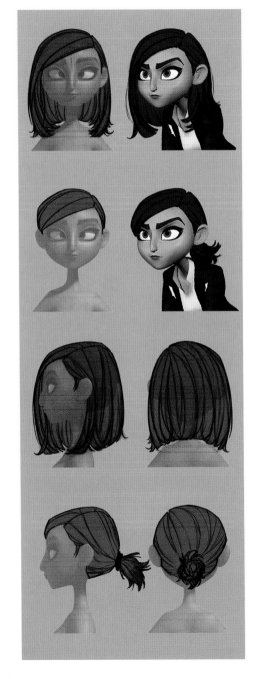

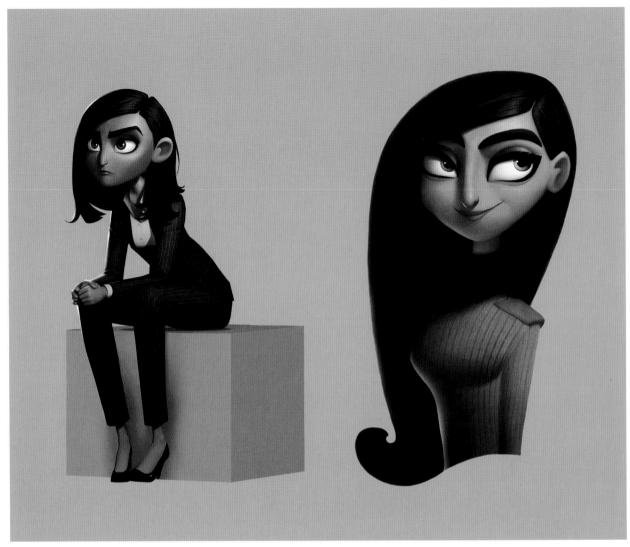

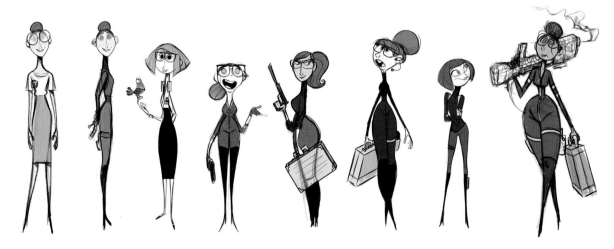

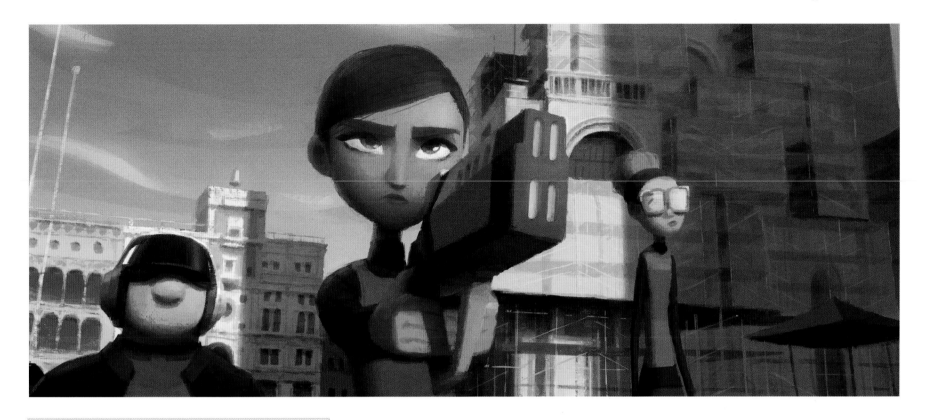

> "Unlike Lance, Marcy embodies the team-oriented ethos of the Agency. The colors of her clothes, whether in the office or in the field, are Agency blue-green."
>
> Michael Knapp, Production Designer

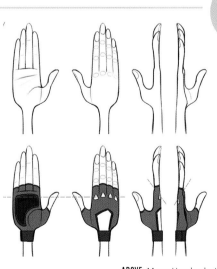

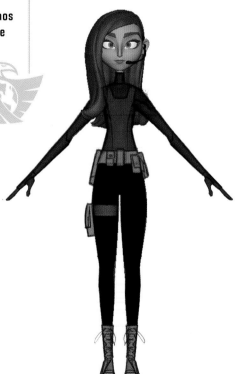

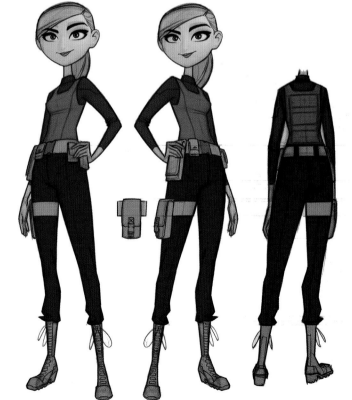

TOP: Marcy, Eyes and Ears Confront Lance: color key by Hye Sung Park

ABOVE: Marcy Hands: design by Jason Sadler

RIGHT: Marcy Tactical Gear: designs by Jason Sadler

EYES & EARS

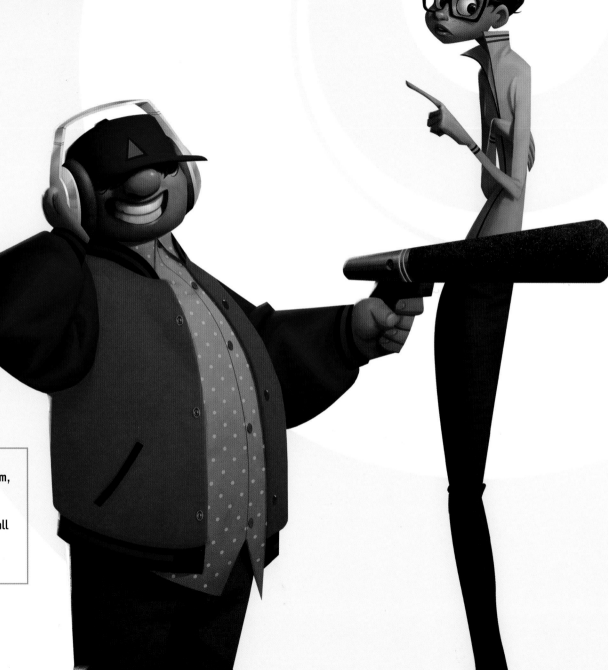

"Ears is the telecommunication of the team, with the flair and attitude of a DJ. Because Eyes and Ears are opposites of each other, it was only natural to design them as a duo; Ears is all energy and Eyes has her protective slouch."

Annlyn Huang, Character Designer

THIS PAGE: Ears: design by Annlyn Huang with Jason Sadler, color by Hye Sung Park; Eyes: design by Annlyn Huang with Jason Sadler, color by Vincent Nguyen

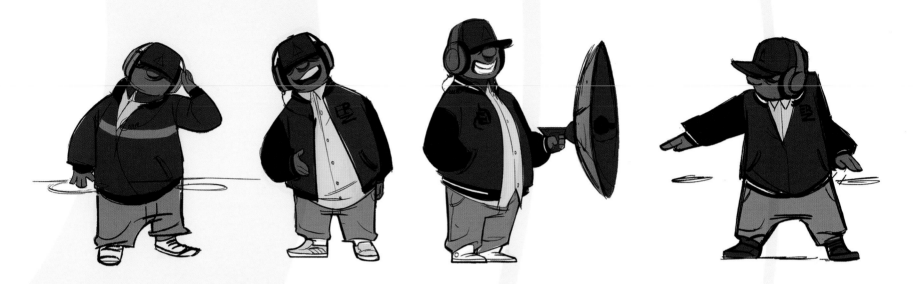

BELOW: Ears Gestures: designs by Annlyn Huang

BOTTOM: Marcy, Eyes and Ears in Pursuit of Lance: color key by Peter Nguyen

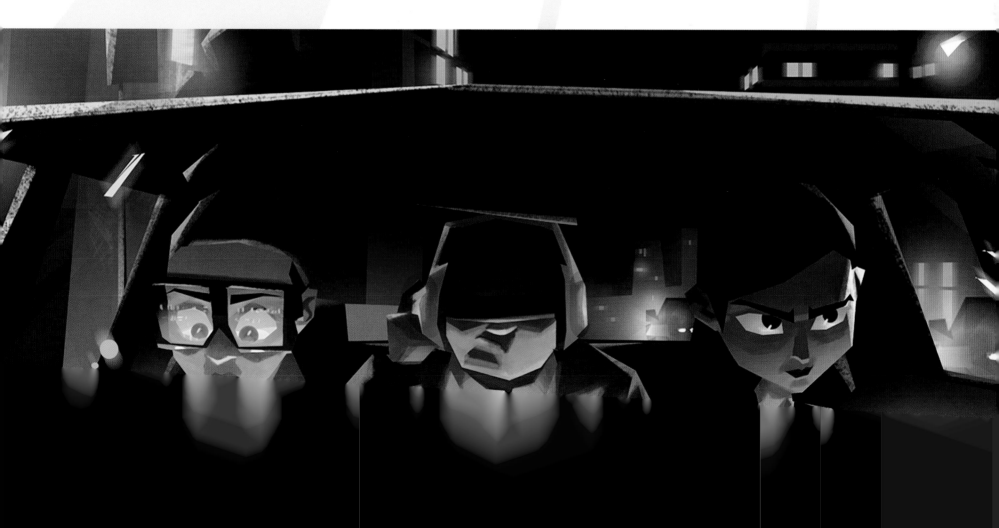

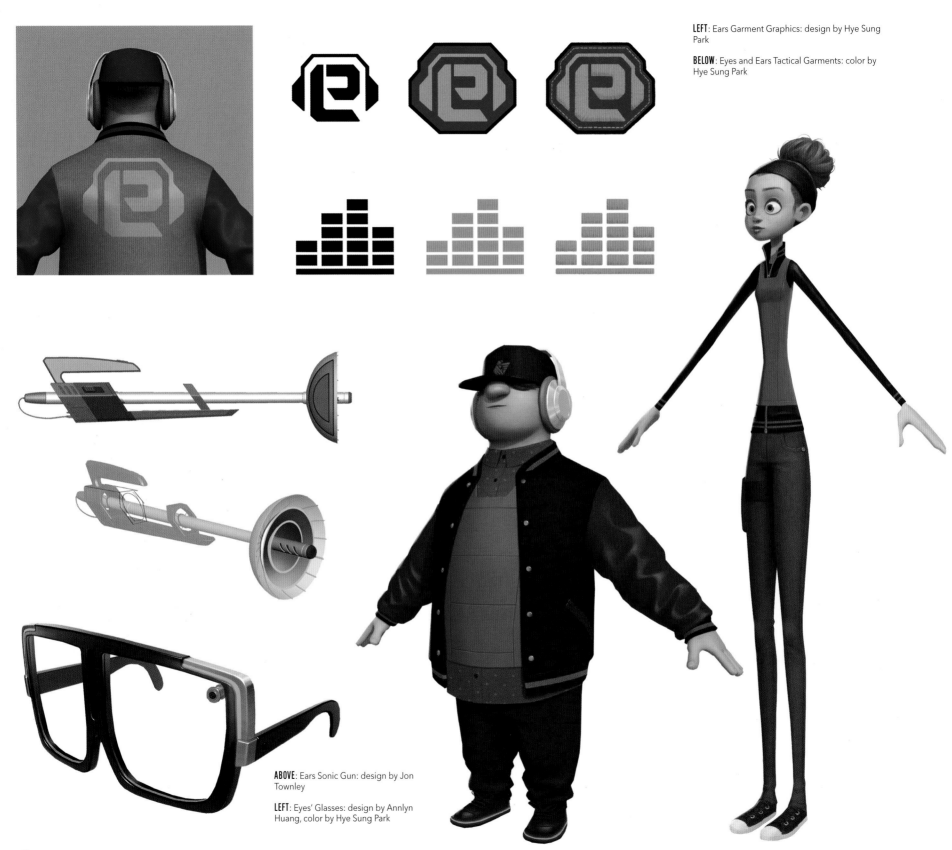

LEFT: Ears Garment Graphics: design by Hye Sung Park

BELOW: Eyes and Ears Tactical Garments: color by Hye Sung Park

ABOVE: Ears Sonic Gun: design by Jon Townley

LEFT: Eyes' Glasses: design by Annlyn Huang, color by Hye Sung Park

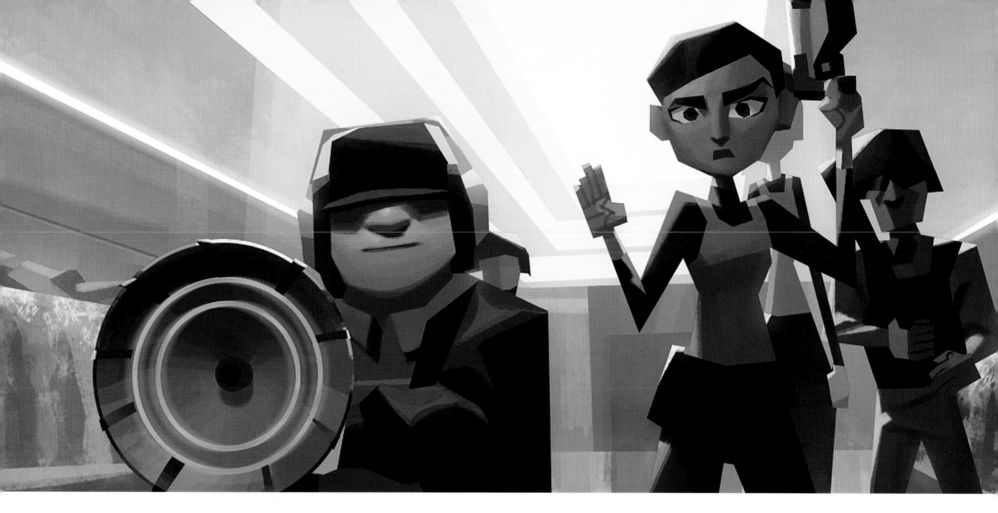

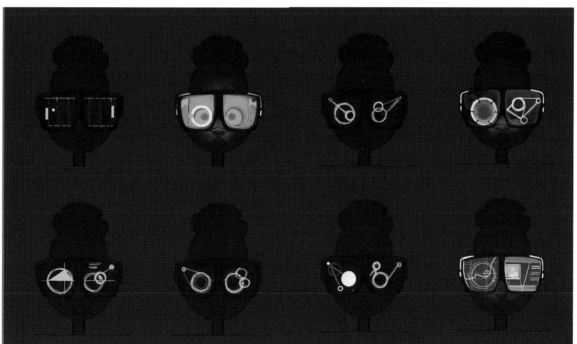

"We gave Eyes glasses that function as both a necessity and an accessory, really emphasizing the gadget aspect of them. The bulky glasses perched on her lanky figure pushed her awkwardness so much more. It made her such an entertaining character to work with."

Annlyn Huang, Character Designer

ABOVE: Marcy, Eyes and Ears Breaking Down Hotel Door: color key by Peter Nguyen

LEFT: Eyes' Glasses Graphics Concepts: designs by Annlyn Huang

LOVEY

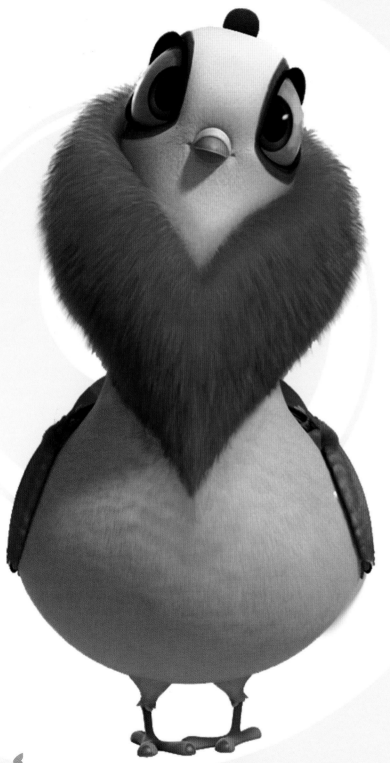

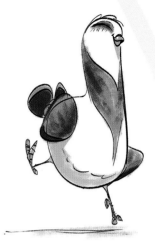

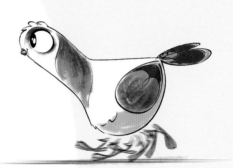

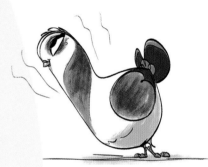

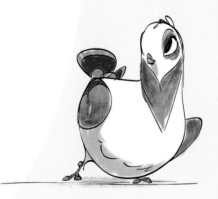

ABOVE: Lovey Gestures: designs by Aidan Sugano

LEFT: Lovey: design by Aidan Sugano, color by Vincent Nguyen

"Each bird was based off one simple shape repeated. Lovey is all hearts."

Aidan Sugano, Designer

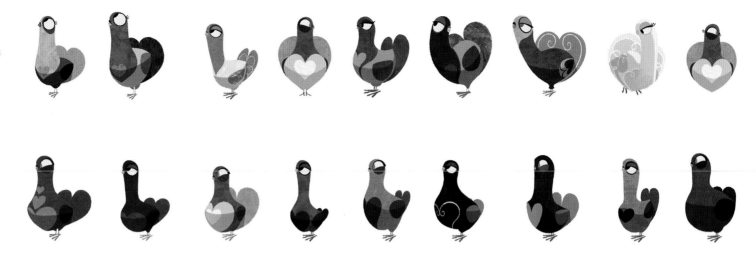

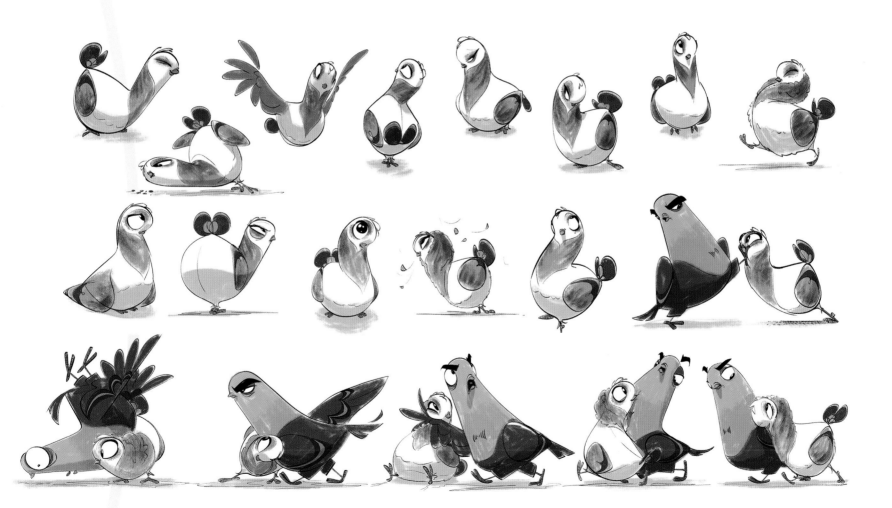

CRAZY EYES

"Crazy Eyes is the embodiment of the scrappy pigeon. Mangy, mutated, missing a leg, most of his tail, covered in trash. So, we made him into one of those inflatable punching bags that come back when you hit them, because no matter what happens, he will always survive."

Aidan Sugano, Designer

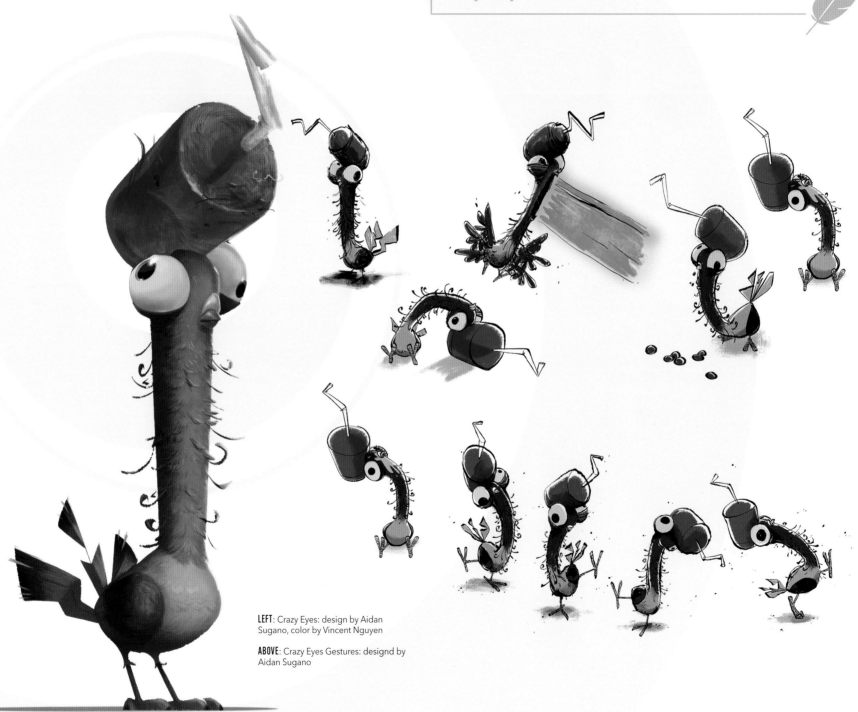

LEFT: Crazy Eyes: design by Aidan Sugano, color by Vincent Nguyen

ABOVE: Crazy Eyes Gestures: designd by Aidan Sugano

RIGHT: Early Crazy Eyes Sketches: designs by Peter de Sève

FAR RIGHT: Early Crazy Eyes Concepts: designs by Jason Sadler

BELOW: The Flock: design and color by Aidan Sugano

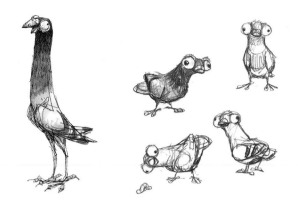

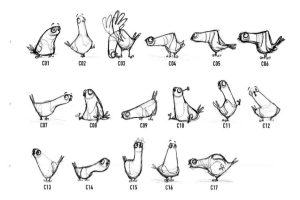

C01 C02 C03 C04 C05 C06

C07 C08 C09 C10 C11 C12

C13 C14 C15 C16 C17

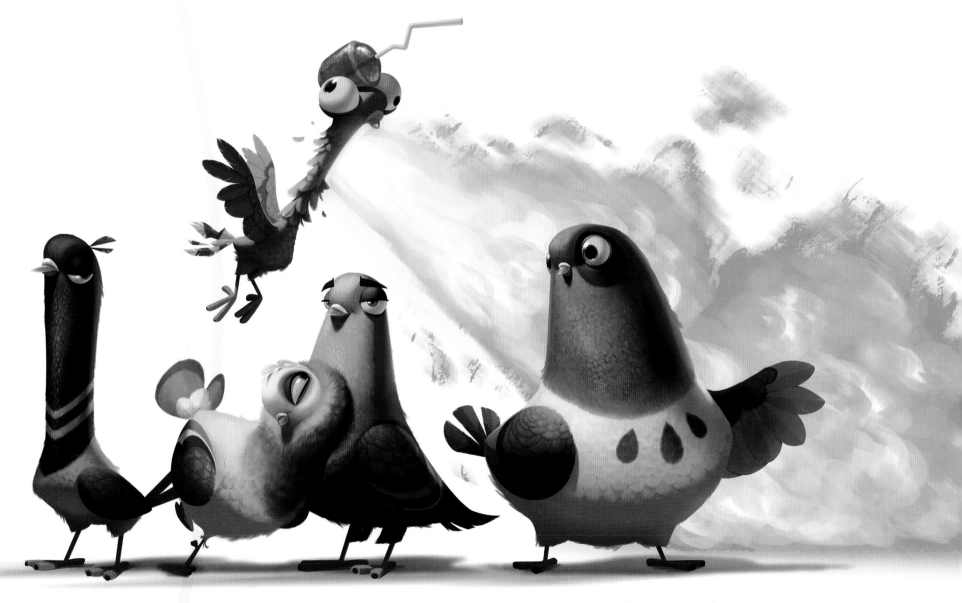

JEFF AKA FANBOY

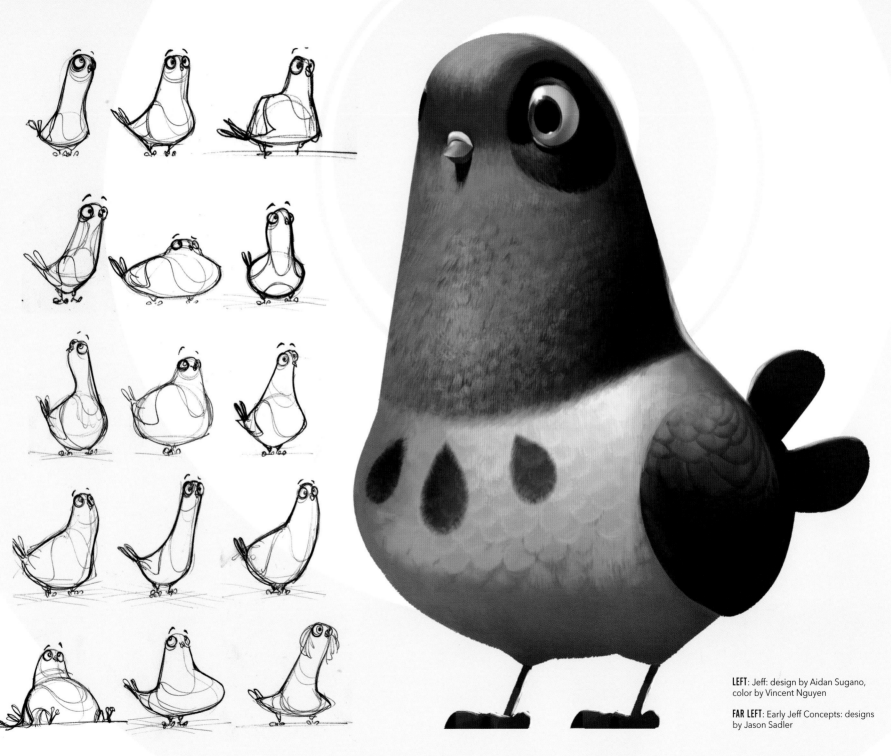

LEFT: Jeff: design by Aidan Sugano, color by Vincent Nguyen

FAR LEFT: Early Jeff Concepts: designs by Jason Sadler

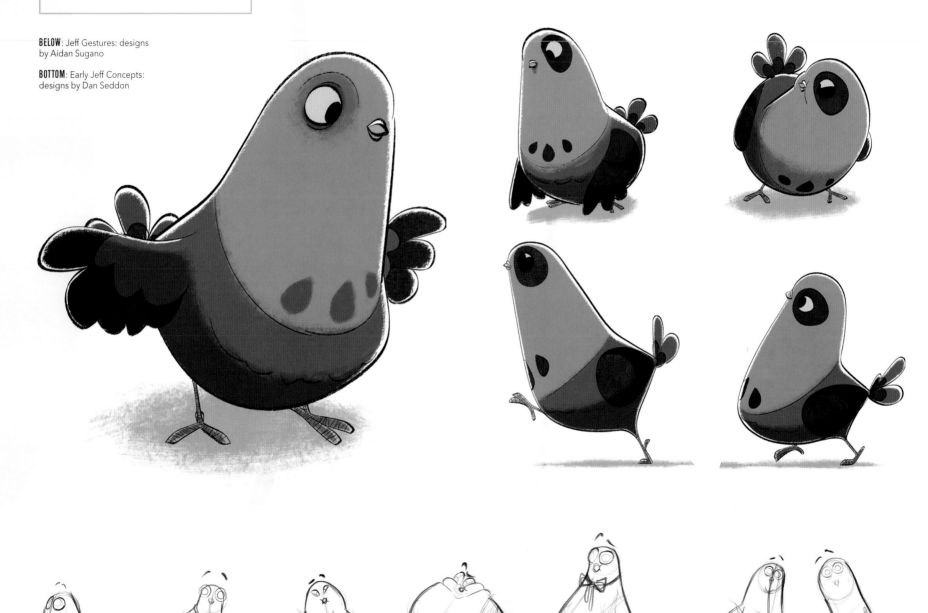

"Jeff aka Fanboy, had to be big. His shape is a teardrop. I have no idea how he flies."

Aidan Sugano, Designer

BELOW: Jeff Gestures: designs by Aidan Sugano

BOTTOM: Early Jeff Concepts: designs by Dan Seddon

THE FLOCK

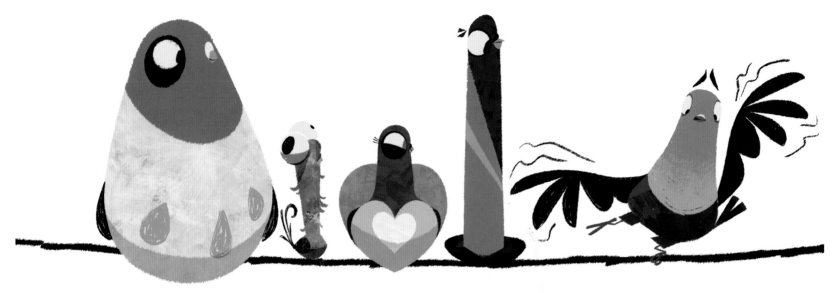

ABOVE: The Flock on a Wire: design by Aidan Sugano

BELOW: The Flock in Flight: design by Aidan Sugano

OPPOSITE: The Flock on a Statue: design by Aidan Sugano

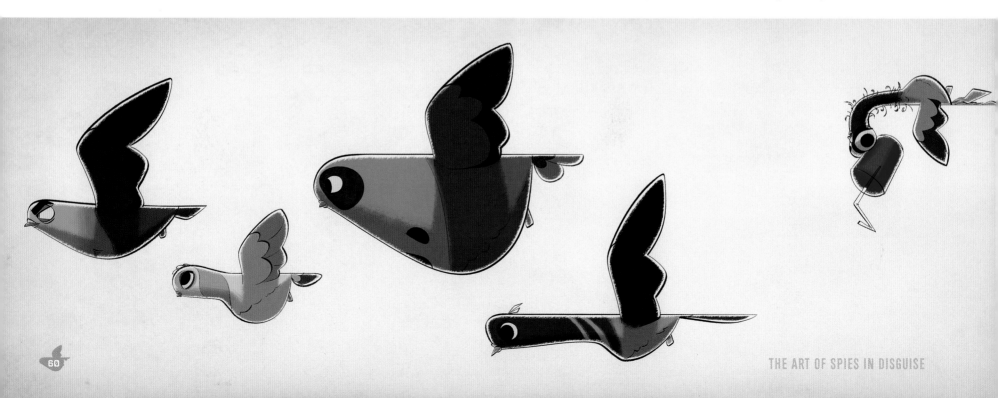

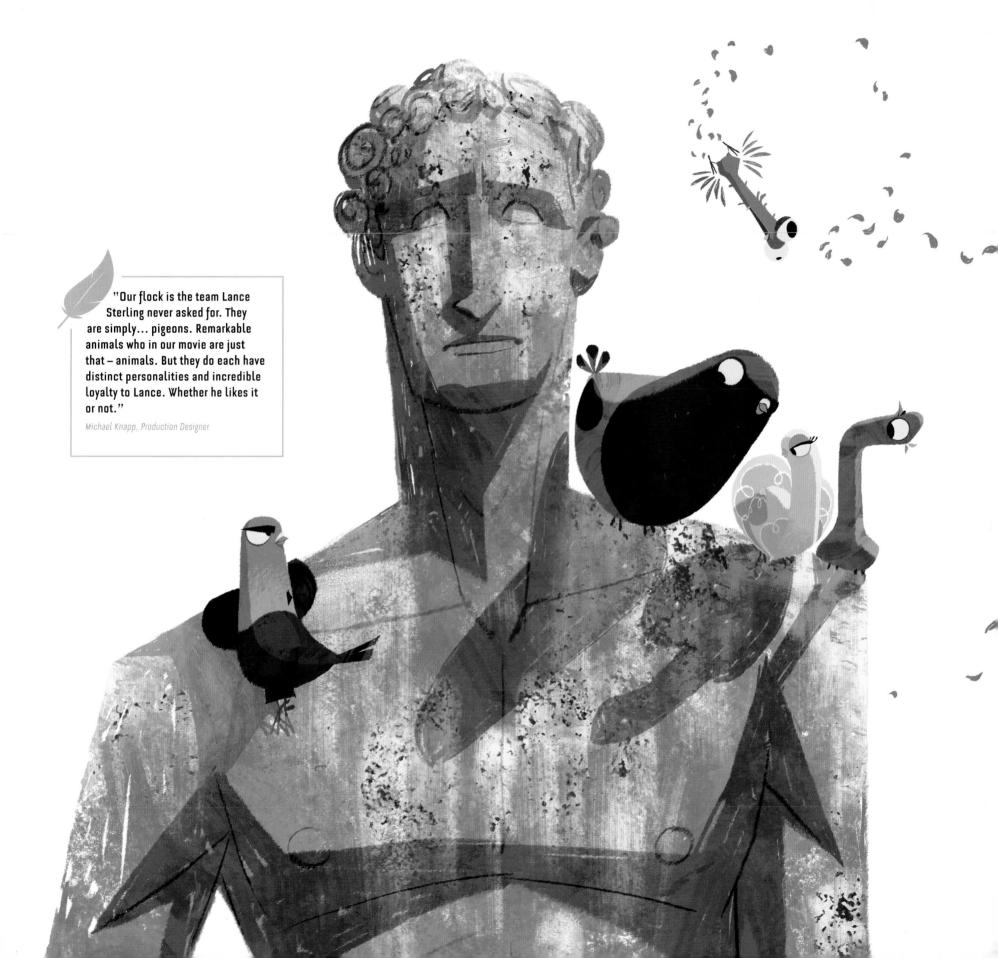

"Our flock is the team Lance Sterling never asked for. They are simply… pigeons. Remarkable animals who in our movie are just that – animals. But they do each have distinct personalities and incredible loyalty to Lance. Whether he likes it or not."

Michael Knapp, Production Designer

BACKGROUND CHARACTERS

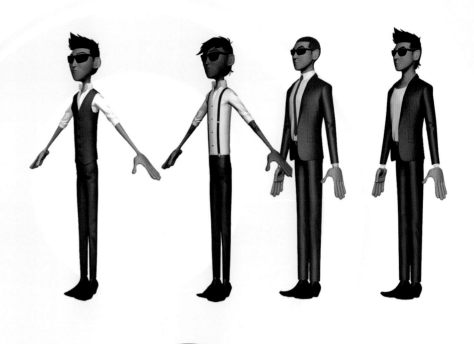

"Although background characters are rarely noticed on screen, they are still extremely essential to any film and play a huge role in making our world feel alive and believable. When designing the background characters, we faced different challenges than we did designing the leads, so planning ahead and problem solving in the most economical ways became of most importance. Thinking about contrasting shapes, body types, face shapes, grooms and wardrobe all became key in getting the most out of only a little."

Dan Seddon, Character Designer

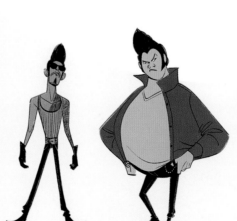

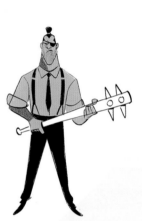

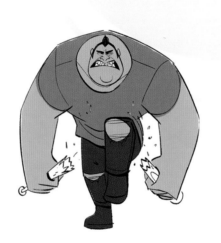

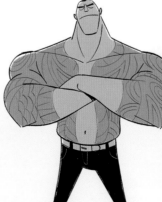

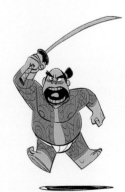

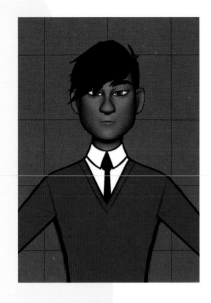

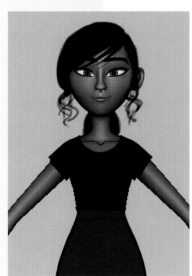

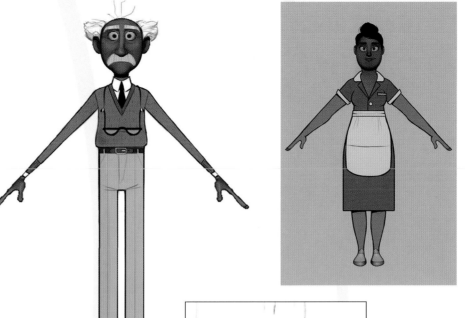

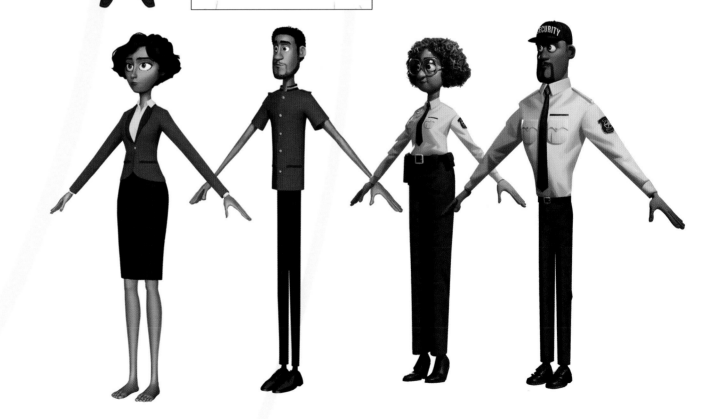

ABOVE: Old Man, Army General and Maid: designs by Dan Seddon

LEFT: Old Man: story panel by Seth Boyden

BELOW: Agency Security Guards: color by Peter Nguyen

OPPOSITE TOP: Yakuza Variations: color by Peter Nguyen

OPPOSITE LEFT: Yakuza Tattoo: color by Peter Nguyen

OPPOSITE BOTTOM: Early Yakuza Concept Designs: designs by Bobby Pontillas

ABOVE: Korean Soap Opera Stars: designs by Jason Sadler

RIGHT: Hotel Receptionist and Bellhop: color by Ron DeFelice

BELOW: Venician Grandma: designs by Jason Sadler

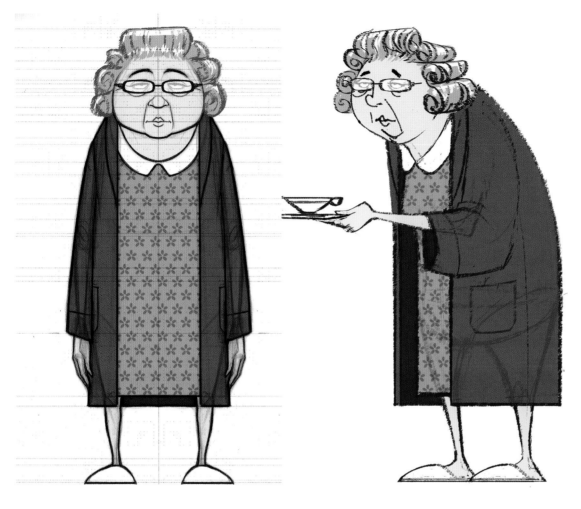

"The design of every supporting character is approached in regards to its particular purpose in the story. Whether it is designed to attract the audience's attention or blend in with the crowd is entirely dependent on the needs of the narrative."

Jason Sadler, Lead Character Designer

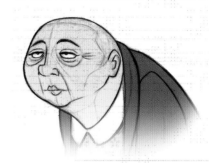

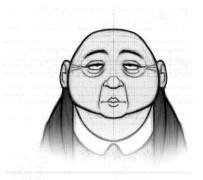

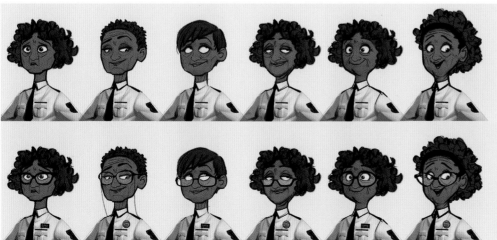

LEFT: Early Agency Security Guard Concepts: designs by Jason Sadler

RIGHT & BELOW: Agency Security Guard Pins and Badge: designs by Peter Nguyen

GOOD MORNING SUNSHINE!

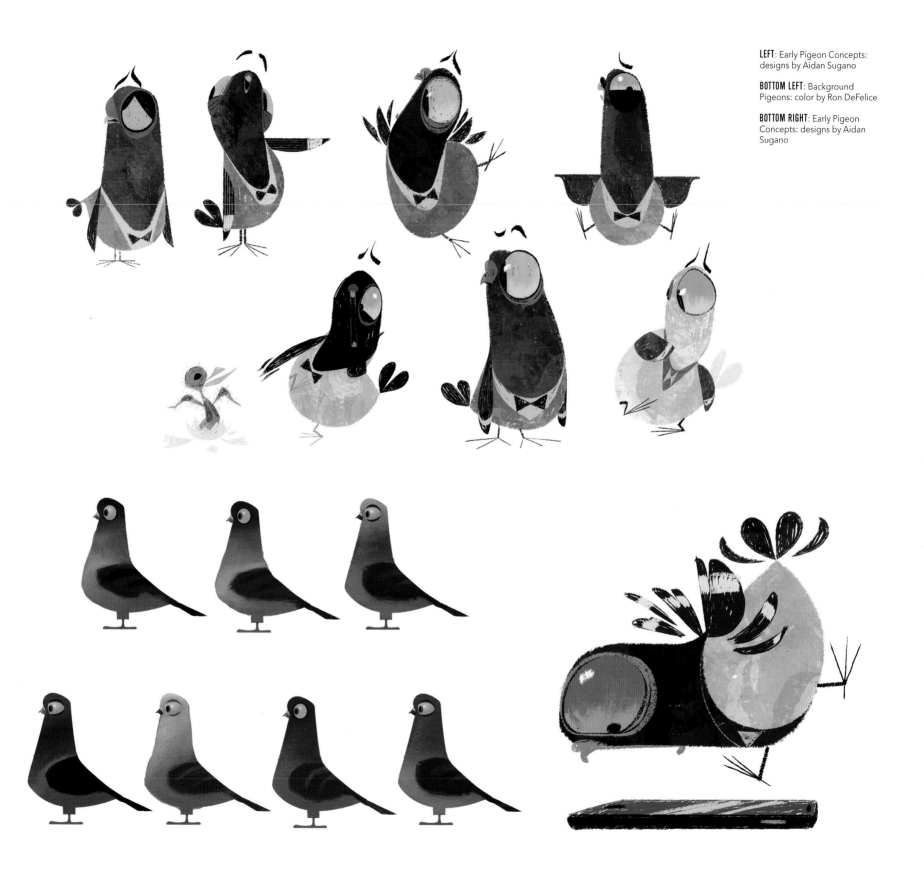

LEFT: Early Pigeon Concepts: designs by Aidan Sugano

BOTTOM LEFT: Background Pigeons: color by Ron DeFelice

BOTTOM RIGHT: Early Pigeon Concepts: designs by Aidan Sugano

M-9 ASSASSIN ATTACK DRONE

"The tick was great inspiration for the drone. There was something creepy yet menacing about its bulb-like body and tiny legs. This silhouette actually lent itself perfectly to the fact that the drone is literally a weapon: robust chassis on the outside, a frightening arsenal of gadgets within."

Annlyn Huang, Character Designer

LEFT: Early Drone Concepts: designs by Annlyn Huang

BELOW: Drone Flying Alongside Killian's Helicopter: color key by Hye Sung Park

OPPOSITE: Stealth Drone: color by Vincent Nguyen

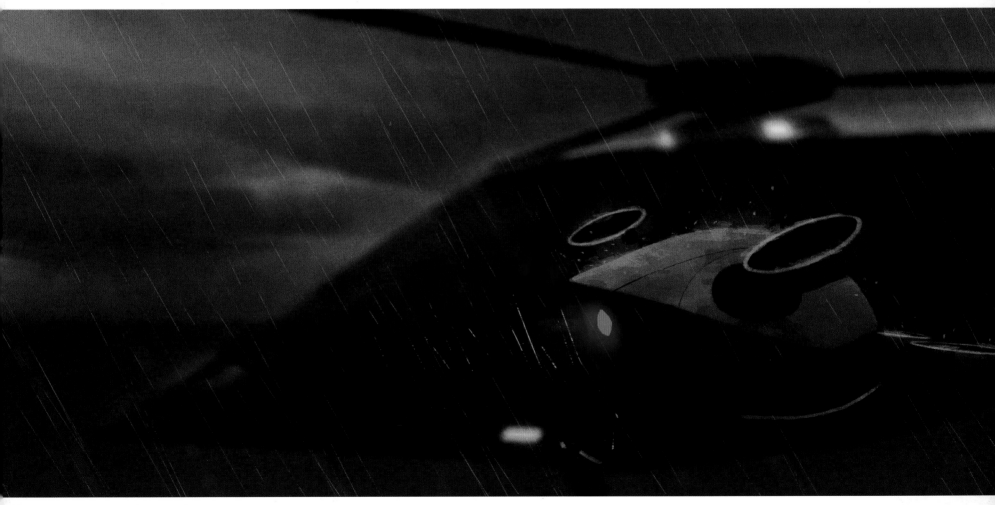

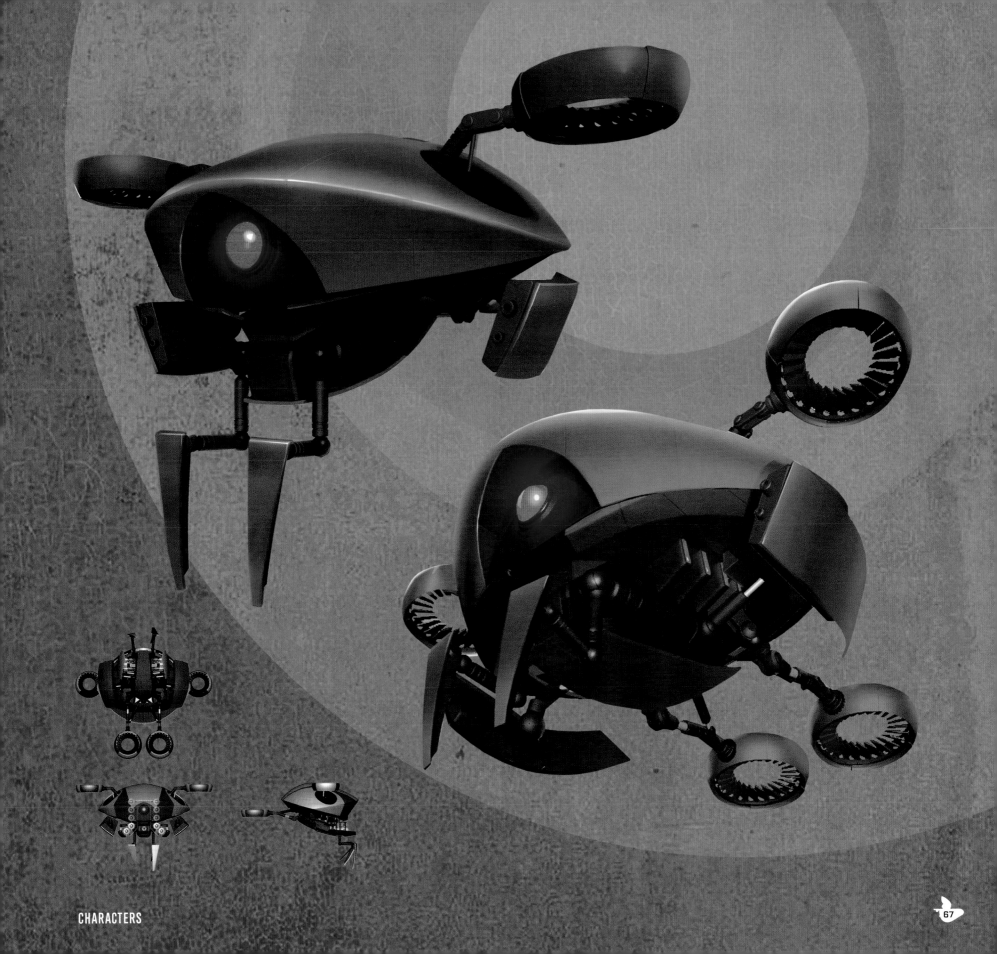

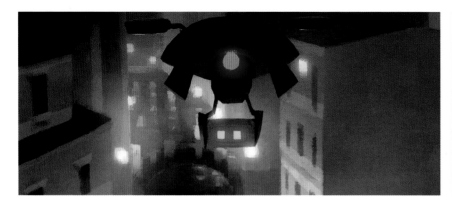

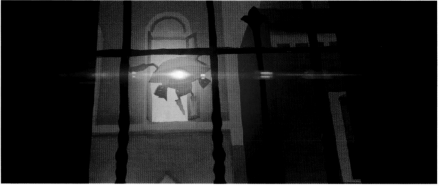

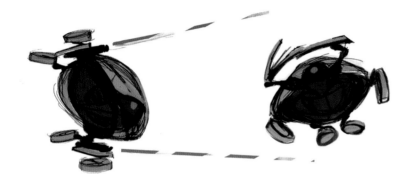

ABOVE: Drone Flying Through Venice: color key by Hye Sung Park

LEFT: Drone Gestures: designs by Annlyn Huang

BELOW LEFT: Early Drone Sketches: designs by Peter de Sève

BELOW: Drone Kidnapping Walter: design by Annlyn Huang

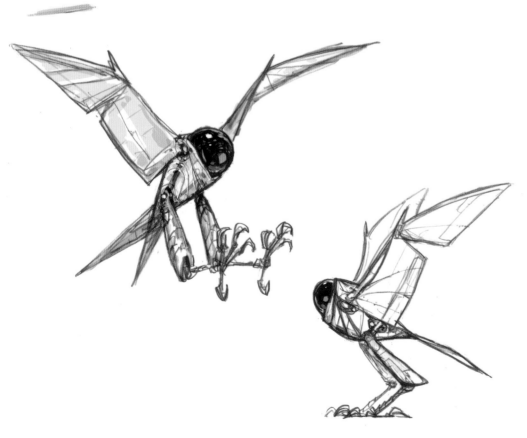

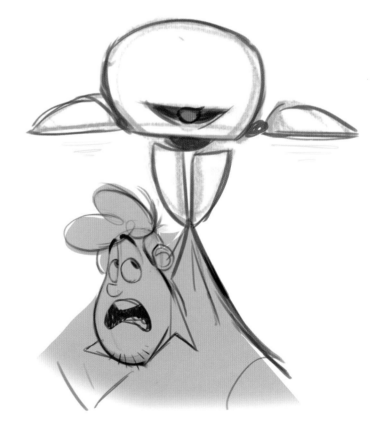

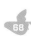

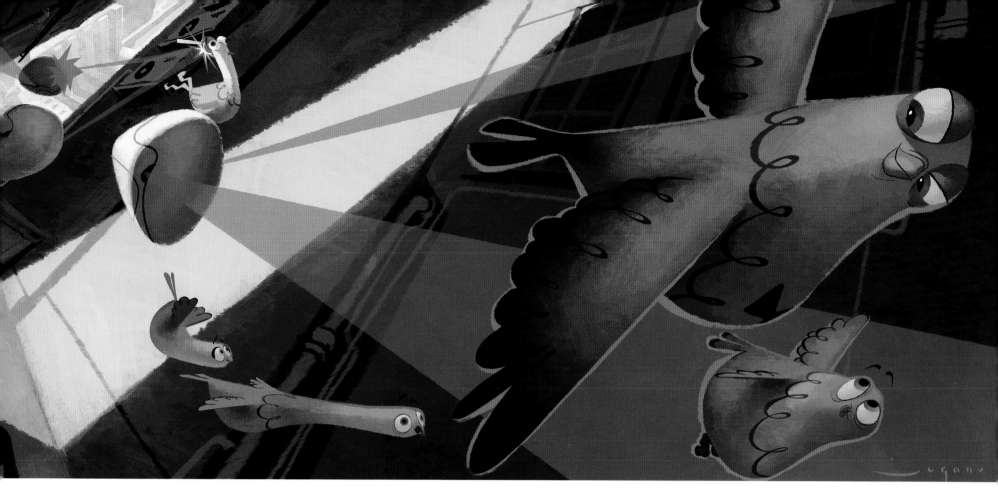

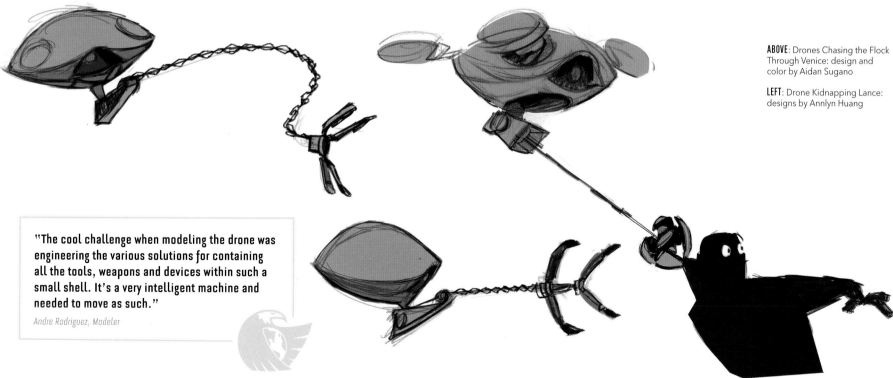

ABOVE: Drones Chasing the Flock
Through Venice: design and
color by Aidan Sugano

LEFT: Drone Kidnapping Lance:
designs by Annlyn Huang

"The cool challenge when modeling the drone was
engineering the various solutions for containing
all the tools, weapons and devices within such a
small shell. It's a very intelligent machine and
needed to move as such."

Andre Rodriguez, Modeler

AGENCY GADGETS

LEFT: Agency Sonic Gun: designs by Jon Townley

BELOW: Marcy's Stun Gun: design and color by Tyler Carter

BOTTOM: Lance Walking Through Agency Gadget Lab: color key by Peter Nguyen

Speaker Array Options

Mini Speaker

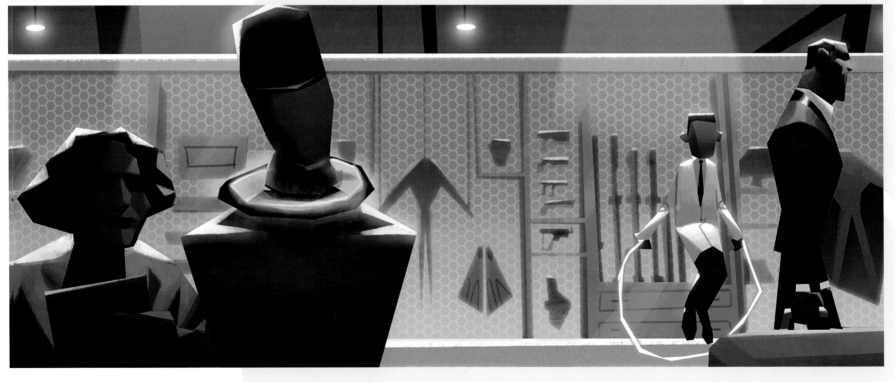

BELOW: Agency Field Camera: design by Tyler Carter

BELOW RIGHT: Cufflink Drone: design and color by Tyler Carter

BOTTOM: Grappling Hook Pen: design by Nash Dunnigan

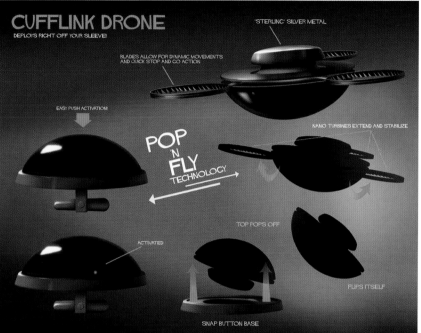

CUFFLINK DRONE
DEPLOYS RIGHT OFF YOUR SLEEVE!

'STERLING' SILVER METAL

BLADES ALLOW FOR DYNAMIC MOVEMENTS
AND QUICK STOP AND GO ACTION

EASY PUSH ACTIVATION!

POP
N
FLY
TECHNOLOGY

NANO TURBINES EXTEND AND STABILIZE

ACTIVATED

TOP POPS OFF

FLIPS ITSELF

SNAP BUTTON BASE

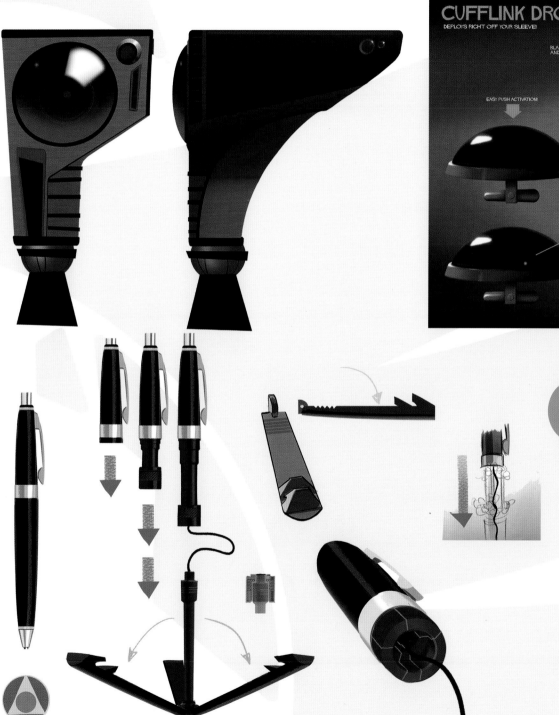

"We designed the agency gadgets with sharp shapes to echo our established spycraft style. These were cutting-edge devices, so they needed to feel sleek and sophisticated. Each asset was approached with a major line or through-shape to accentuate a simple silhouette. This gave them their own 'shape statement,' which often became more prominent in the final form."

Tyler Carter, Designer

"The Agency's gadgets are extremely sleek, efficient, and often violent. They employ a 'get the job done at any cost' mentality which often continues the cycle of destruction the Agency holds the bad guys responsible for starting."

Michael Knapp, Production Designer

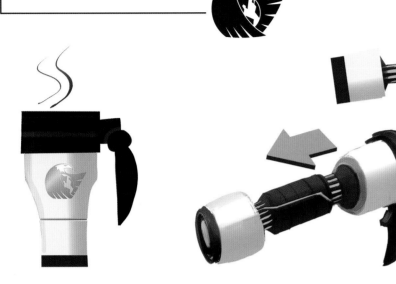

ABOVE: Flamethrower Coffee Mug: design by Sandeep Menon

BELOW: Lance Walking Through Agency Gadget Lab: color key by Peter Nguyen

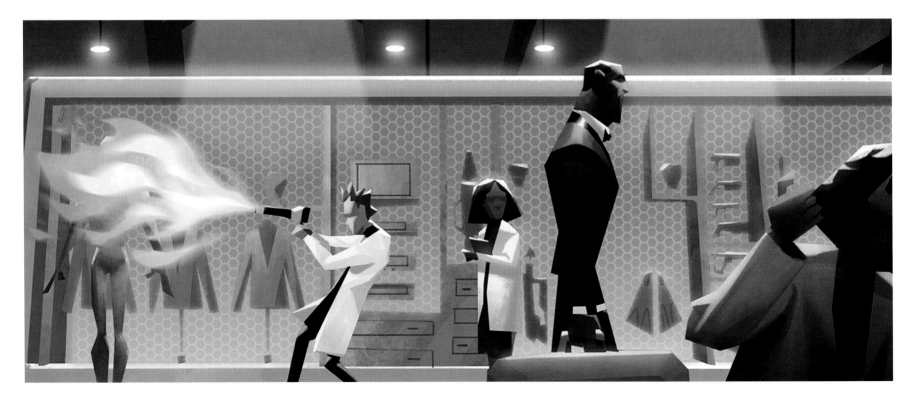

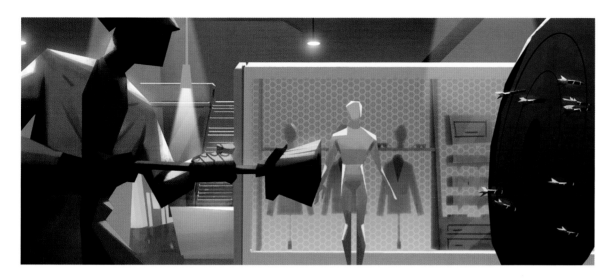

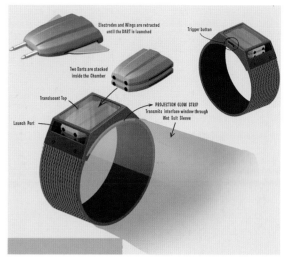

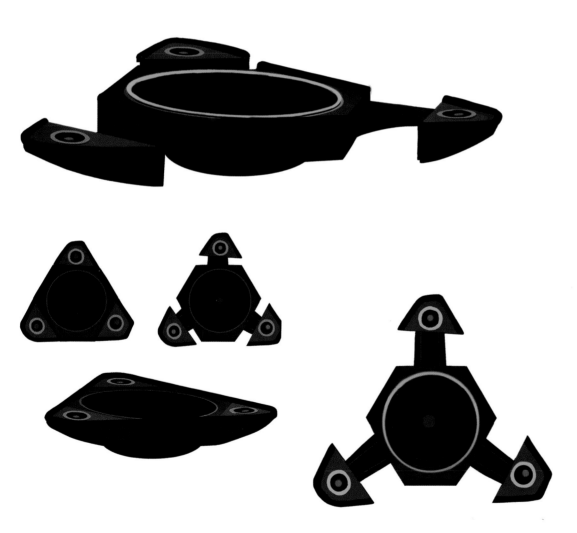

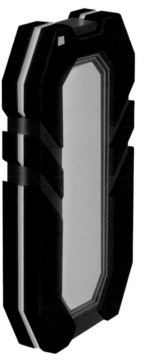

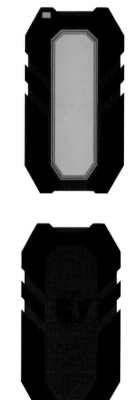

TOP LEFT: Testing Broom Dart Launcher in Gadget Lab: color key by Peter Nguyen

TOP RIGHT: Lance's Taser Dart Watch: design by Jon Townley

LEFT: Sticky Sonic Shockwave Bomb: design by Tyler Carter

ABOVE: Agency Database Hard Drive: design by Tom Humber, color by Ron DeFelice

WALTER'S GADGETS

"Walter's backpack was essentially a mobile laboratory housed inside a tiny cavity. Working backwards to first account for all the potential functions, it was a matter of collapsing each compartment into itself like a 3D jigsaw puzzle to ensure practicality. The design challenge was stuffing Walter's necessary science gear into a small space without straining credibility."

Tyler Carter, Designer

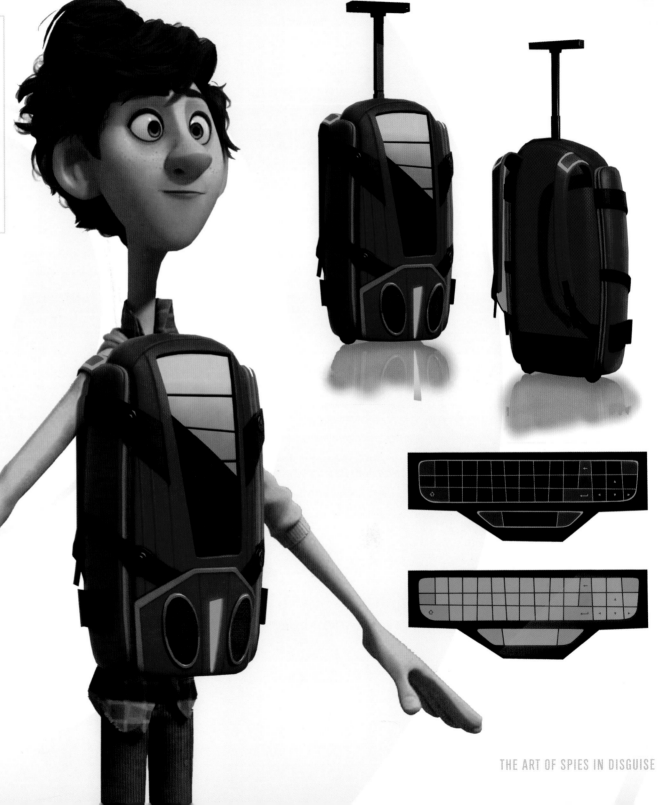

RIGHT: Walter's Backpack: color style guides by Hye Sung Park

FAR RIGHT: Compact Keyboard: design by Hye Sung Park

BELOW: Walter's Backpack Concepts: drawings by Kevin Yang

RIGHT: Walter's Backpack and Mobile Lab: design by Tyler Carter

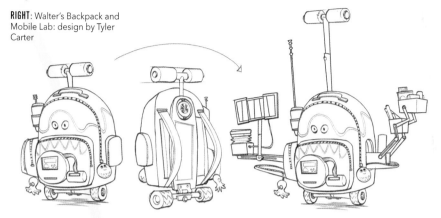

BELOW: Walter's Mobile Lab: color style guide by Hye Sung Park

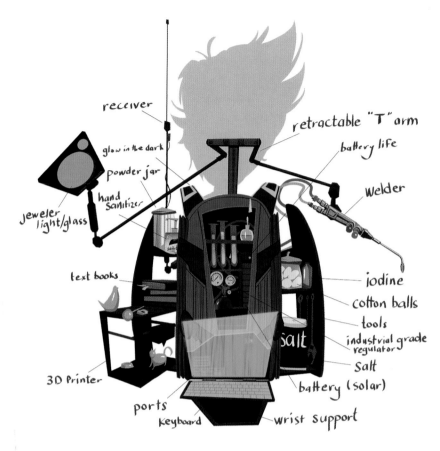

receiver

retractable "T" arm

glow in the dark

battery life

powder jar

Welder

jeweler light/glass

hand sanitizer

iodine

text books

cotton balls

tools

industrial grade regulator

salt

3D Printer

Salt

battery (solar)

ports

Keyboard

wrist support

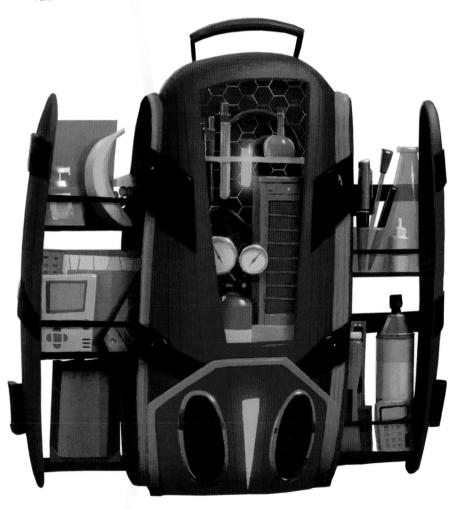

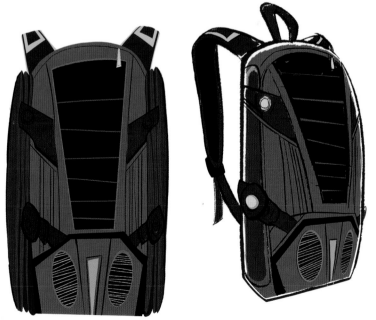

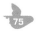

"Walter's gadgets are an expression of his strong conviction that there's a better way to protect people than blowing up the bad guys. This has not endeared him to his fellow gadget inventors, his superiors at the Agency, or Lance Sterling for that matter."

Michael Knapp, Production Designer

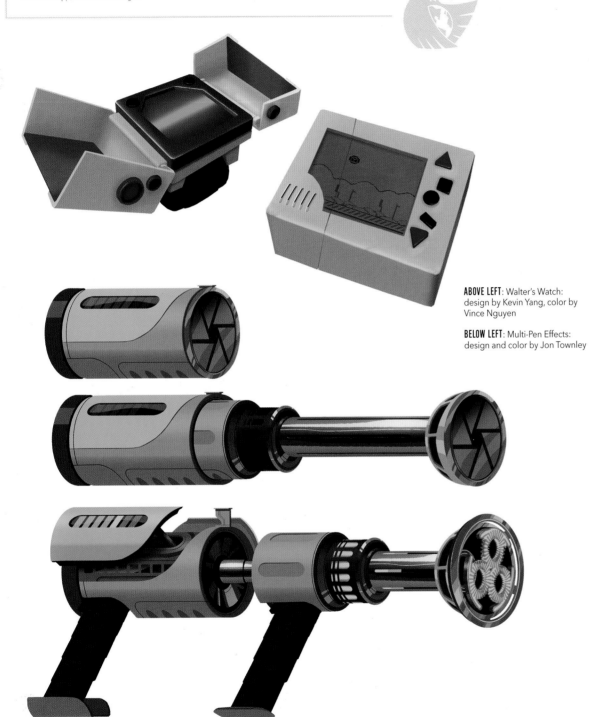

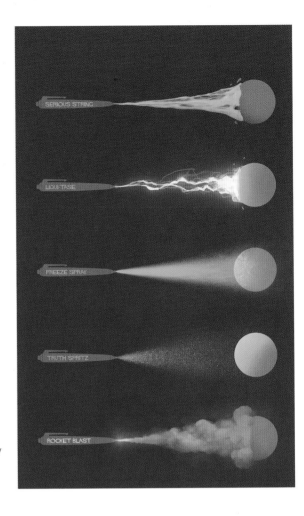

ABOVE LEFT: Walter's Watch: design by Kevin Yang, color by Vince Nguyen

BELOW LEFT: Multi-Pen Effects: design and color by Jon Townley

ABOVE: Binder Bubble Gun: design and color by Tyler Carter

BELOW: Mobile Mini Centrifuge: design by Kevin Yang, color by Hye Sung Park

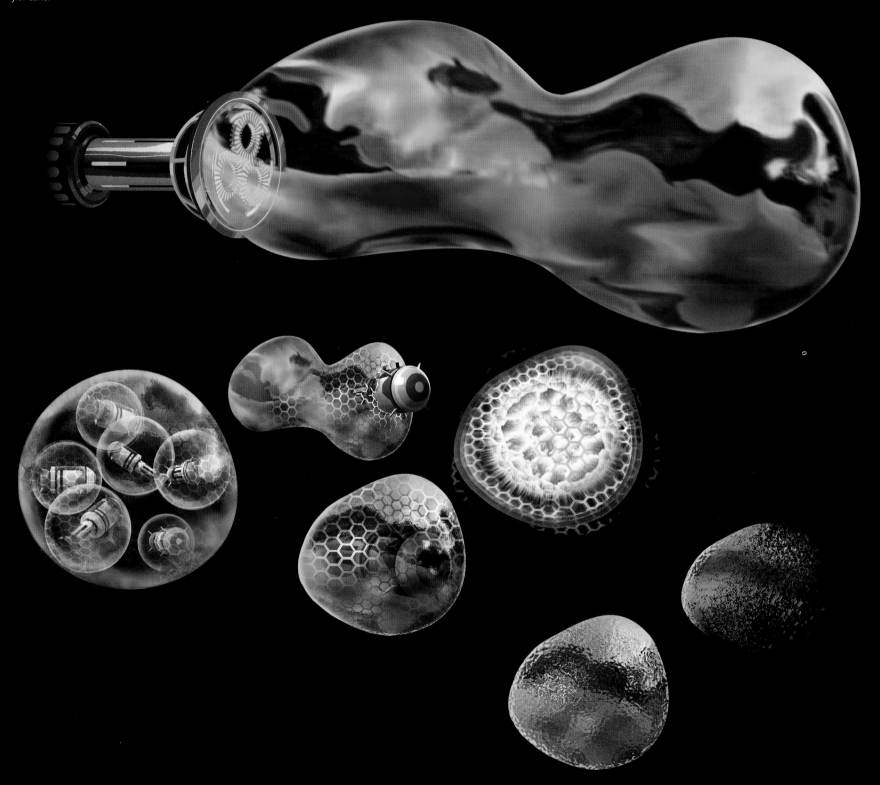

BELOW: Binder Bubble FX Step by Step: design and color by Tyler Carter

ABOVE: Security Blanket
Launcher: design and color by
Tyler Carter

LEFT: Collide-O-Scope: design
by Kevin Yang

COMPOSE DIACONALLY

"The funny thing about Unitee is that she simply started out as a design for a band-aid pattern. Then she became a plushie and expanded into a subtle part of Walter's story."

Tom Humber, Lead Set Designer

LEFT: Unitee Bandage and Pattern: design by Tom Humber

MIDDLE LEFT: Inflatable Hug: design by Tom Humber

BOTTOM LEFT: Inflatable Hug and Unitee: design by Tom Humber

BELOW: Unitee: color style guide painting by Hye Sung Park

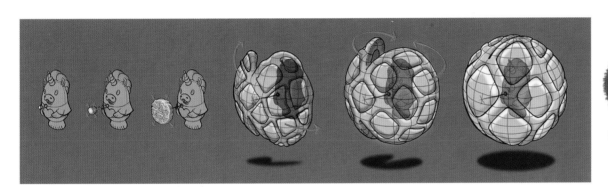

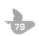

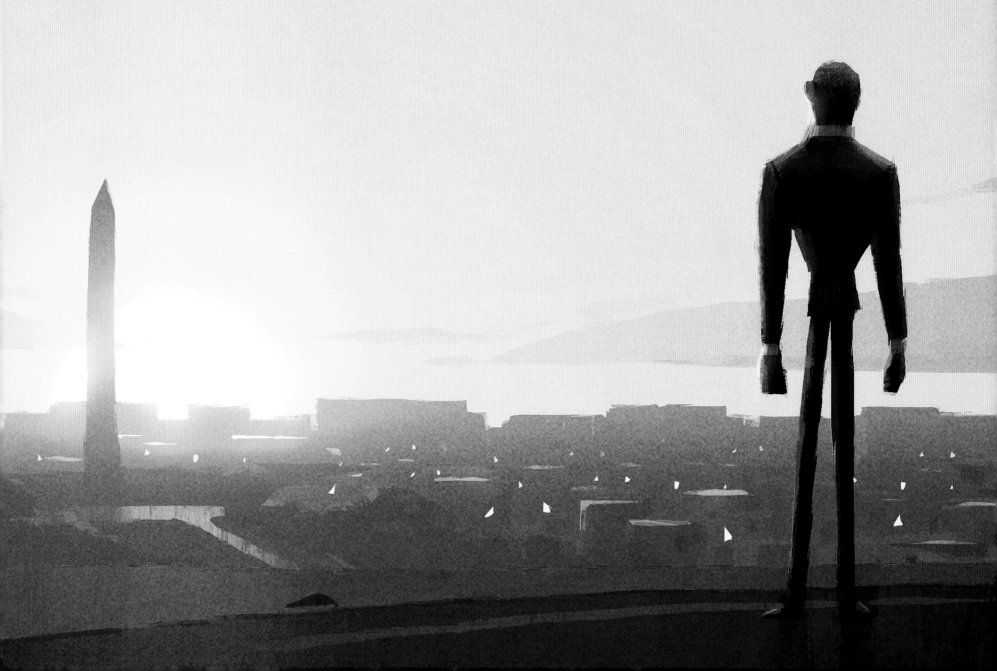

LOCATIONS

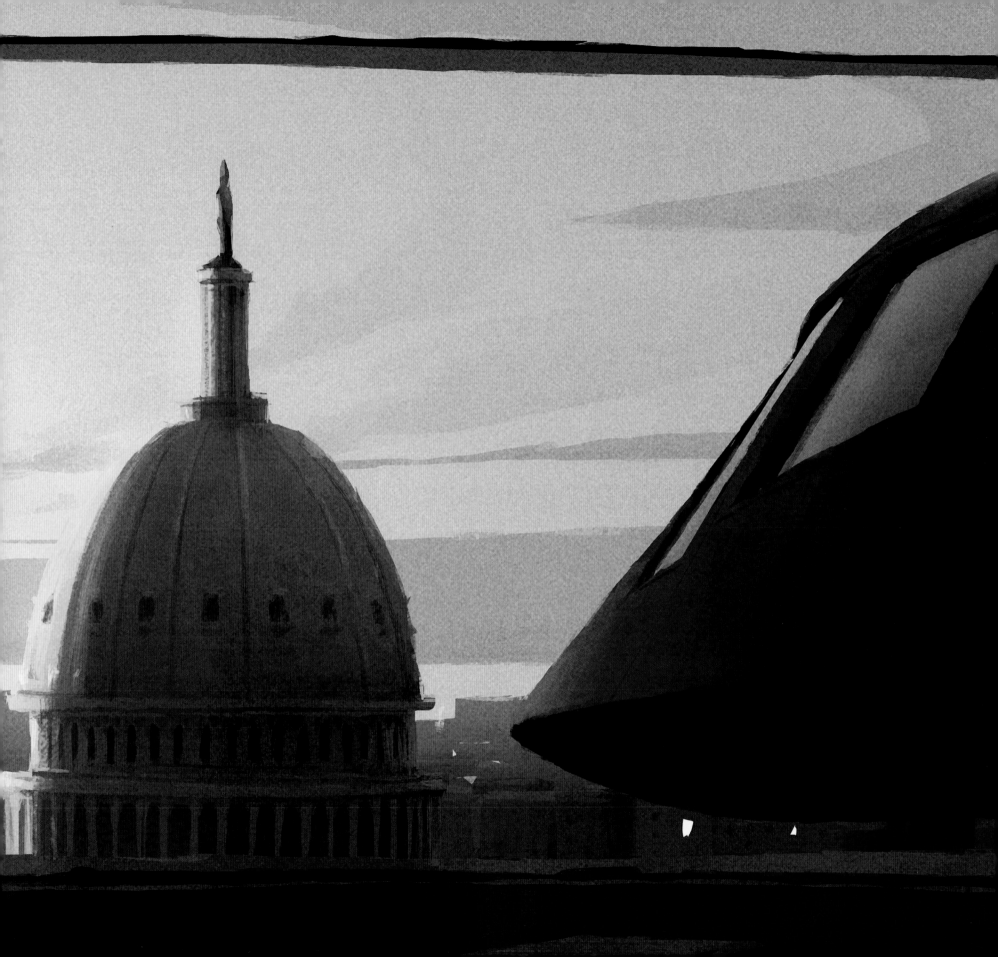

AGENCY HEADQUARTERS

PREVIOUS SPREAD: Lance Looking Out
Over DC: color key by Hye Sung Park

OPPOSITE: The Washington Monument:
color key by Hye Sung Park

BELOW: Stylized Capitol Building: design
by Nash Dunnigan

BELOW RIGHT: Stylized Lincoln
Monument: design by Nash Dunnigan

BOTTOM: Washington DC National Mall:
color key by Hye Sung Park

"We took a scouting trip early in the production to see how the real landscape of Washington DC would inform the construction of our DC sets. To our surprise, we discovered that much of the urban plan utilized hills, trees, and rises in the ground to obscure traffic and focus the eye on specific landmarks in a very dramatic and intentional way. For example, the Washington Monument is on a very pronounced hill, and traffic is obscured by berms on either side of the reflection pond as it leads to the Lincoln Memorial. This made our staging and set dressing decisions easier as the landscape design already suggested clarity."

Nash Dunnigan, Lead Set Designer

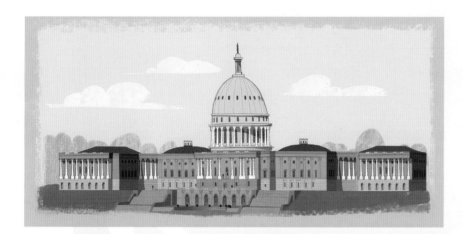

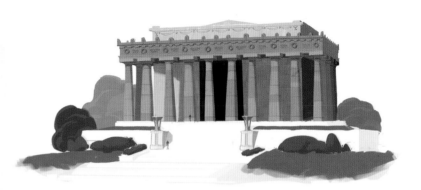

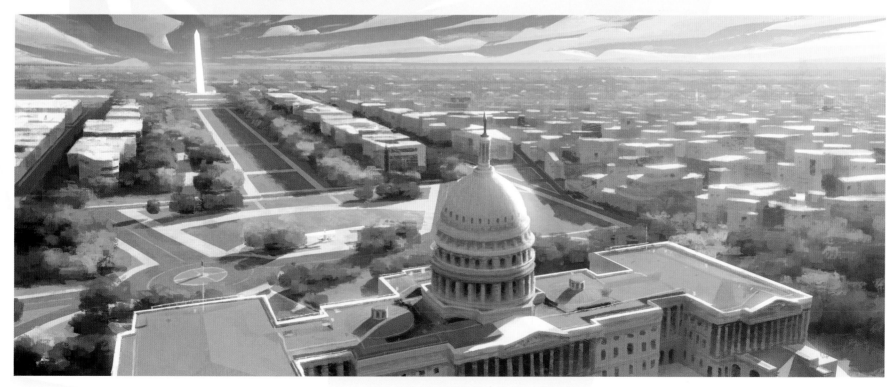

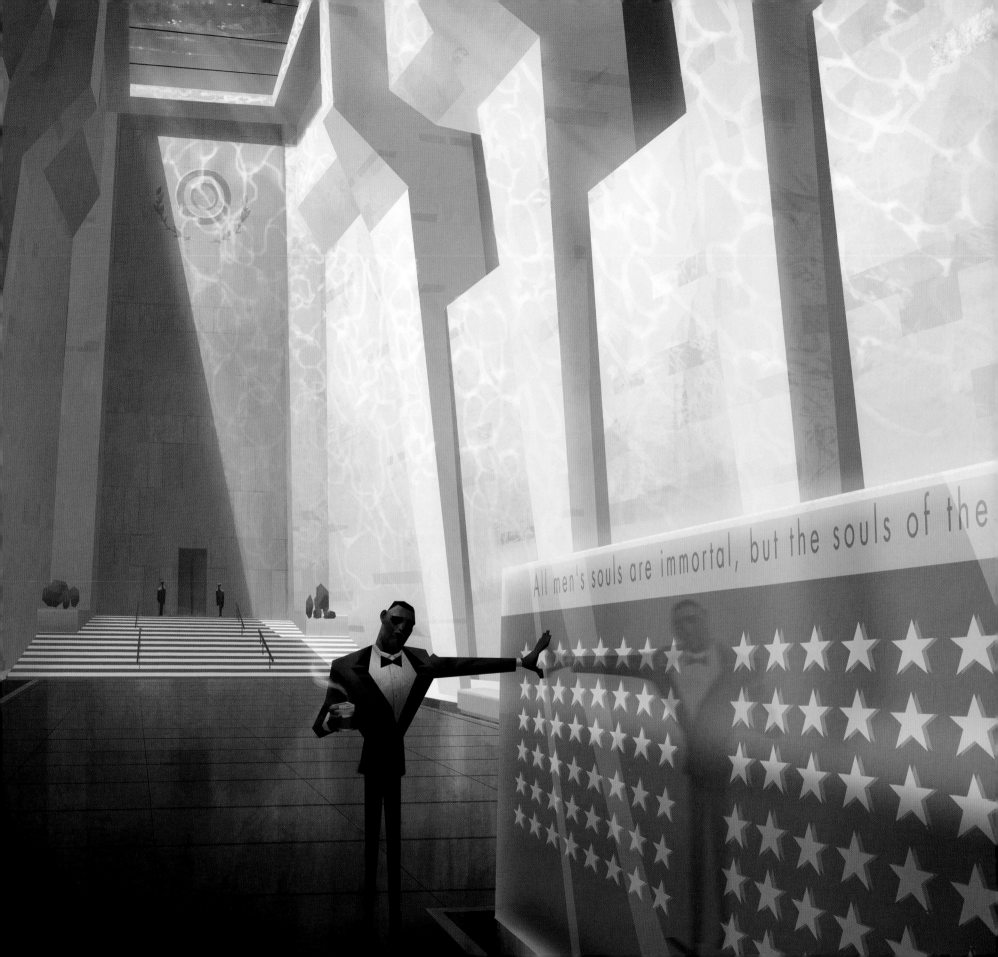

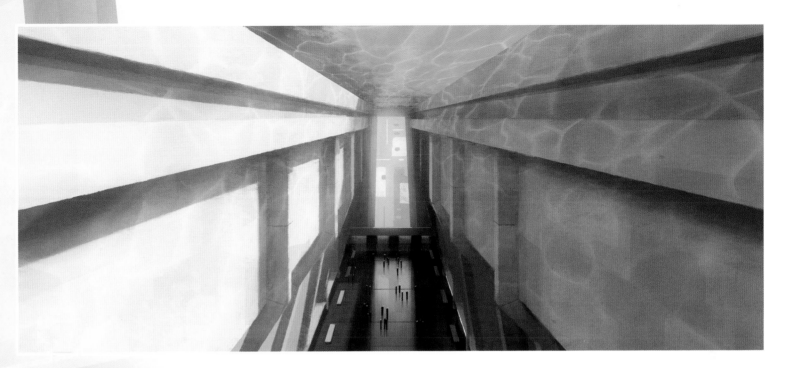

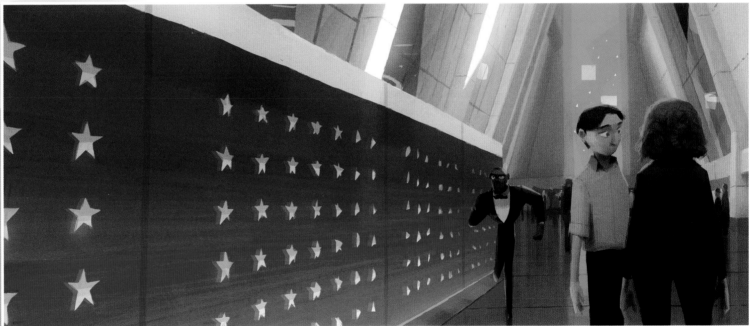

LEFT: Lance Walking Through the Agency Atrium: design by Nash Dunnigan, color by Peter Nguyen

TOP: The Agency: color key by Hye Sung Park

ABOVE: Lance Running Out of the Agency: color key by Hye Sung Park

"The Agency is a huge, important facility and as soon as you enter its main atrium we wanted that to be clear. The grand open volume of this space is a reflection of the monuments you see around Washington, DC, it's almost a monument itself."

Tom Humber, Lead Set Designer

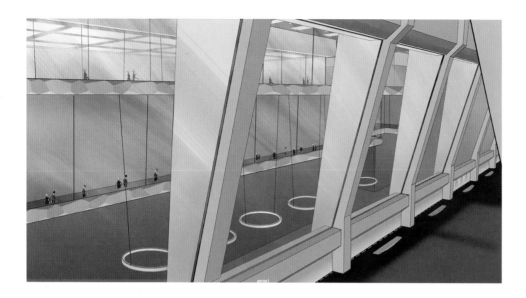

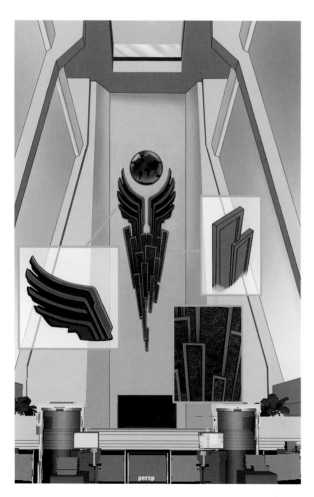

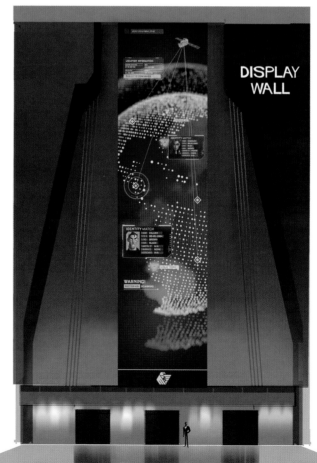

DISPLAY WALL

ABOVE LEFT: Offices in the Agency Atrium: designs by Tom Humber

ABOVE: Agency Logo: design by Hye Sung Park

FAR LEFT: Agency Sculpture: design by Tom Humber

LEFT: Agency Jumbotron: design by Nash Dunnigan, graphics by John Koltai

OPPOSITE TOP: Walter Crashes into Elevator: storyboards by John Jackson

OPPOSITE MIDDLE: Walter Walking into Elevator: color key by Ron DeFelice

OPPOSITE BOTTOM: Walter and Lance in Elevator: color key by Ron DeFelice

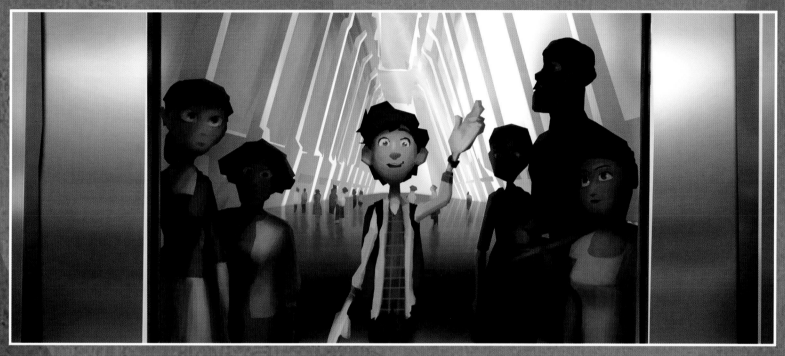

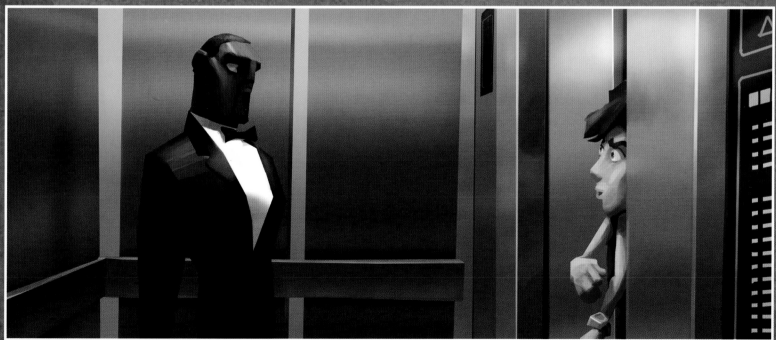

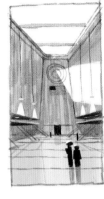

"Willie Real's initial inspirational sketches [right] served as a springboard for our Agency design work in the big interior. We wanted an exaggerated vertical space with very little detail that felt stately and classical. It served as both entry into the Agency, and then into the many layers of its labs and offices."

Nash Dunnigan, Lead Set Designer

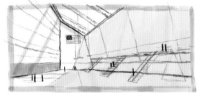

RIGHT: Early Agency Interior Sketches: designs by Willie Real

BELOW: Lance Entering the Agency: design by Nash Dunnigan, color by Peter Nguyen

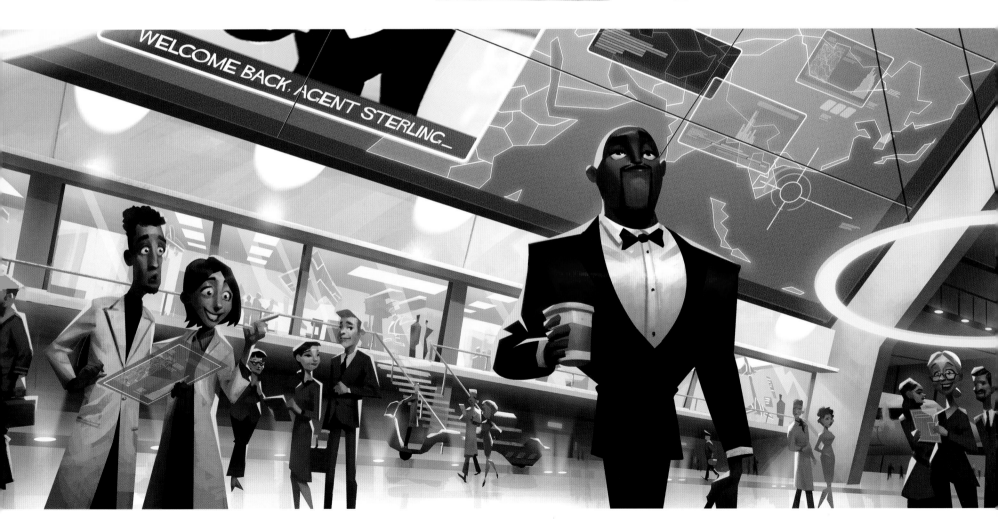

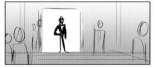
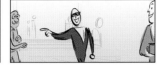
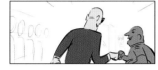

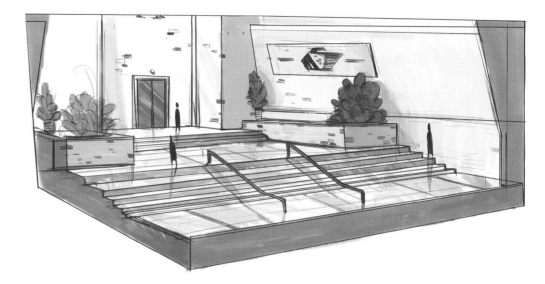

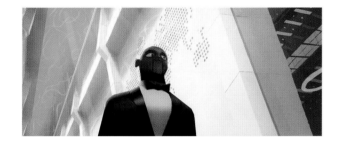

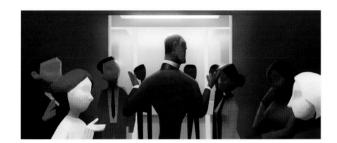

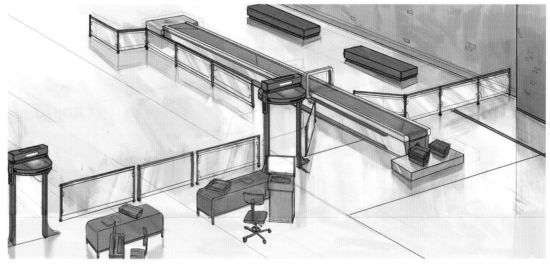

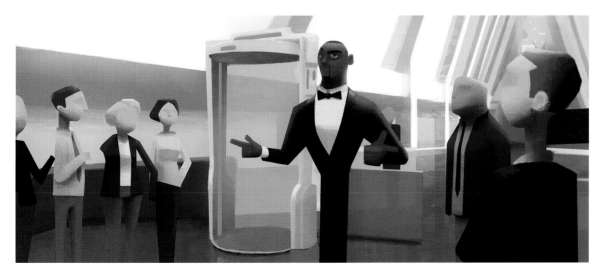

TOP LEFT: Lance Arrives at the Agency: storyboards by John Jackson

BOTTOM LEFT: Lance Walking Through the Agency Atrium: color keys by Hye Sung Park

ABOVE: Agency Interior: designs by Kevin Yang

LEFT: Early Agency Interior Sketch: design by Willie Real

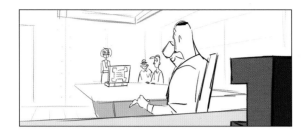
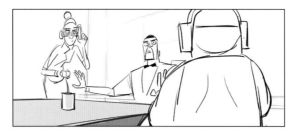
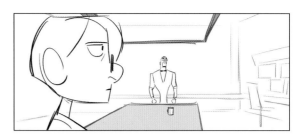

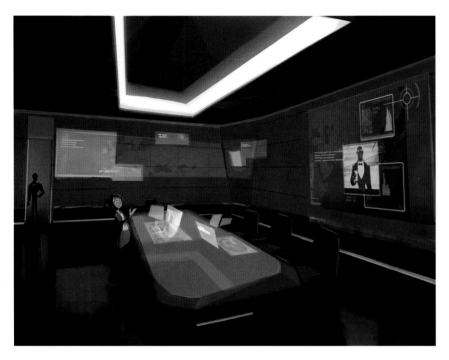

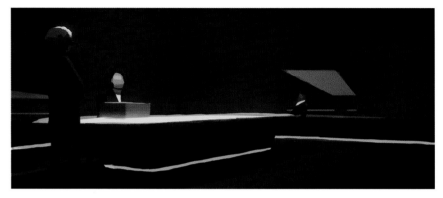

"Initially, the briefing room was going to be located at the top of the Washington Monument. We had been looking at lots of stealth panels for sound proofing, and we used it as reference for the ceiling of the briefing room. Even the table has angles that suggest sound redirection. The chairs have facets and were designed to catch the light in ways that showed the stealth polygon shape."

Nash Dunnigan, Lead Set Designer

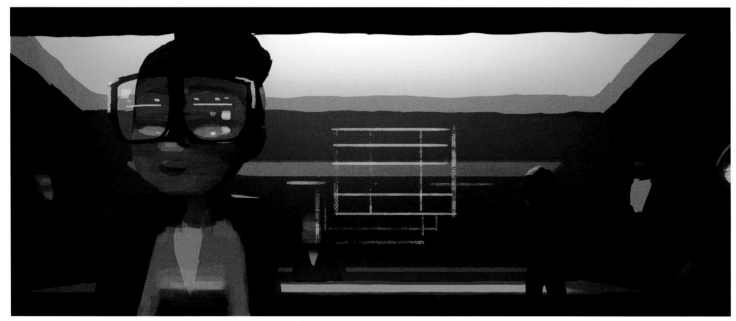

TOP: Tension in the Briefing Room: storyboards by Ian Abando

ABOVE LEFT: Agency Briefing Room Interior: design by Nash Dunnigan

ABOVE: Joyless and Lance in Agency Briefing Room: color key by Hye Sung Park

LEFT: Eyes Pulling Up Footage in Agency Briefing Room: color key by Hye Sung Park

BELOW LEFT: Agency Graphics Shape Language: designs by Sandeep Menon

BELOW RIGHT: Agency Briefing Room Interior: designs by Nash Dunnigan

BOTTOM: Agency Briefing Room Holographic Table: designs by Sandeep Menon

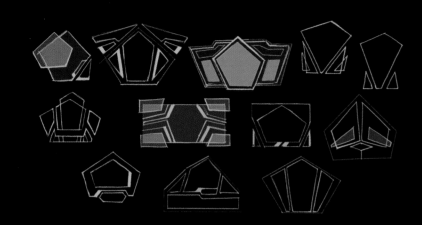

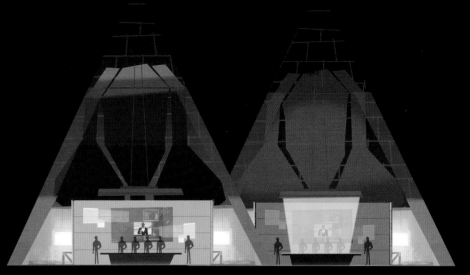

A

B

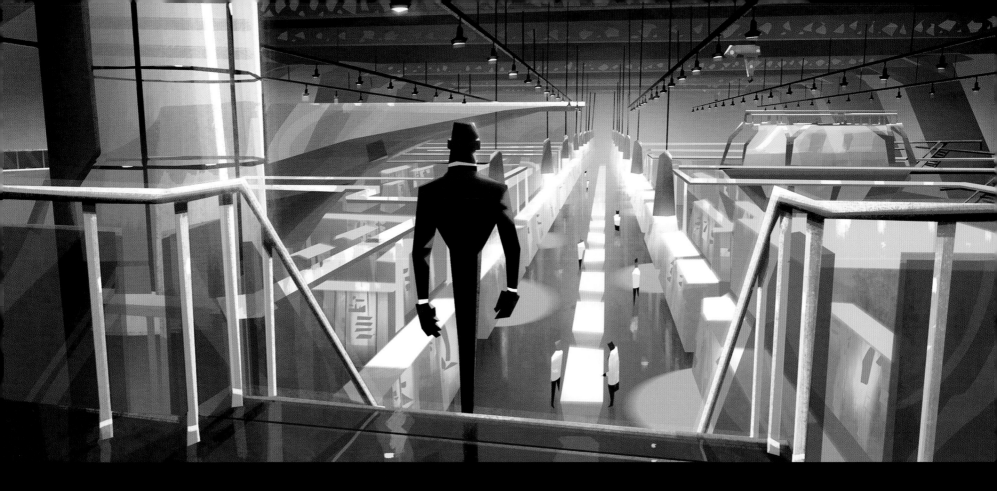

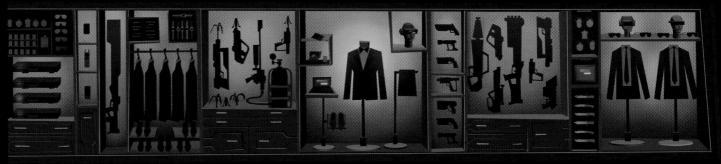

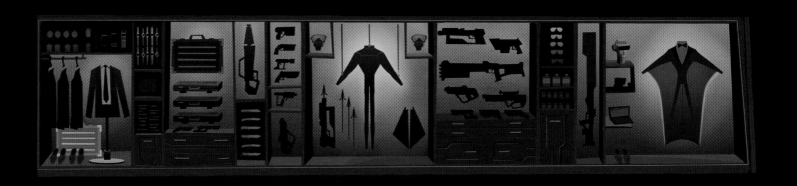

OPPOSITE TOP: Lance Looks Out Over Gadget Lab: color key by Peter Nguyen

OPPOSITE BOTTOM: Gadget Lab Display Cases: designs by Sandeep Menon

BELOW: Early Sketches of Walter's Work Space: designs by Willie Real

MIDDLE LEFT: Gadget Lab Concepts: design by Jon Townley

BOTTOM: Lance Confronts Walter in Gadget Lab: color key by Peter Nguyen

RIGHT: Gadget Lab Robotic Arm: design by Sandeep Menon

"We tried to create a sleek, modern look while still invoking that old classic super-spy feeling."

Jon Townley, Sr., Set Designer

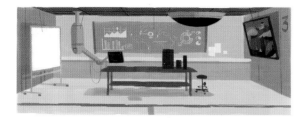

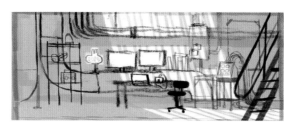

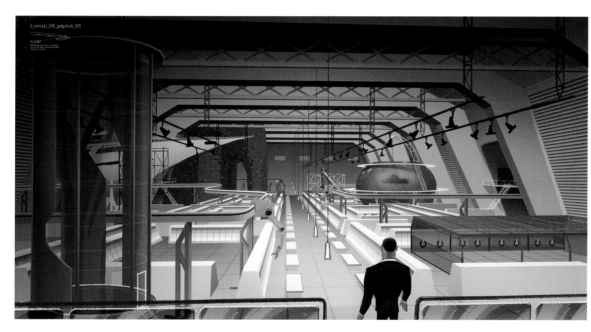

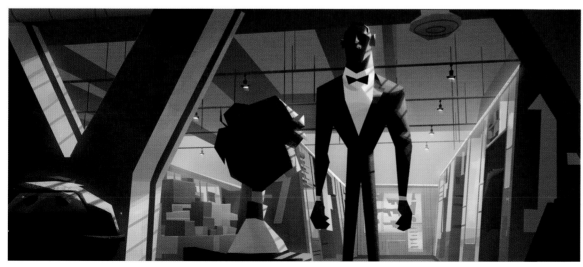

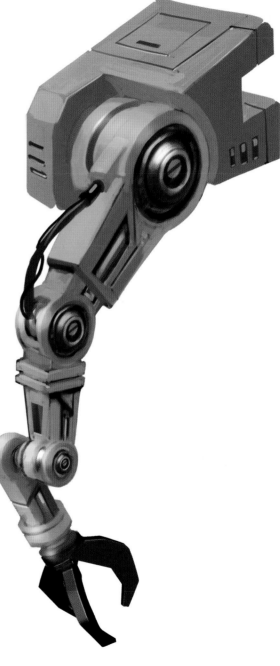

JAPANESE PAGODA LAIR

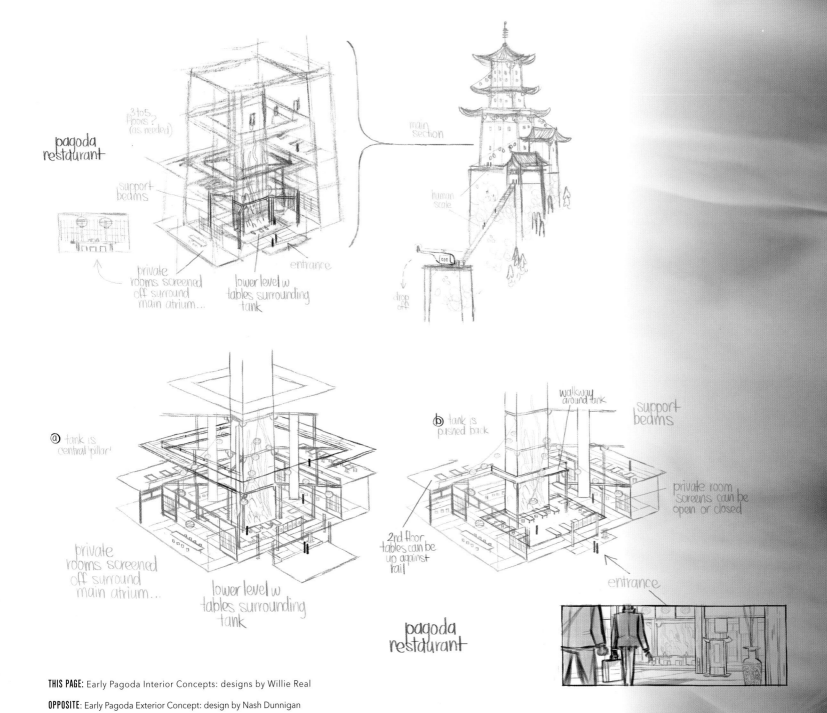

pagoda restaurant

3 to 5 floors? (as needed)

main section

support beams

human scale

private rooms screened off surround main atrium...

lower level w tables surrounding tank

entrance

drop off

ⓐ tank is central pillar

private rooms screened off surround main atrium...

lower level w tables surrounding tank

ⓑ tank is pushed back

walkway around tank

support beams

private room screens can be open or closed

2nd floor tables can be up against rail

entrance

pagoda restaurant

THIS PAGE: Early Pagoda Interior Concepts: designs by Willie Real

OPPOSITE: Early Pagoda Exterior Concept: design by Nash Dunnigan

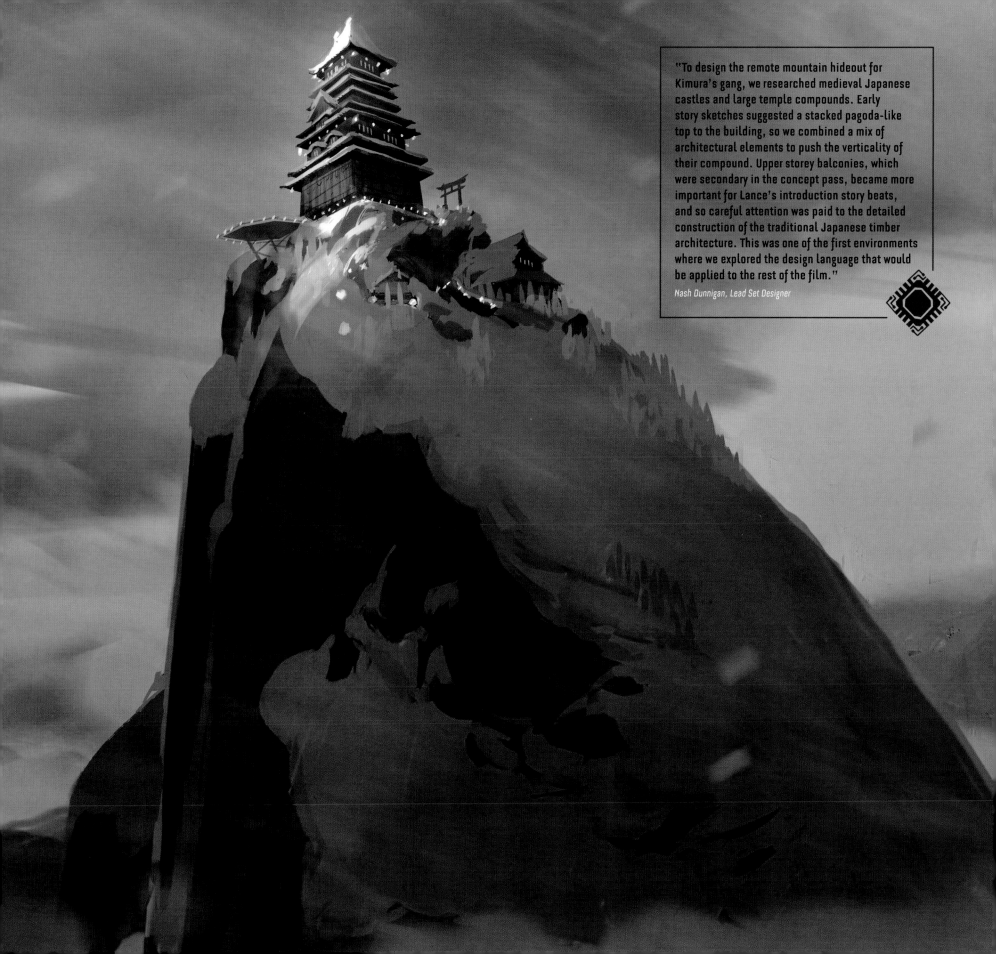

"To design the remote mountain hideout for Kimura's gang, we researched medieval Japanese castles and large temple compounds. Early story sketches suggested a stacked pagoda-like top to the building, so we combined a mix of architectural elements to push the verticality of their compound. Upper storey balconies, which were secondary in the concept pass, became more important for Lance's introduction story beats, and so careful attention was paid to the detailed construction of the traditional Japanese timber architecture. This was one of the first environments where we explored the design language that would be applied to the rest of the film."

Nash Dunnigan, Lead Set Designer

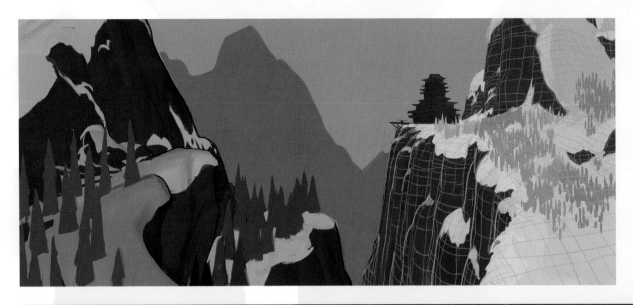

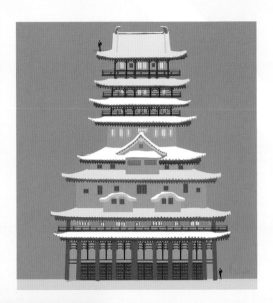

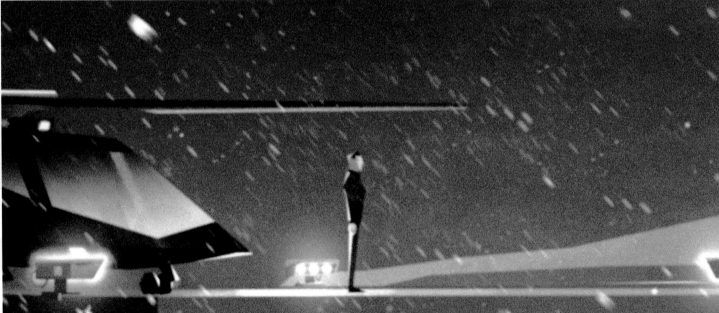

ABOVE: Pagoda Exterior Concepts: designs by Nash Dunnigan

LEFT: Killian Arrives on the Helipad color key: color by Peter Nguyen

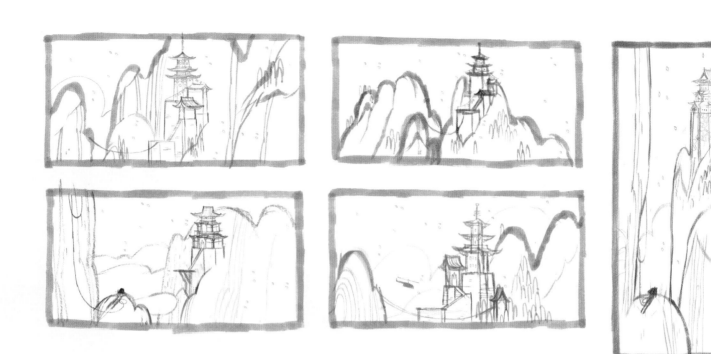

ABOVE: Early Pagoda Exterior Concepts: designs by Willie Real

BELOW: Agents Staking Out Pagoda: design by Nash Dunnigan

RIGHT: Interior Pagoda Layout with Kimura: designs by Tom Humber

BELOW: Killian Speaks with Kimura: color key by Peter Nguyen

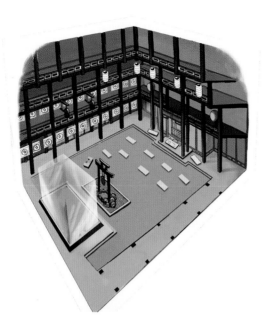

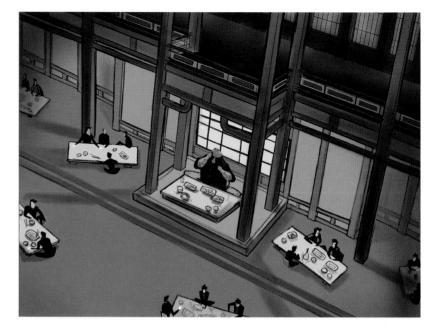

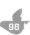

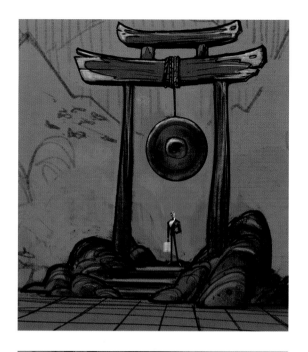

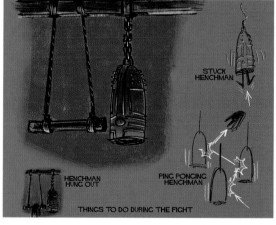

STUCK
HENCHMAN

HENCHMAN
HUNG OUT

PING PONGING
HENCHMAN

THINGS TO DO DURING THE FIGHT

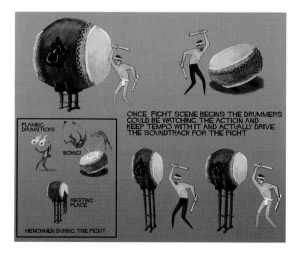

FLAMING
DRUMSTICKS

BOING!

RESTING
PLACE

ONCE FIGHT SCENE BEGINS THE DRUMMERS
COULD BE WATCHING THE ACTION AND
KEEP TEMPO WITH IT AND ACTUALLY DRIVE
THE SOUNDTRACK FOR THE FIGHT

HENCHMEN DURING THE FIGHT

"The great thing about this set
is that it accommodated several
different moods; it began looking
like a cool hang out for the bad
guys, became the stage for a stand-
off, and then a massive fight."

Tom Humber, Lead Set Designer

LEFT: Gong and Drum: designs by Tom Humber

BELOW: Lance Surrounded by Yakuza: color key by
Peter Nguyen

BOTTOM: Killian Enters the Pagoda: color key by
Peter Nguyen

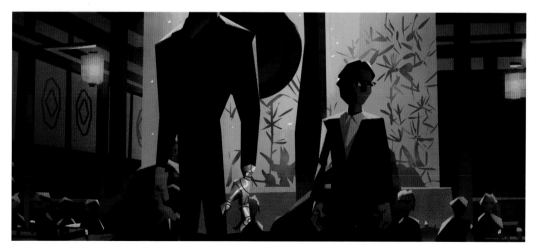

WALTER'S HOUSE

"Walter's house had to feel very different from Lance's clean, modern pad and reflect Walter as a character. Messy, overgrown, odd-ball, eclectic, but homey and friendly... with an enormous pigeon coop."

Aidan Sugano, Designer

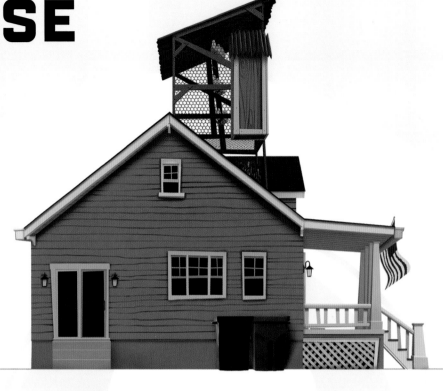

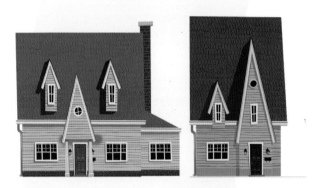

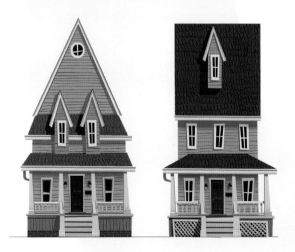

LEFT: Houses in Walter's Neighborhood: designs by Tyler Carter

RIGHT: Walter's House: concept design by Willie Real, final design by Tyler Carter

OPPOSITE: Walter's Neighborhood at Night: design and color by Aidan Sugano

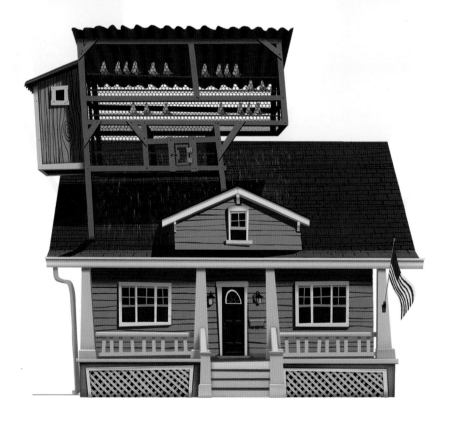

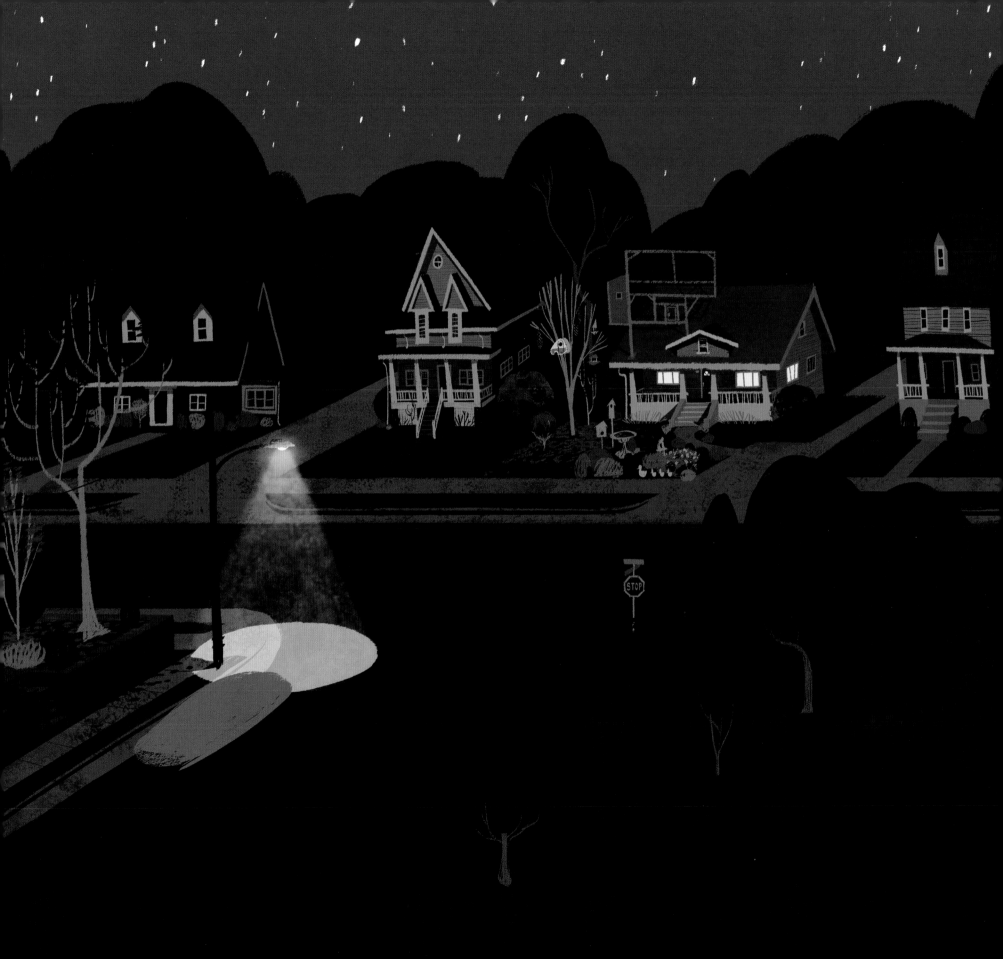

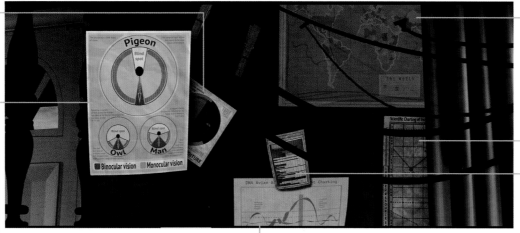

TOP: Walter's Papers: designs by Tom Humber

ABOVE: Kitty Poster: design by Michael Knapp; Cat design by Annlyn Huang, color by Tyler Carter; Pigeons design by Aidan Sugano

RIGHT: Walter's Living Room: design by Tom Humber

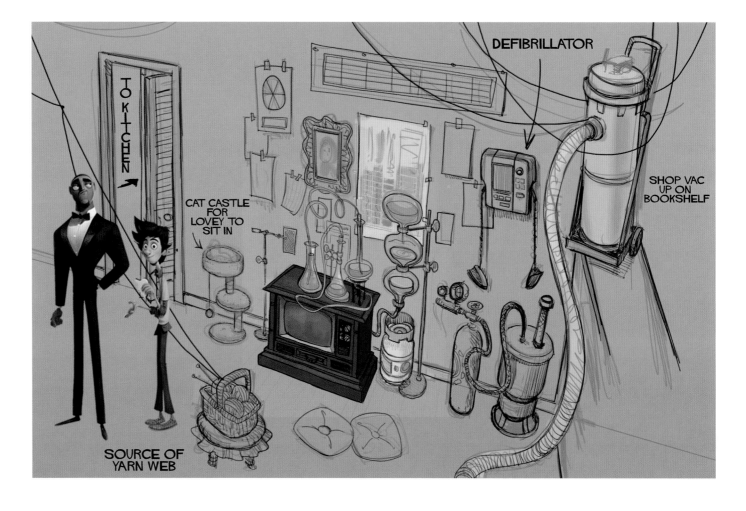

"I imagined this set to be a glimpse inside Walter's head. There is nothing slick or stylish about it, but every homemade piece of scientific equipment somehow works in a very Walter way. That is to say that the things Walter makes don't work the way you think they're going to work, but they work!"

Tom Humber, Lead Set Designer

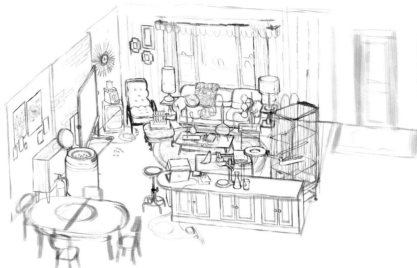

RIGHT: Cat Clock: design by Tom Humber

FAR RIGHT: Early Concept Sketch of Walter's House Interior: design by Willie Real

BELOW: Washing Machine Centrifuge: design by Tom Humber

BELOW RIGHT: Walter's Kitchen: design by Tom Humber

NEXT SPREAD: Walter's Nest: design by Willie Real, color by Peter Nguyen

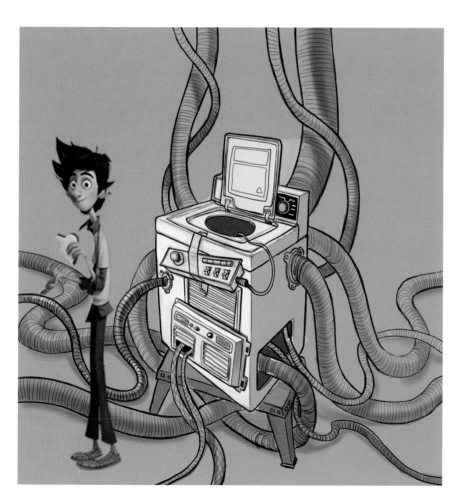

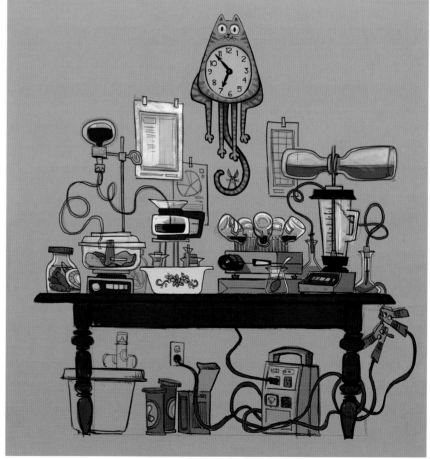

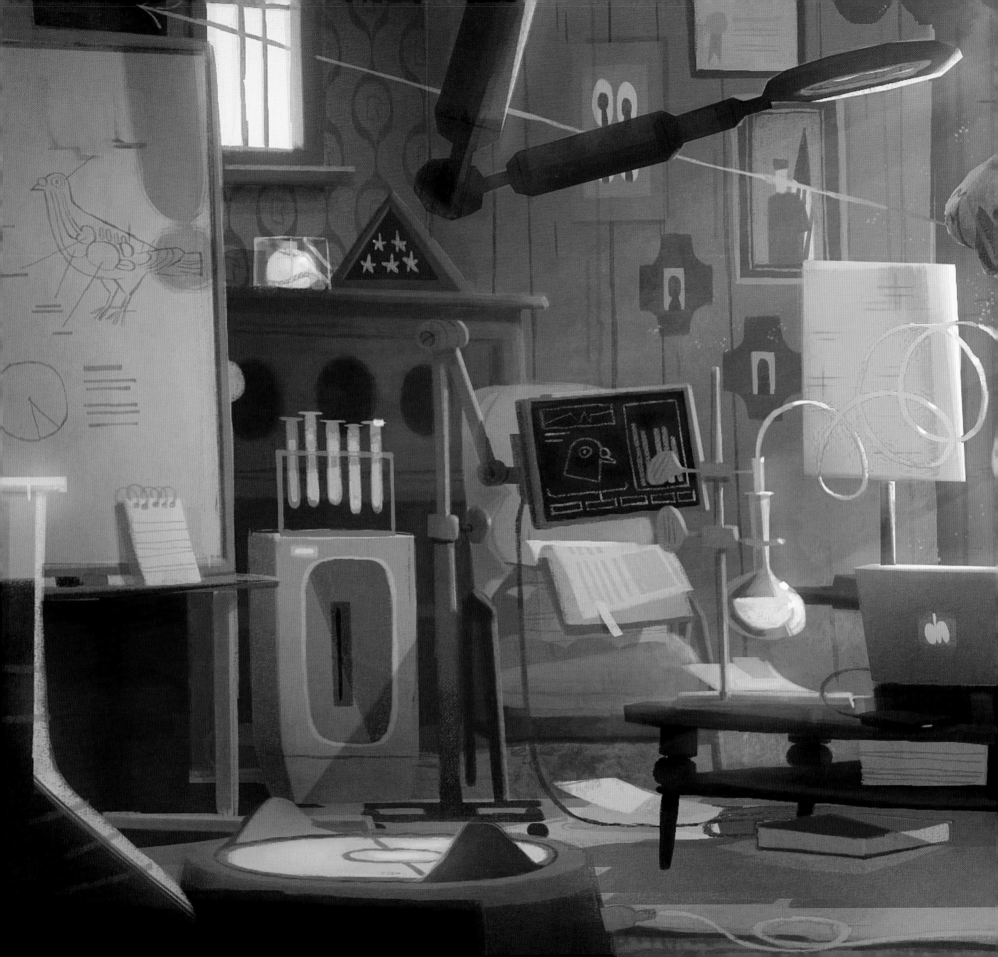

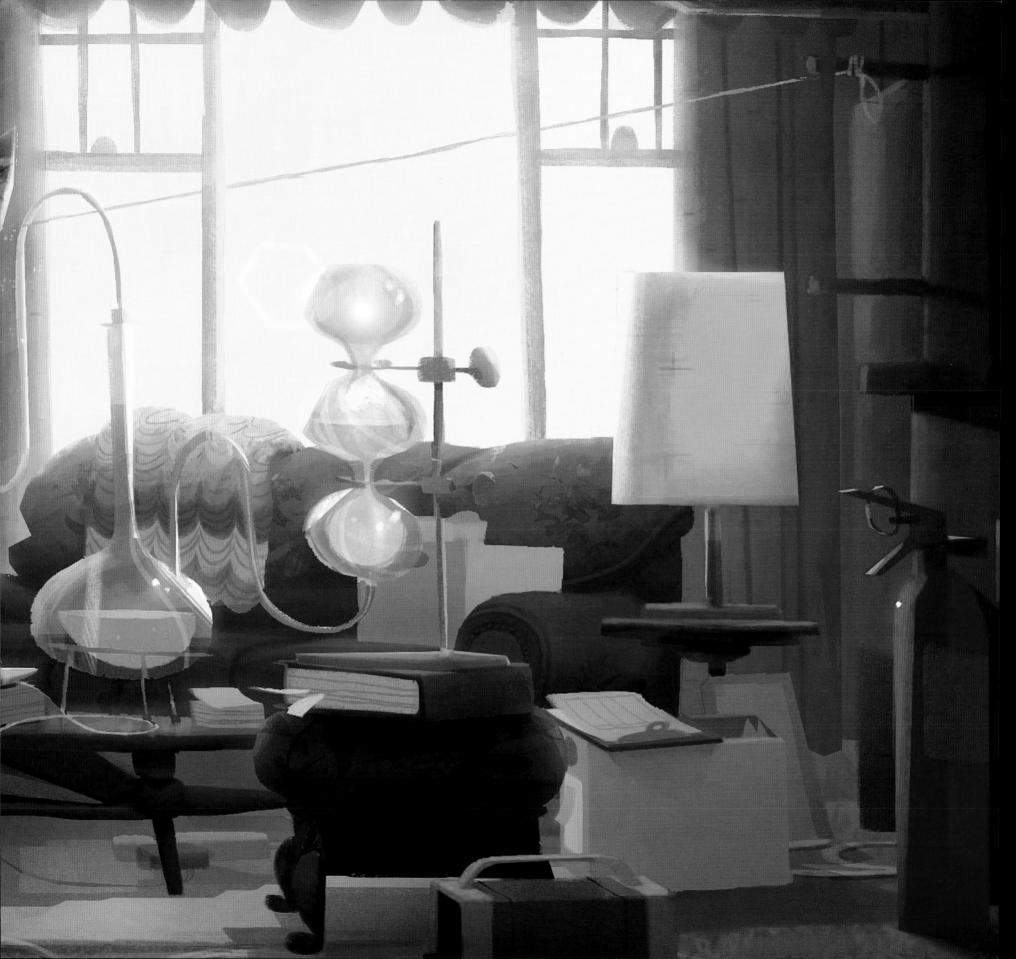

THE TRANSFORM SEQUENCE

THIS SPREAD: Lance Surprises
Walter at Home: storyboards by
John Jackson

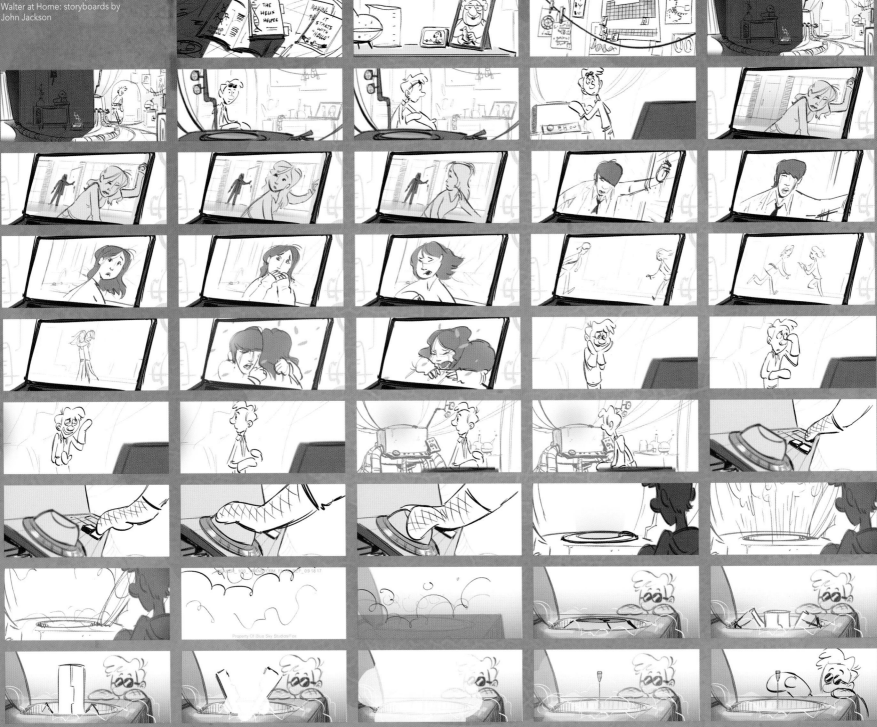

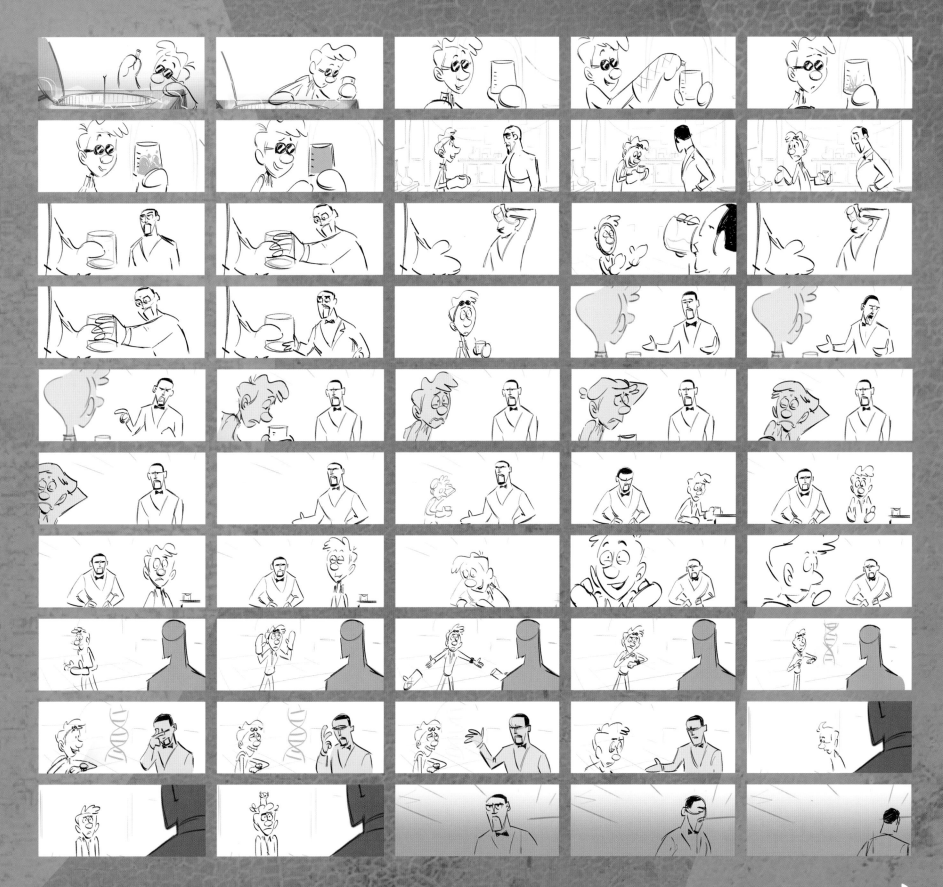

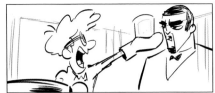

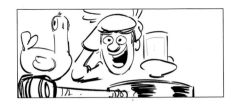

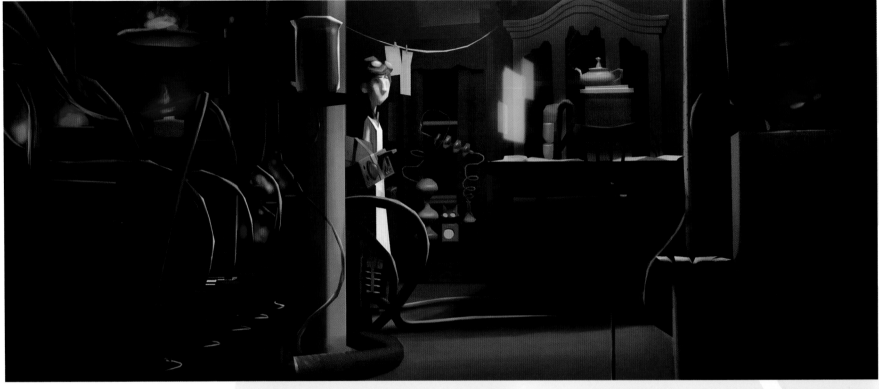

TOP: Lance's Transformation: storyboards by Jeff Call

ABOVE & RIGHT: Transformation: color keys by Vincent Nguyen

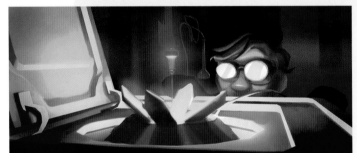

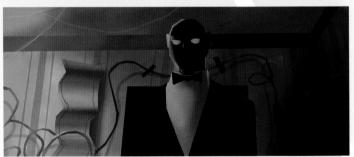

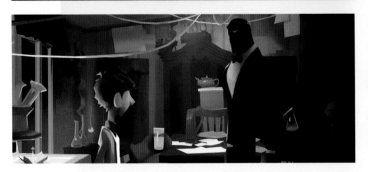

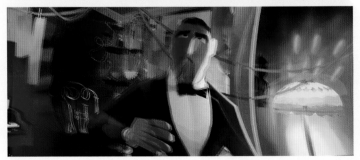

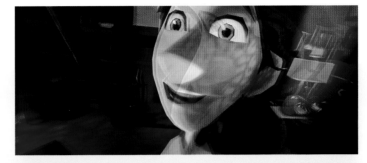

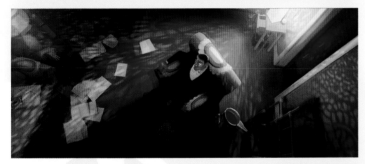

TOP: Lance's Transformation: storyboards by Jeff Call

LEFT & BELOW: Transformation: color keys by Vincent Nguyen

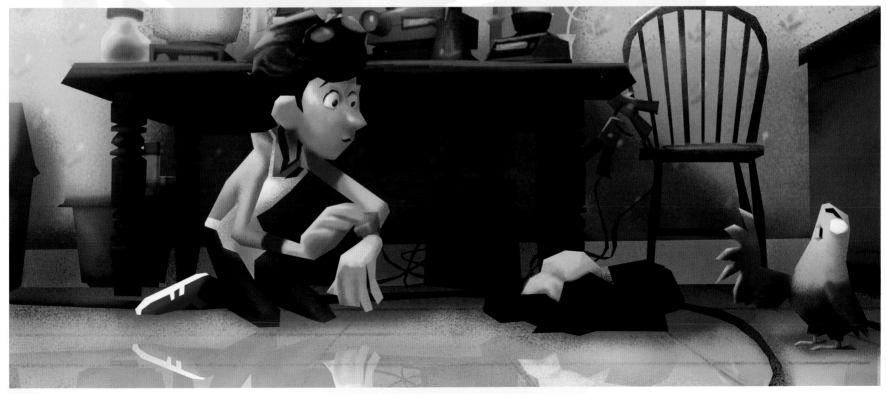

MAYAN RIVIERA RESORT

BELOW: Mayan Riviera Resort: color key by Peter Nguyen

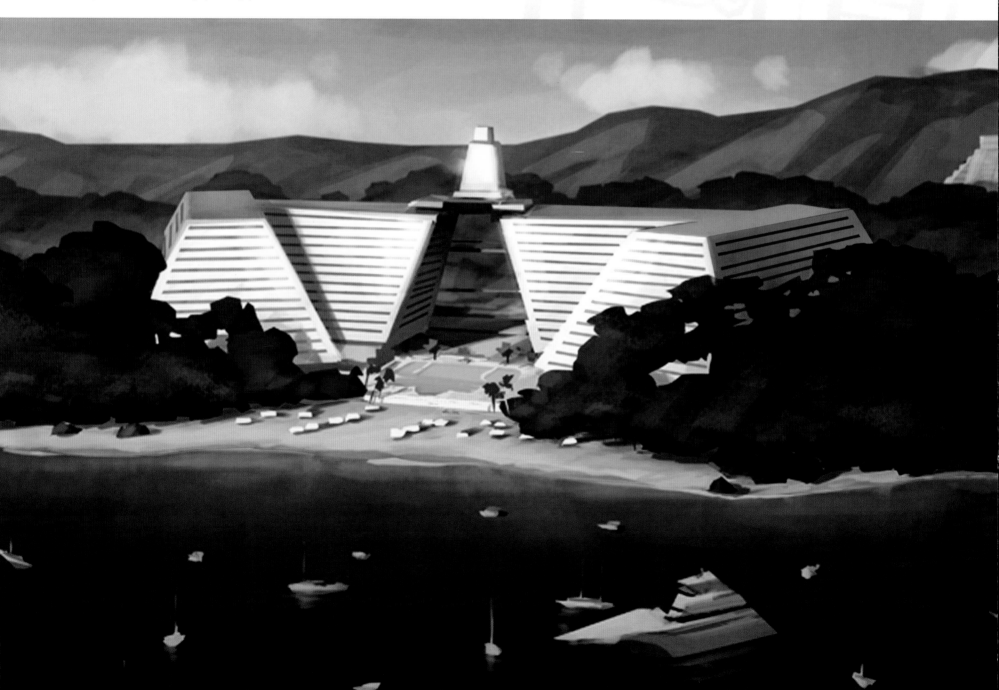

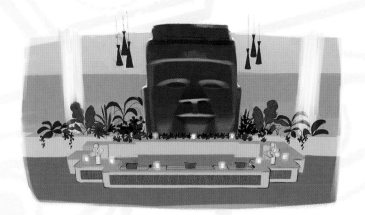

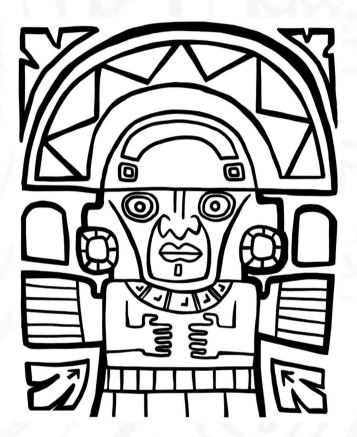

"Springing from some of Willie Real's inspirational sketches, we explored a hotel design that was both over-the-top extravagant and felt hyper-exclusive. We looked at luxury yachts and modern tropical spas for inspiration for the detailing, and to Mayan ruins for some of the thematic elements that run throughout the decor and architecture. Sprinkled throughout the open-air lobby are relics from local ruins, which mix the ancient world with the more modern streamline architecture."

Nash Dunnigan, Lead Set Designer

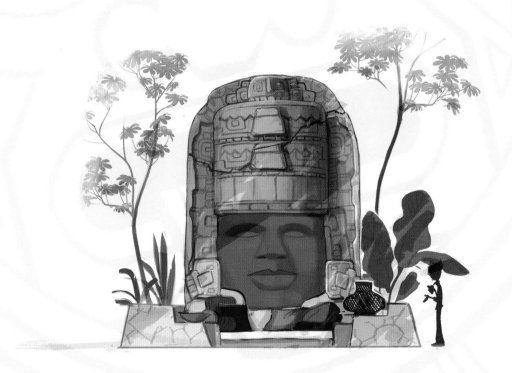

TOP: Reception Desk: design by Nash Dunnigan

ABOVE: Mayan Statue: design by Nash Dunnigan

ABOVE RIGHT: Mayan Graphic: design by Peter Nguyen

RIGHT: Mayan Hotel Furniture: design by Kevin Yang

RIGHT: Marcy, Eyes and Ears Arrive at the Hotel: color key by Ron DeFelice

MIDDLE RIGHT: Lance, Jeff and Crazy Eyes Get the Key Card: color key by Ron DeFelice

BELOW: Key Card Hacker: design by Sandeep Menon

OPPOSITE: Walter and Lance Arrive at the Hotel: design by Nash Dunnigan, color by Peter Nguyen

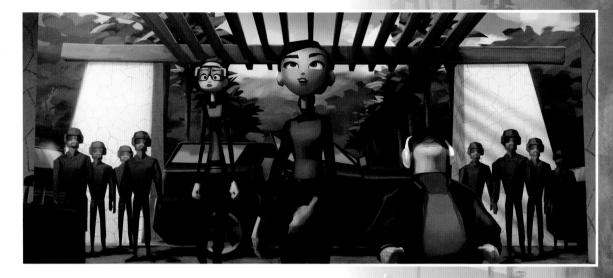

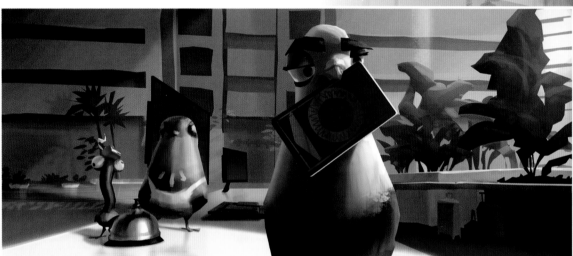

"For the scene where Walter attempts to escape Marcy's pursuit, we kept a balance in controlling the blown-out lights and the subtle ranges for the fill lights while maintaining a nice color palette. The goal was to let the shadows and different specular lights cater to the staging for our characters."

Peter Nguyen, Lead Color Designer

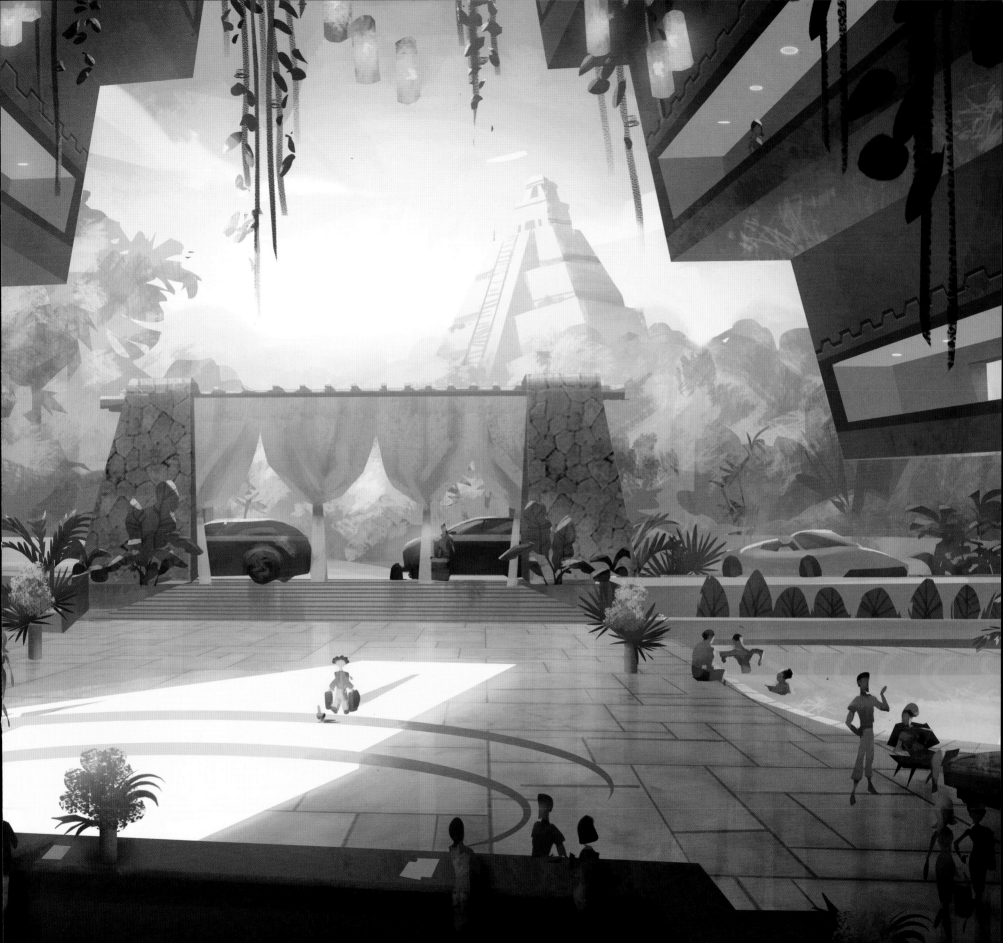

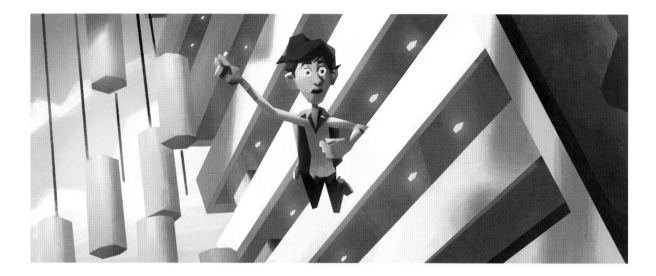

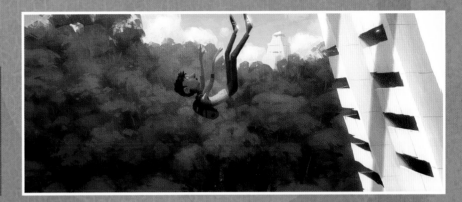

"The intense sunlight warms the space enough to make the cast-shadow area look cool, and the warm and cool complementary color combination brings us a nice color harmony."

Hye Sung Park, Color Designer

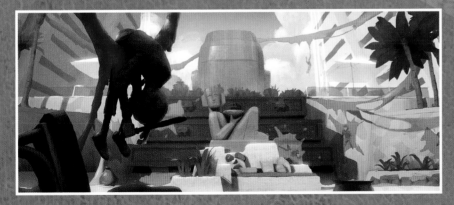

THIS PAGE: Walter and Lance Evade Agents with Serious String: color keys by Hye Sung Park

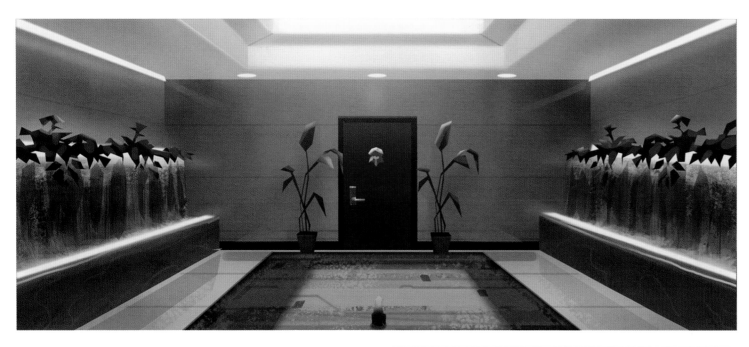

LEFT: Entrance to Penthouse: color key by Peter Nguyen

MIDDLE LEFT: Penthouse Layout: design by Tom Humber

BOTTOM LEFT: Early Concept Sketch of Penthouse: design by Willie Real

BOTTOM RIGHT: Kimura in His Penthouse Pool: color keys by Peter Nguyen

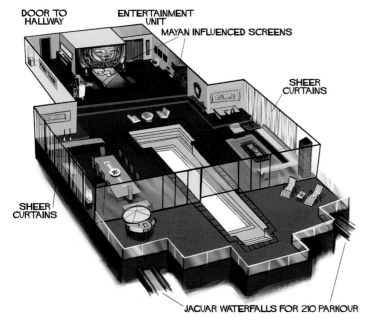

DOOR TO HALLWAY

ENTERTAINMENT UNIT

MAYAN INFLUENCED SCREENS

SHEER CURTAINS

SHEER CURTAINS

JAGUAR WATERFALLS FOR 210 PARKOUR

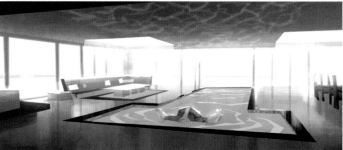

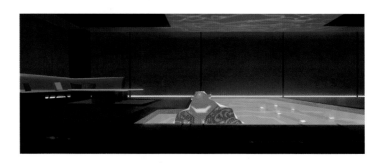

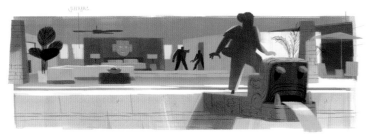

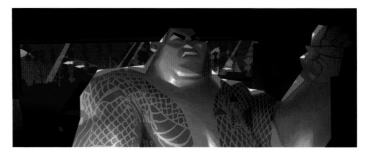

RIGHT: Walter Spritzes Kimura with Truth Serum: color key by Peter Nguyen

MIDDLE: Penthouse Fish Tank: design by Tom Humber

BOTTOM: Marcy and Agents Enter the Penthouse: color key by Peter Nguyen

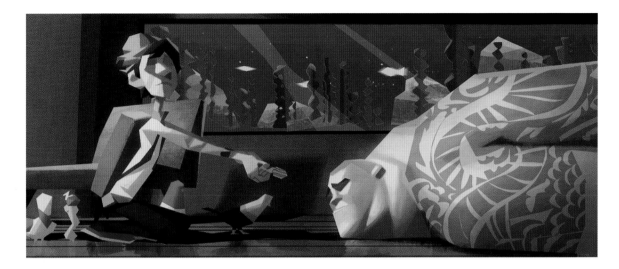

"This is the high-roller suite, the penthouse at the top of the hotel, so it's not your typical hotel room. It is a sleek, modern, luxury pad with a glass-bottomed pool in the center of it. Not the perfect place for a criminal to not draw attention to himself! This set was made for a widescreen movie, with its floating ceiling and expansive panoramic glass walls."

Tom Humber, Lead Set Designer

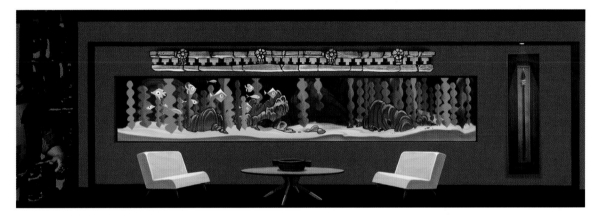

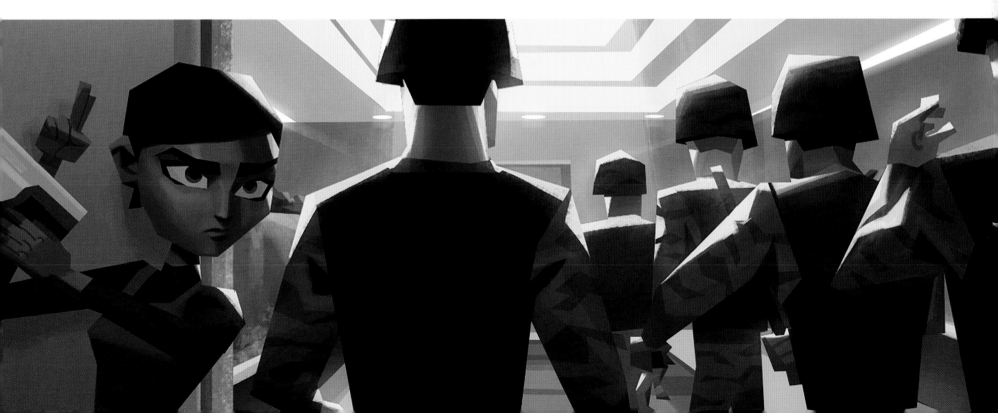

VENICE

BELOW: Venice Buildings: design and color by Tyler Carter

OPPOSITE TOP: Pigeon Vision Venice at Night: color key by Hye Sung Park

> "The Venice challenge! How the heck do you represent a city with infinite variety using a finite number of reusable buildings?"
>
> *Jon Townley, Sr., Set Designer*

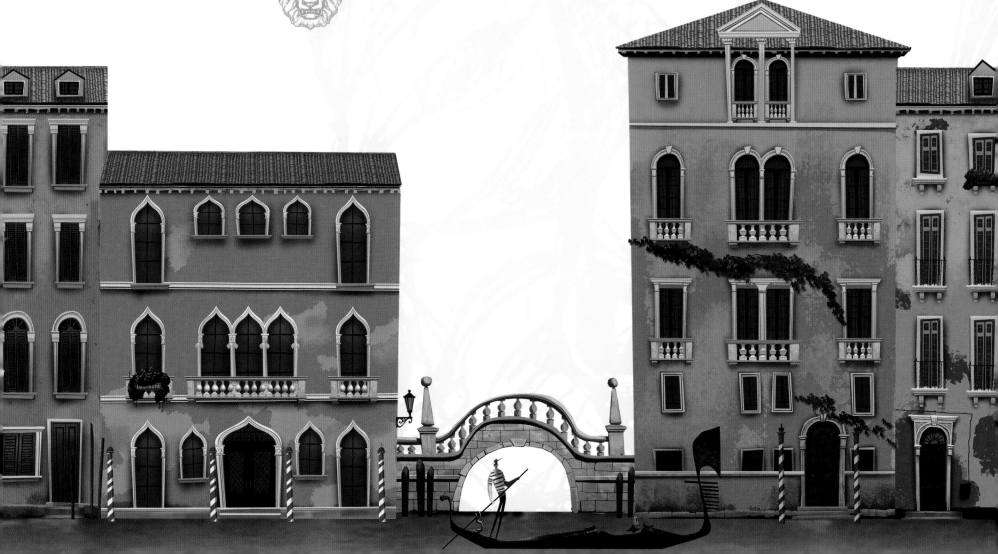

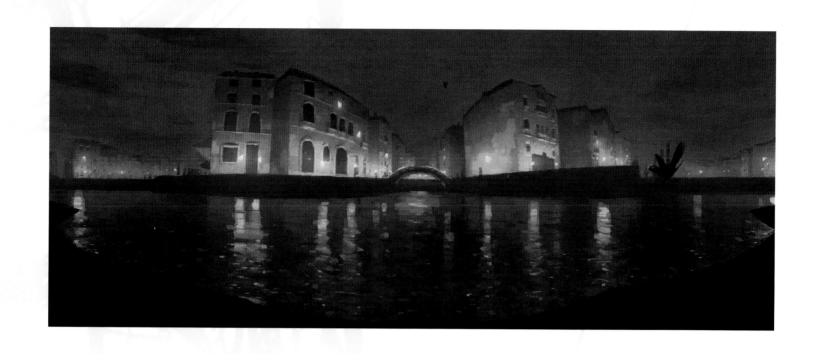

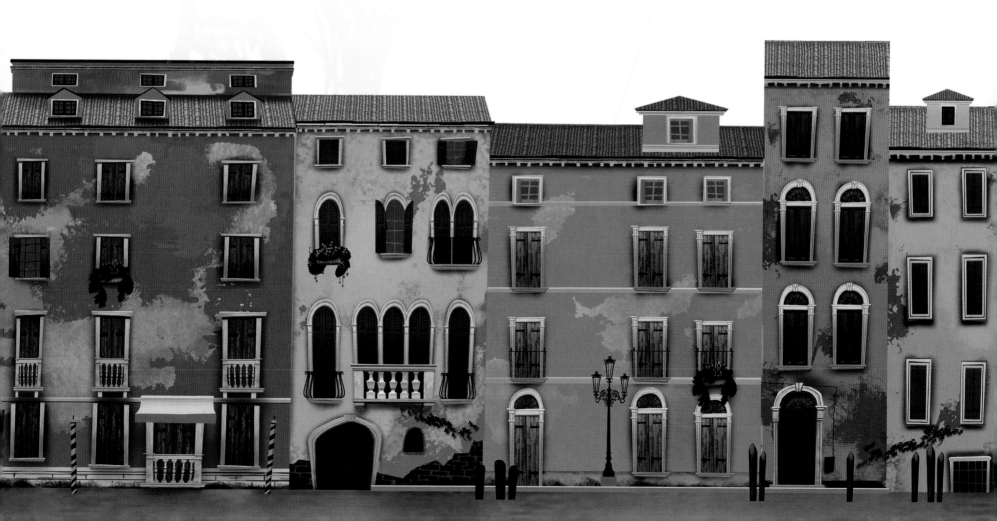

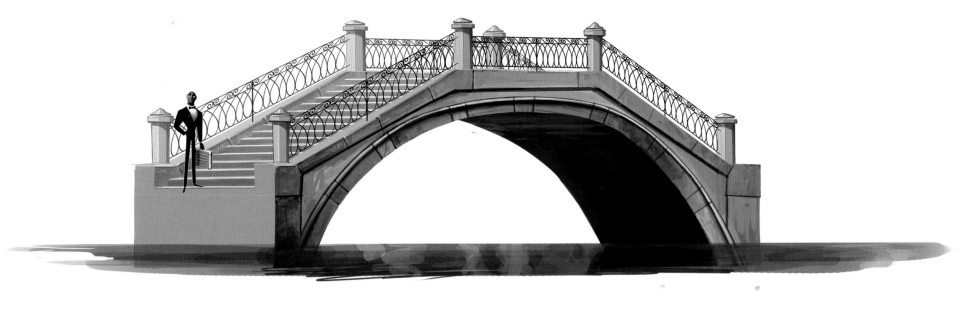

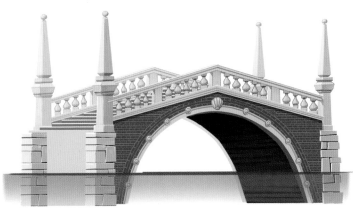

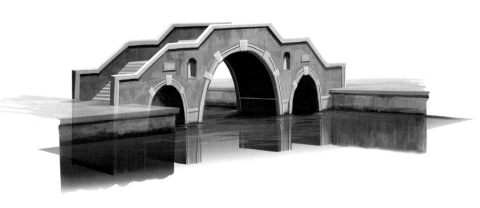

ABOVE: Venician Bridges: designs
by Jon Townley

BELOW: Gondola and Moorings:
design by Tyler Carter

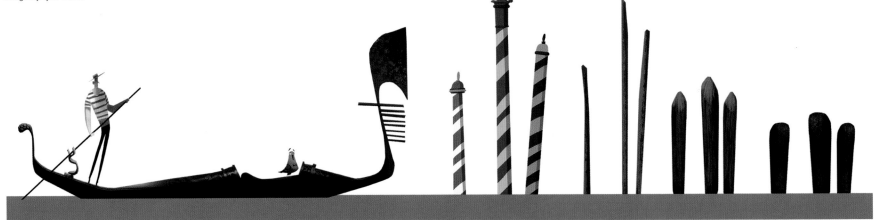

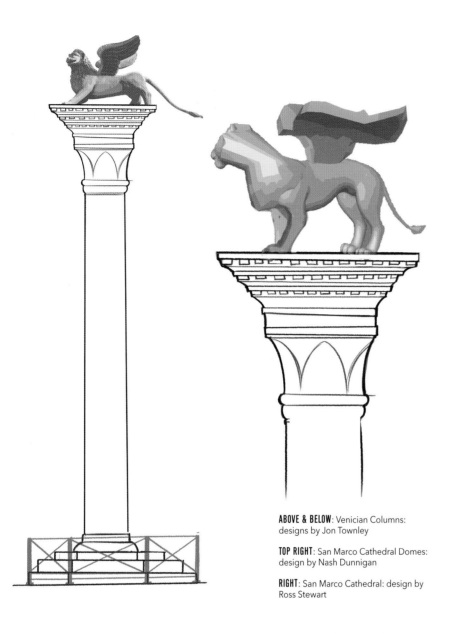

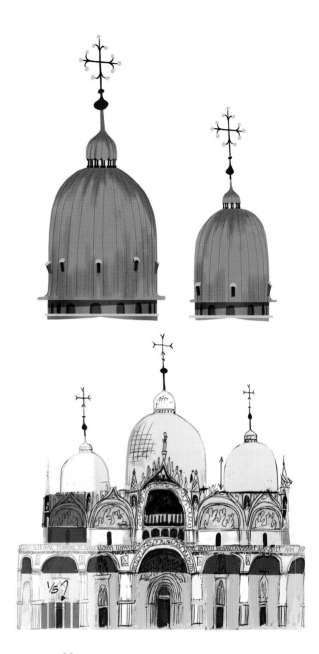

ABOVE & BELOW: Venician Columns: designs by Jon Townley

TOP RIGHT: San Marco Cathedral Domes: design by Nash Dunnigan

RIGHT: San Marco Cathedral: design by Ross Stewart

"Venice is an incredible location to stage an aerial chase scene. One of our challenges was to make sure we conveyed its history and character as efficiently as possible. The bridges, the canals, the clotheslines hanging from window to window all provided fun obstacles for our flock to maneuver around like little fighter jets."

Michael Knapp, Production Designer

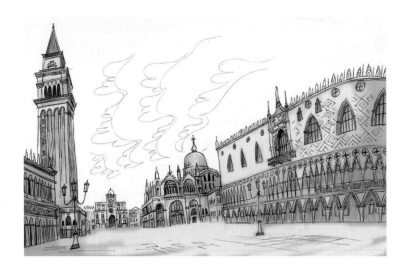

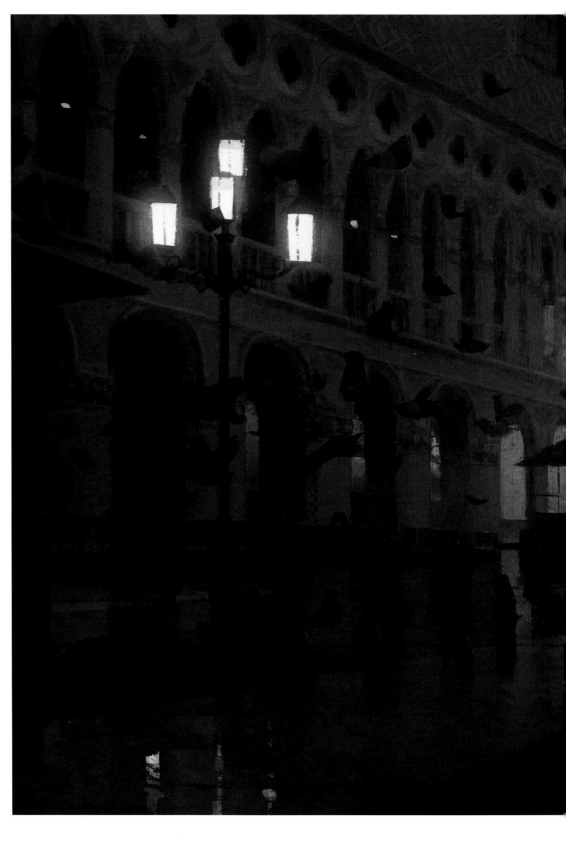

TOP: San Marco Plaza: design by Ross Stewart

ABOVE: Venician Posters and Graphics: designs by Sandeep Menon, Hye Sung Park and Peter Nguyen

RIGHT: Walter Crashes Moped in San Marco Plaza: color key by Hye Sung Park

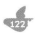

BELOW: Venetian Attic: design by Jon Townley

BOTTOM: Grandma in Venetian Apartment: color key by Hye Sung Park

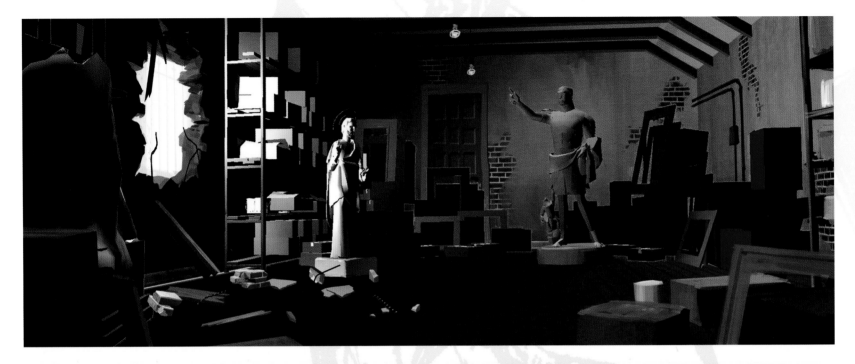

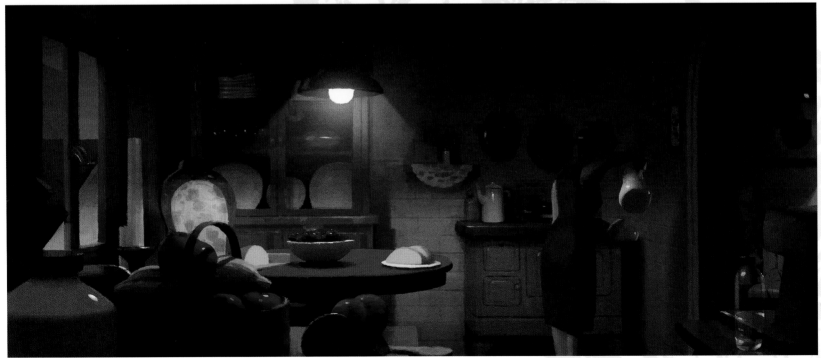

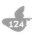

"We wanted to really capture the spirit of
'the floating city' and its brimming culture.
The building designs are pushed by keeping
windows and doors aligned on one vertical
axis while other elements break free.
The combination gives us a playful feel
without losing architectural integrity."

Tyler Carter, Designer

BELOW: Grandma Sees Drone Damage:
design by Jon Townley

BELOW RIGHT: Drone Aims Plasma
Cannon at Lance: color key by Hye
Sung Park

BOTTOM: Lance Bursts Through Window:
color key by Hye Sung Park

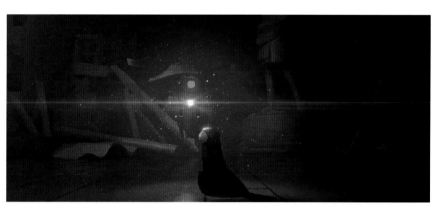

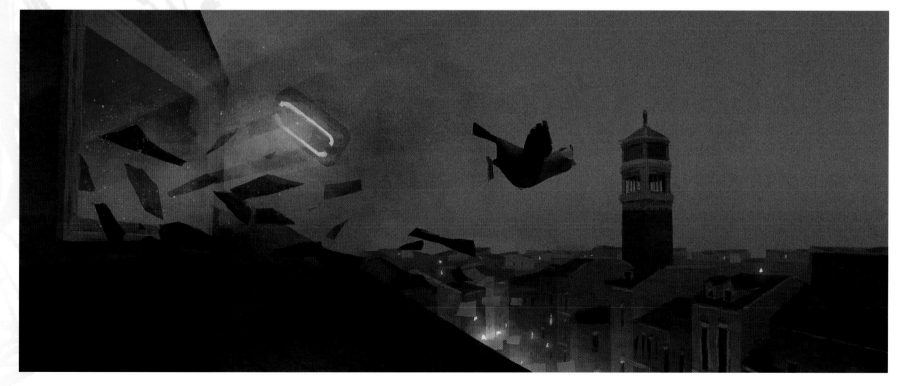

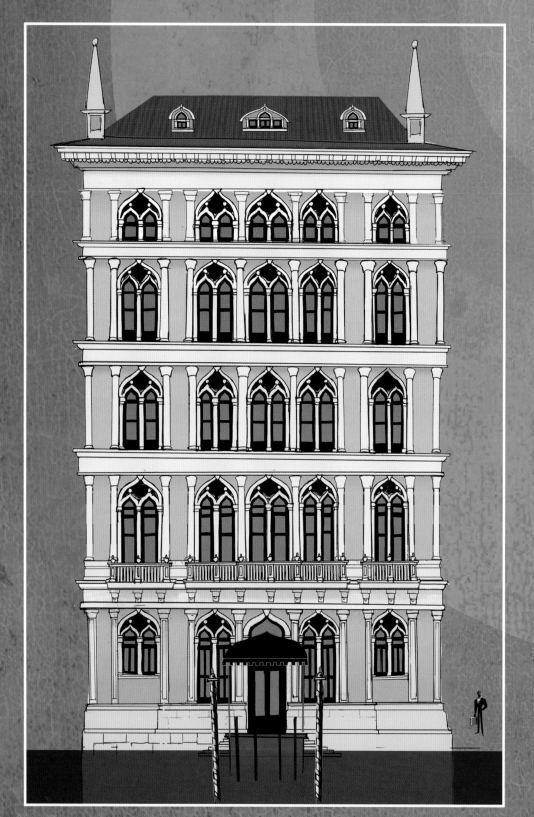

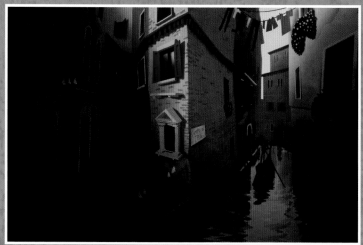

LEFT: Agency Data Vault Exterior: design by Jon Townley

TOP: Early Agency Data Vault Sketch: design by Ross Stewart

ABOVE: Venice Side Streets and Canals: design by Ross Stewart, color by Tyler Carter

OPPOSITE TOP: Venice Canals: designs by Jon Townley

OPPOSITE MIDDLE: Early Venice Canal Sketches: designs by Ross Stewart

OPPOSITE BOTTOM: Riding a Gondola Down the Canal: design and color by Tyler Carter

NEXT SPREAD: Drone Chasing Lance Through Venice: design and color by José Manuel Fernández Oli

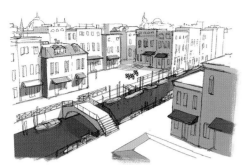

MOPED PLAZA
CONCEPT DESIGN

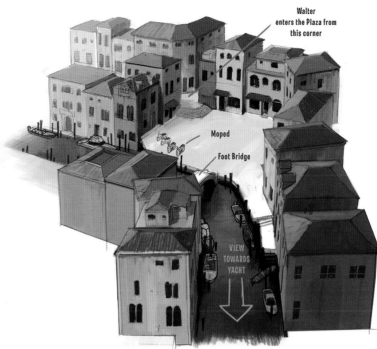

Walter enters the Plaza from this corner

Moped

Foot Bridge

VIEW TOWARDS YACHT

PLAN VIEW

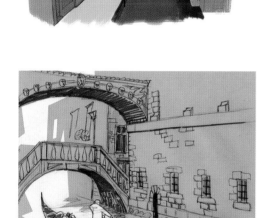

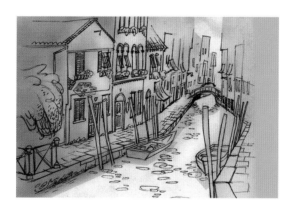

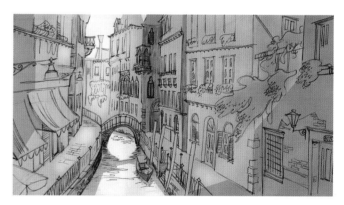

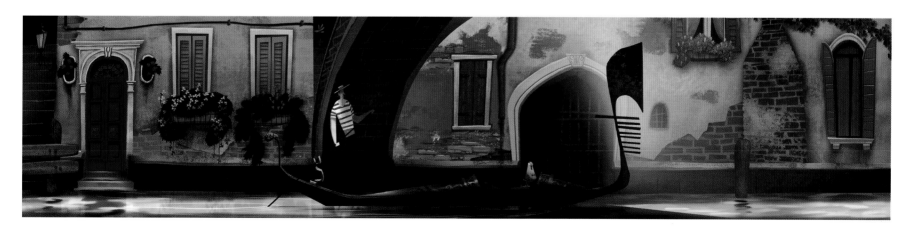

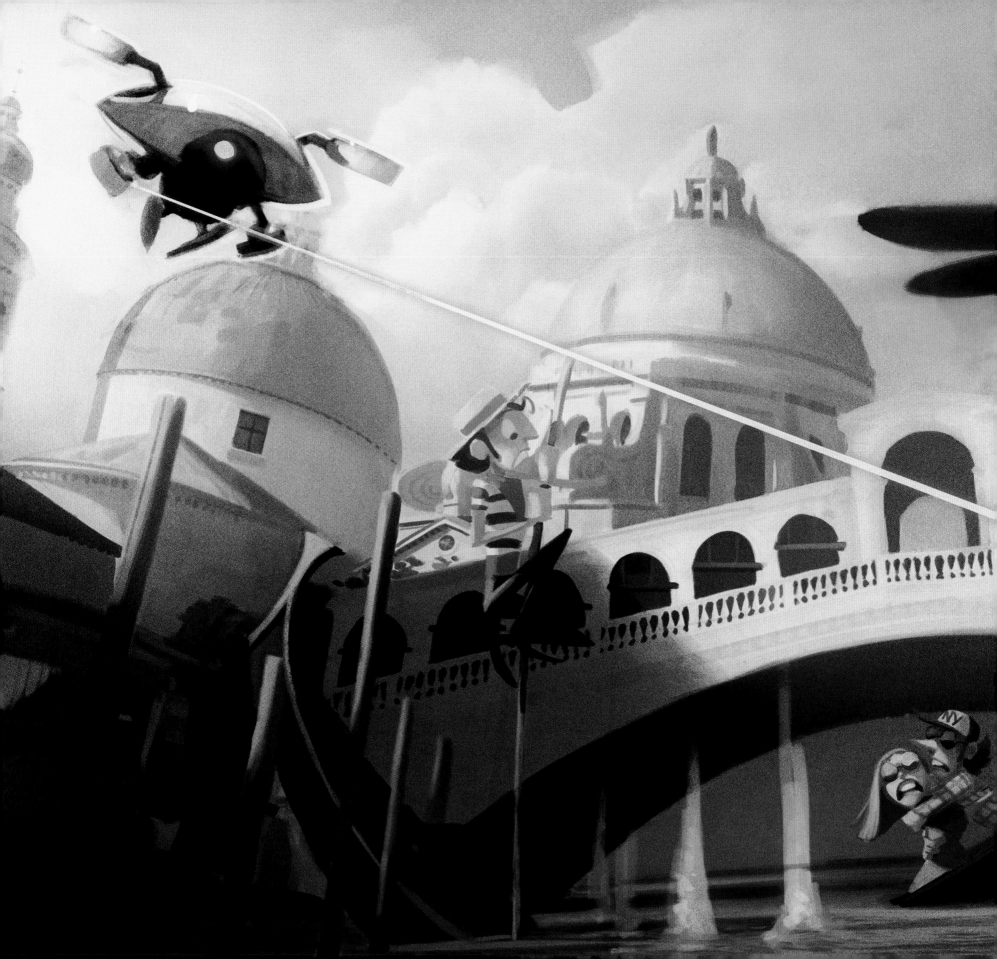

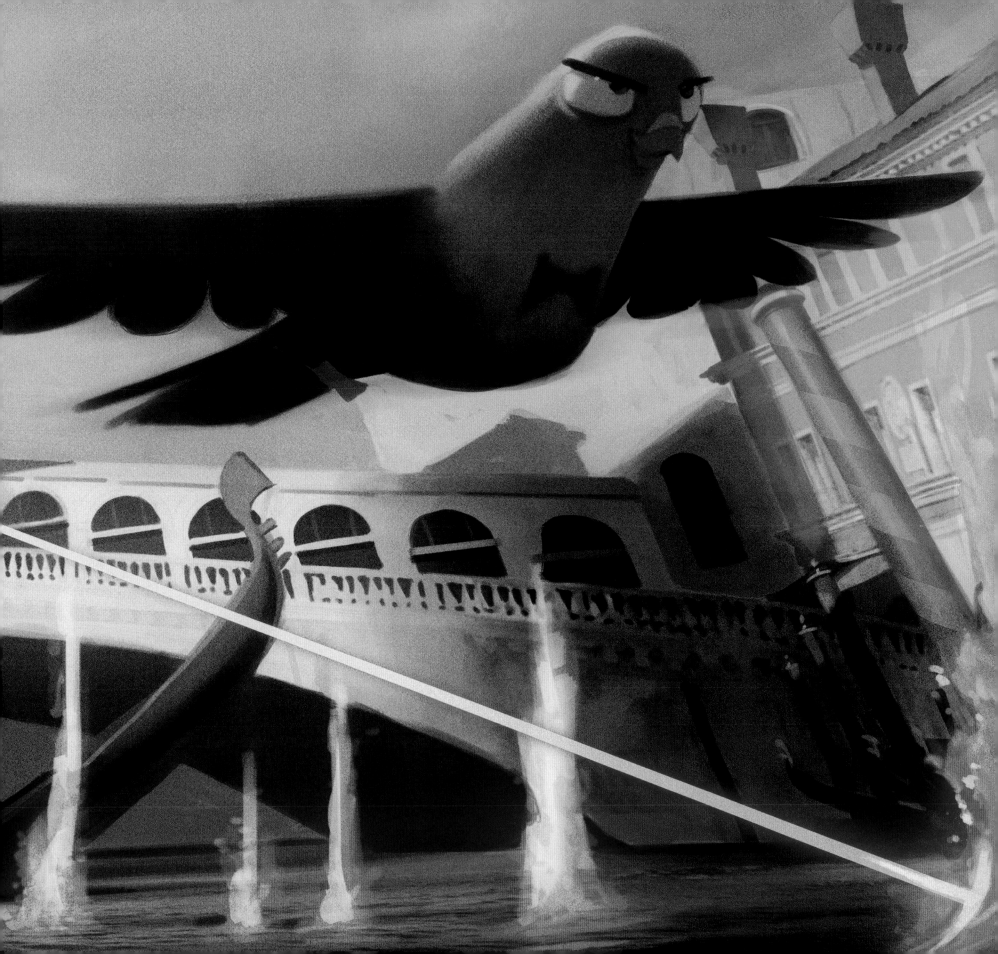

COVERT WEAPONS FACILITY

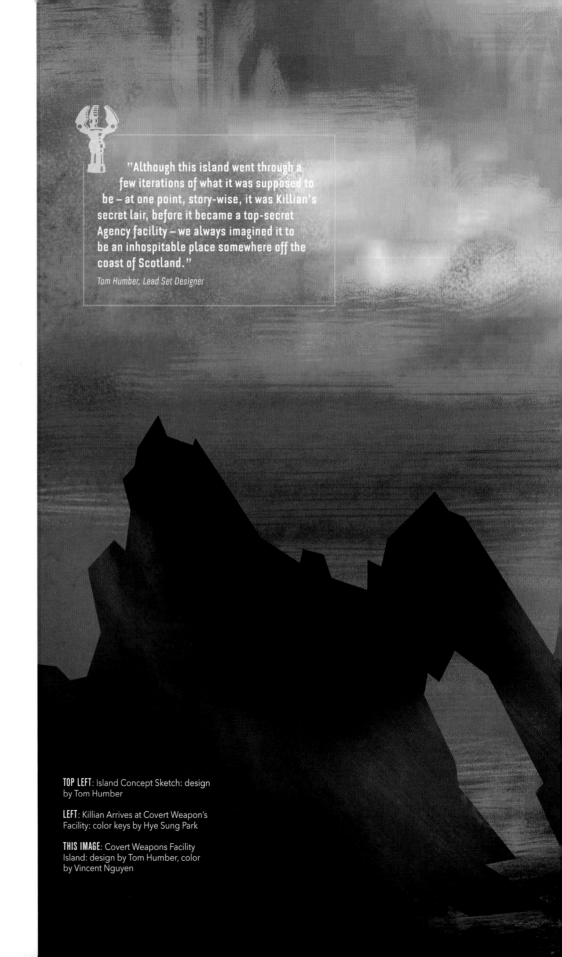

"Although this island went through a few iterations of what it was supposed to be – at one point, story-wise, it was Killian's secret lair, before it became a top-secret Agency facility – we always imagined it to be an inhospitable place somewhere off the coast of Scotland."

Tom Humber, Lead Set Designer

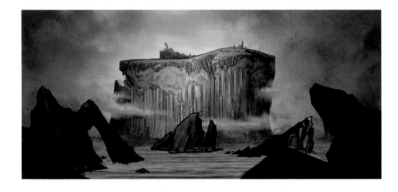

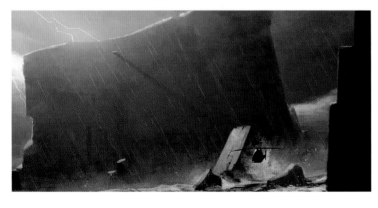

TOP LEFT: Island Concept Sketch: design by Tom Humber

LEFT: Killian Arrives at Covert Weapon's Facility: color keys by Hye Sung Park

THIS IMAGE: Covert Weapons Facility Island: design by Tom Humber, color by Vincent Nguyen

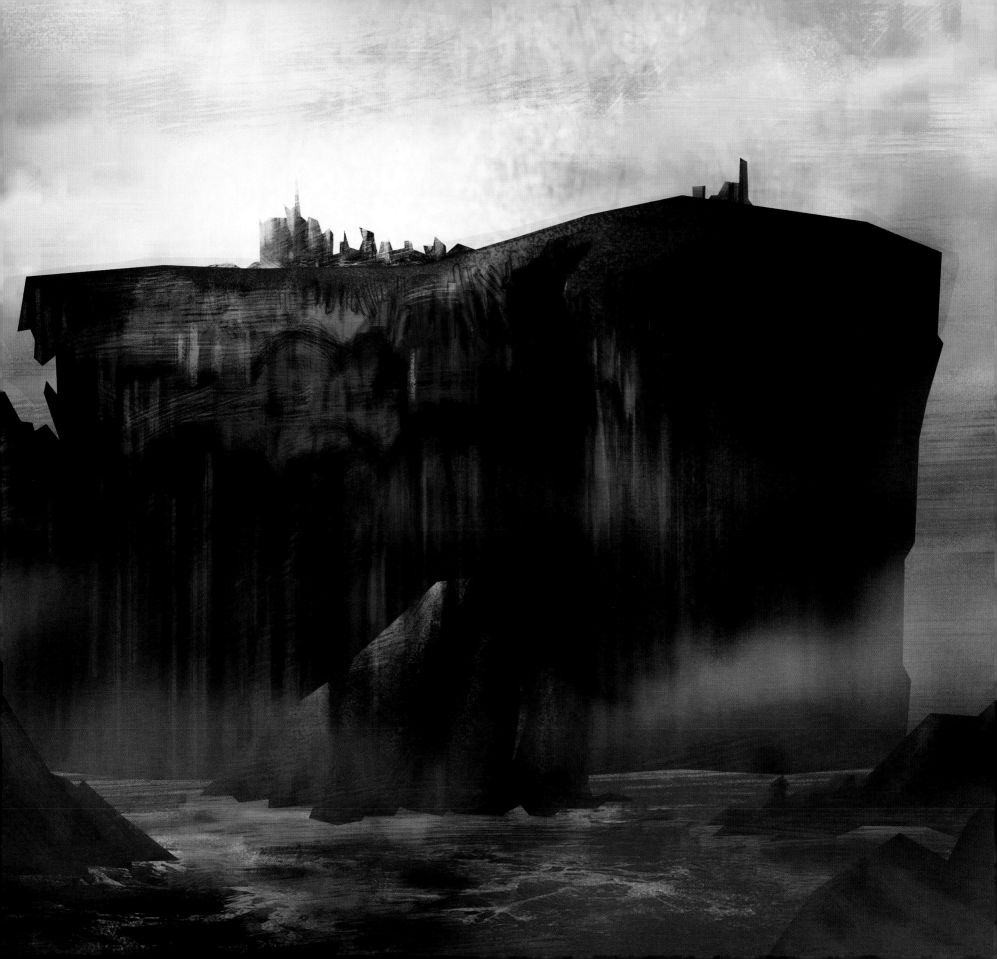

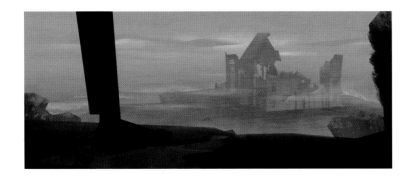

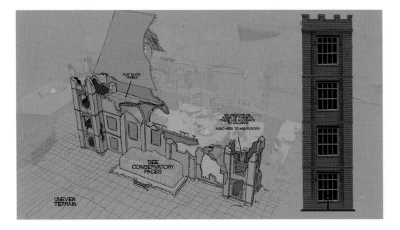

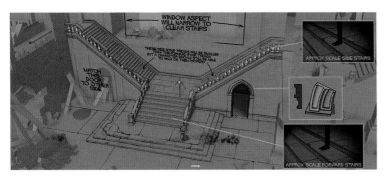

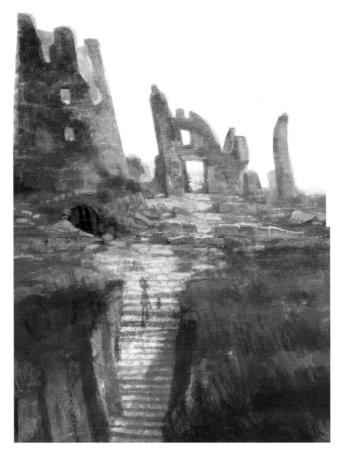

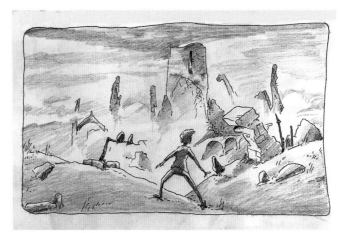

TOP LEFT: Lance Arrives at Dilapidated Manor: color key by Peter Nguyen

BOTTOM LEFT: Manor Designs: designs by Tom Humber

TOP MIDDLE: Ruins on the Island: designs by Greg Couch

LEFT: Walter and Lance on the Island: sketch by Seth Boyden

ABOVE: Island Staircase Ruins: design by Greg Couch

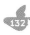

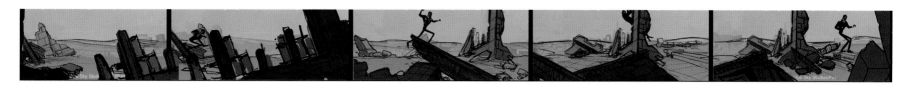

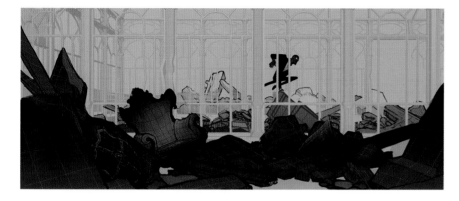

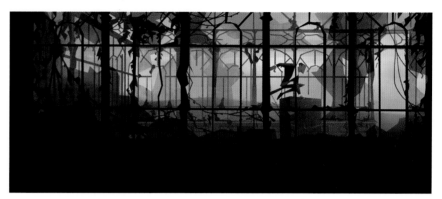

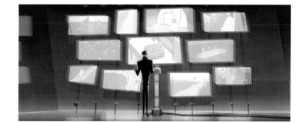

"A derelict manor house on a windswept plain of harsh vegetation set high atop cliffs of massive basalt columns was always the plan. The manor house itself is pure stage craft. If you were to build it based on this design there would be no place for rooms and the spaces wouldn't make sense. This ruin was designed to support the story as an arena for the climactic confrontation in the third act."

Tom Humber, Lead Set Designer

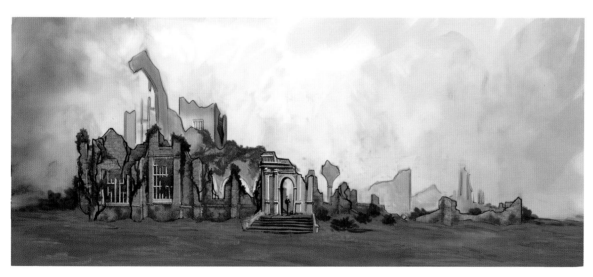

TOP: Lance Running Through Manor Ruins: designs by Tom Humber

ABOVE LEFT & RIGHT: Lance Running Through Greenhouse: design by Tom Humber, color key by Peter Nguyen

MIDDLE LEFT: Lance Entering

Covert Weapons Facility: color key by Peter Nguyen

MIDDLE RIGHT: Killian Looking at Monitors: color key by Peter Nguyen

LEFT: Manor Concept: design by Tom Humber

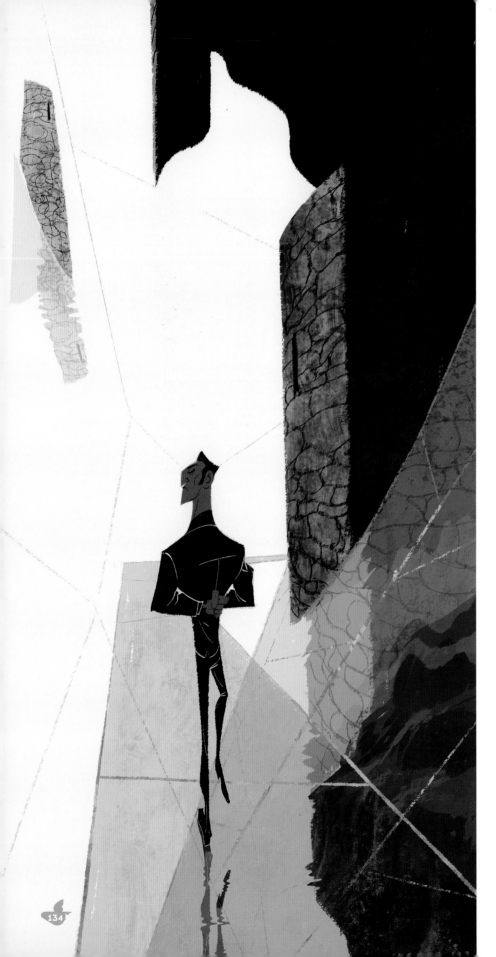

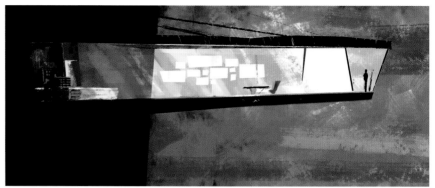

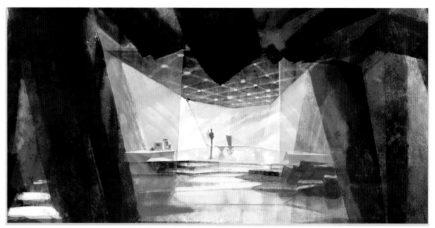

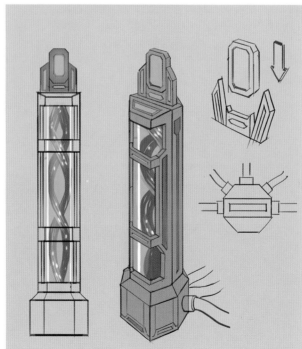

FAR LEFT: Killian Walking Through the Ruins: design by Aidan Sugano

ABOVE: Early Concepts of Killian's Office: designs by Greg Couch

LEFT: Agency Hard Drive Docking Station: design by Tom Humber

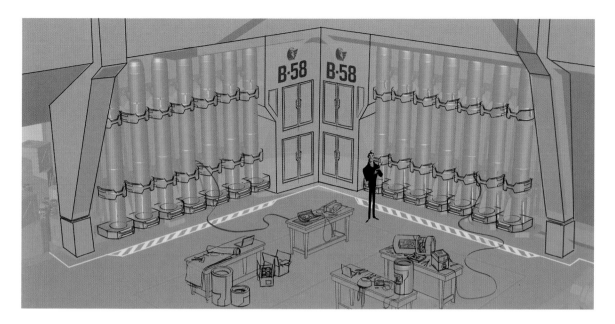

"Deep below the foundations of the ruined manor is hidden a top secret Cold War-era Agency facility where most of our third act takes place. This location allowed us to contrast the shape language of the ruins above to the heavy duty concrete bunker below, but also show through color and lighting Killian's corruption of an Agency outpost into his base of operations."

Tom Humber, Lead Set Designer

ABOVE: Missile Racks: design by Sandeep Menon

BELOW: Drone Carriers: designs by Sandeep Menon

BELOW RIGHT: Factory Machinery: designs by Sandeep Menon

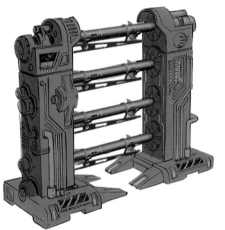

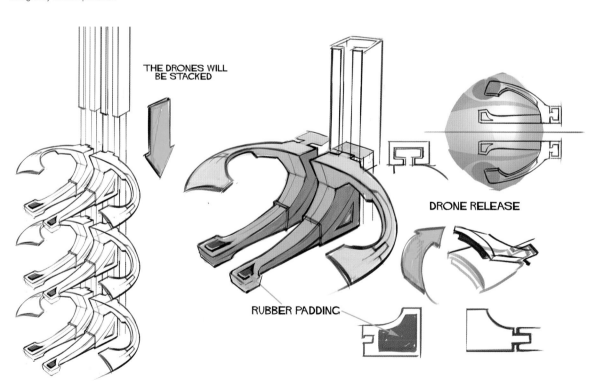

THE DRONES WILL BE STACKED

DRONE RELEASE

RUBBER PADDING

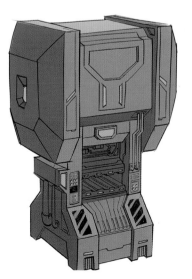

LANCE'S SPORTS CAR

BELOW: Lance Driving in Tunnel: color key by Hye Sung Park

BELOW RIGHT: Car Missile Housing: design by Tyler Carter

BOTTOM: Lance Driving Away from Explosion: color key by Tyler Carter

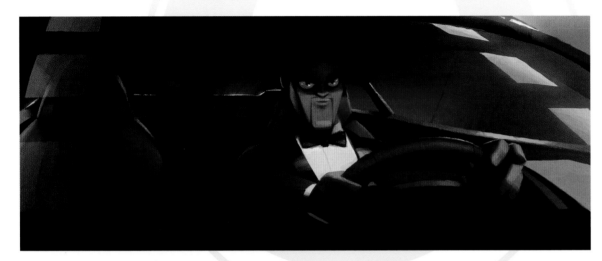

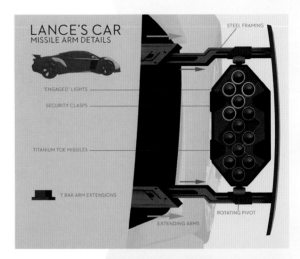

LANCE'S CAR
MISSILE ARM DETAILS

STEEL FRAMING

"ENGAGED" LIGHTS

SECURITY CLASPS

TITANIUM TOE MISSILES

T BAR ARM EXTENSIONS

EXTENDING ARMS

ROTATING PIVOT

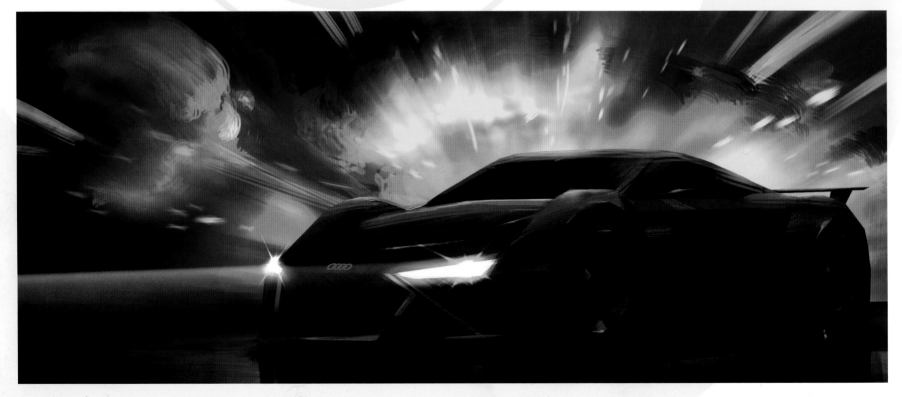

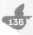

LANCE CAR VARIATIONS

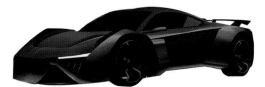

- MEDIUM GRILL
- ANGLED STREAMLINE
- TALL AUDI BUBBLE SHAPE

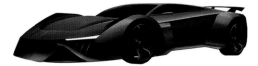

- WIDER GRILL
- LOWERED STREAMLINE
- NO AUDI BUBBLE SHAPE

- BIGGER GRILL
- ROUNDED STREAMLINE
- AUDI BUBBLE SHAPE

LANCE'S CAR
CONCEPTUAL PAINT PASS

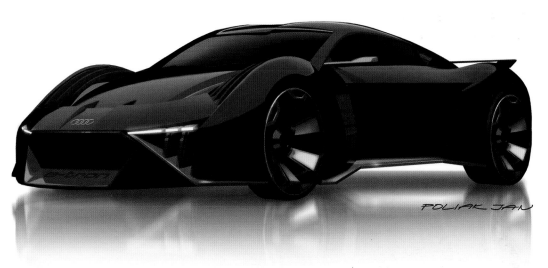

POLIAK JAN

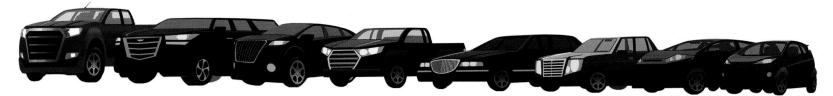

ABOVE: Early Car Variations: designs by Tyler Carter & Jan Poliak, Audi Design Team

RIGHT: Lance's License Plate: designs by Tyler Carter

NATION'S CAPITAL
I GOT ★★★ THIS
DISTRICT OF COLUMBIA

"The exterior design of the Audi RSQ e-tron was mainly inspired by the movie storyline and the main character: Lance, a very smart and stylish super agent. Clearly, our design had to reflect this. On top of that, we always take care that our designed cars are instantly recognizable as Audi vehicles and showcase technology highlights."

Frank Rimili, Audi Design Team

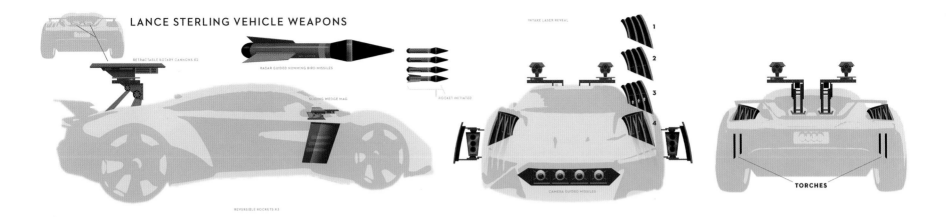

LANCE STERLING VEHICLE WEAPONS

RETRACTABLE ROTARY CANNONS X2

RADAR GUIDED HUMMING BIRD MISSILES

SLIDING WEDGE MAG

ROCKET INITIATED

INTAKE LASER REVEAL

1

2

3

4

CAMERA GUIDED MISSILES

TORCHES

REVERSIBLE ROCKETS X3

ABOVE: Lance Car Weapons Breakdown: designs by Tyler Carter

BELOW: Lance Hides from Searchlights: color key by Vincent Nguyen

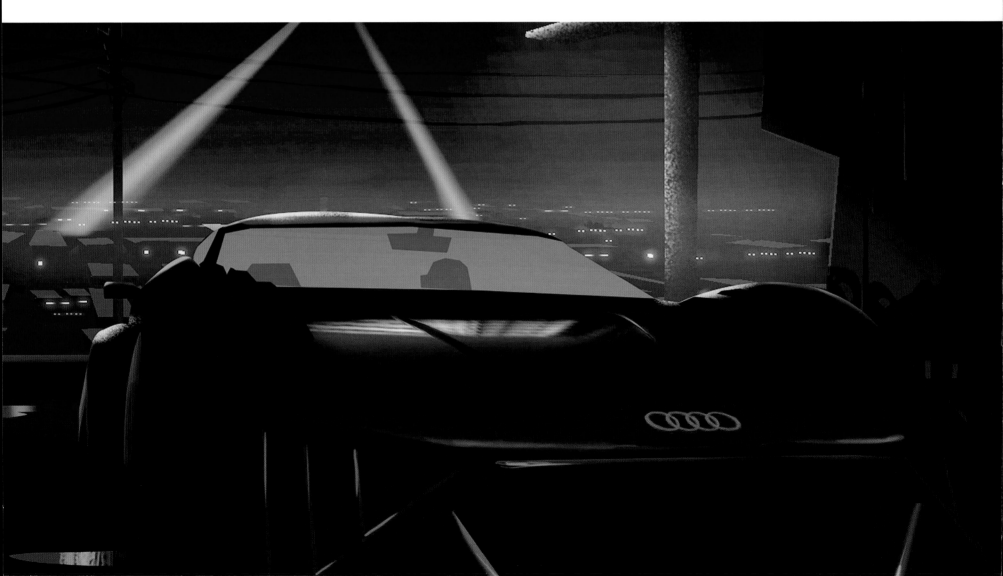

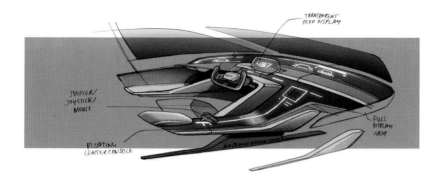

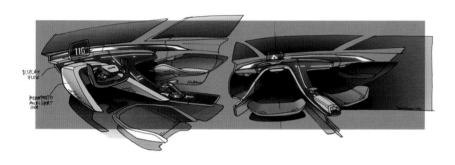

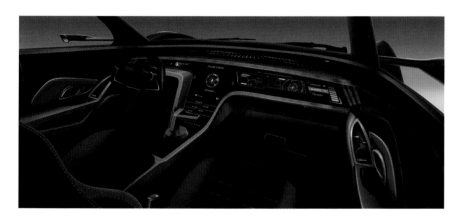

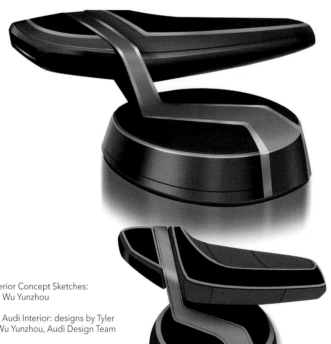

"Compared to designing a real car, the process of making an animated spy car is totally different. In real life we have to respect practical requirements and they need to be ergonomic. With an animated movie we have more freedom, but we have to consider storyboarding and camera positions, which were already established before I started to sketch the interior. To fit our Audi design language into the movie action, incredible environments, and exciting main characters, was one of the biggest challenges for me."

Wu Yunzhou, Audi Design Team

TOP LEFT: Interior Concept Sketches: drawings by Wu Yunzhou

BOTTOM LEFT: Audi Interior: designs by Tyler Carter and Wu Yunzhou, Audi Design Team

RIGHT: Steering Wheel and Gear Shift: designs by Tyler Carter and Wu Yunzhou, Audi Design Team

LANCE'S SPY PLANE

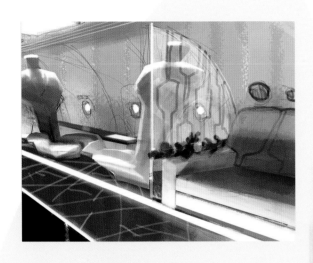

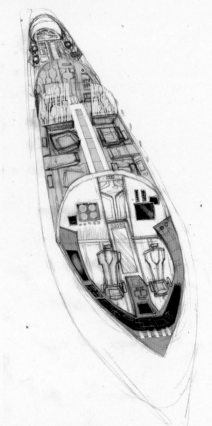

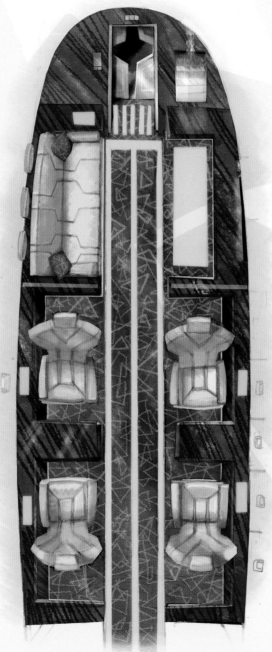

THIS PAGE: Spy Plane Interior: designs by Greg Couch

OPPOSITE: Walter and Pigeon Lance in Spy Plane: color keys by Hye Sung Park

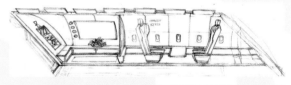

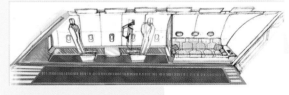

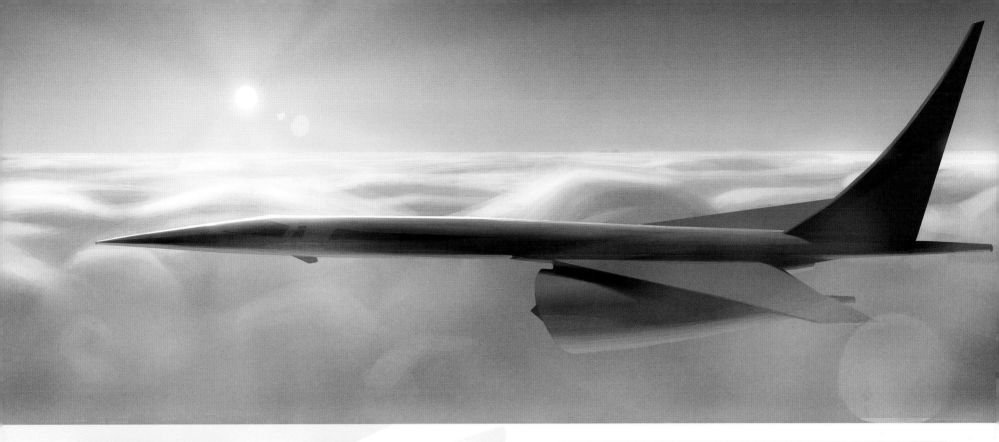

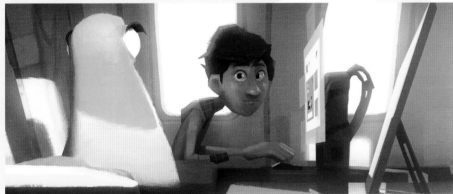

"While conceiving Lance's spy plane, Greg Couch came up with the idea that the plane should be a constant reminder to Lance that he's no longer human. Everything is scaled to Lance's heroic proportions. Lance's human silhouette is even part of the cabin chair and door designs."

Michael Knapp, Production Designer

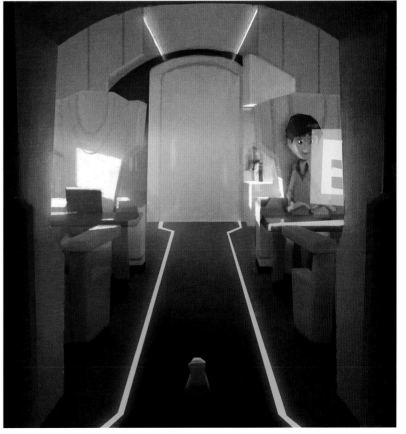

YACHT & MINISUB

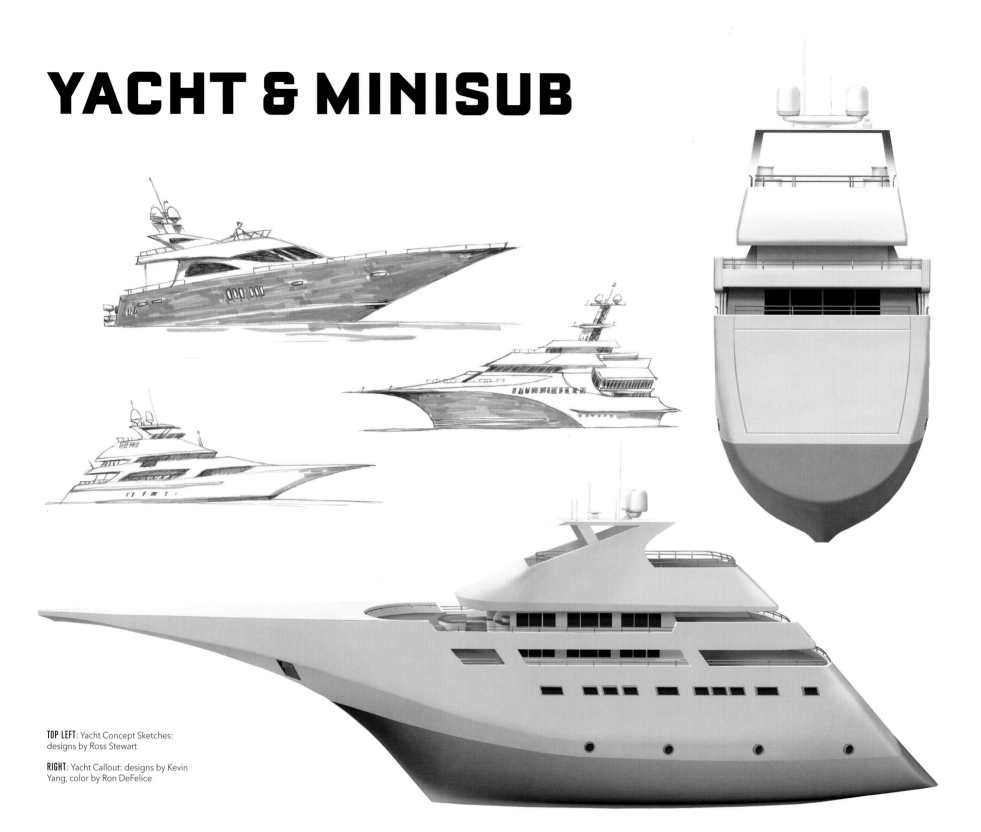

TOP LEFT: Yacht Concept Sketches: designs by Ross Stewart

RIGHT: Yacht Callout: designs by Kevin Yang, color by Ron DeFelice

"Lance only travels in style, whether he's a human or a bird, so of course he 'commandeers' the largest, most luxurious yacht he could find. Perhaps it helps him forget he's a tiny pigeon while he's on it?"

Michael Knapp, Production Designer

THIS PAGE: Yacht Exterior Layout: designs by Kevin Yang

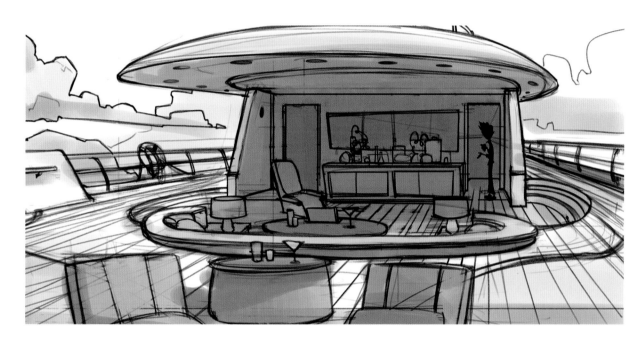

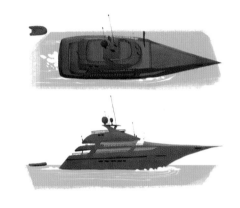

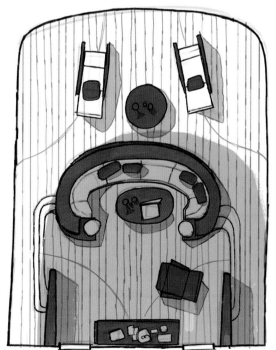

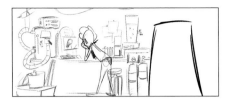
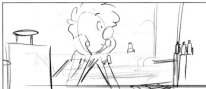
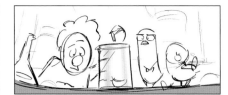
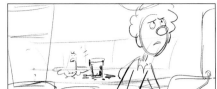

ABOVE: Walter Works on the Antidote: storyboard by Heather Larkin

RIGHT: Walter's Makeshift Centrifuge: design by Kevin Yang

FAR RIGHT & BELOW: Walter's Workspace on Yacht: design by Kevin Yang, color by Tyler Carter

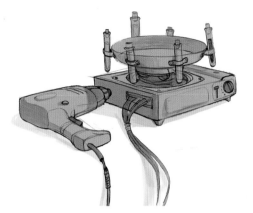
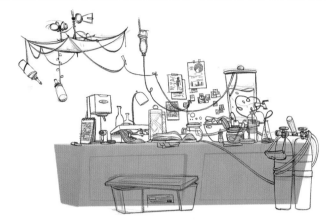

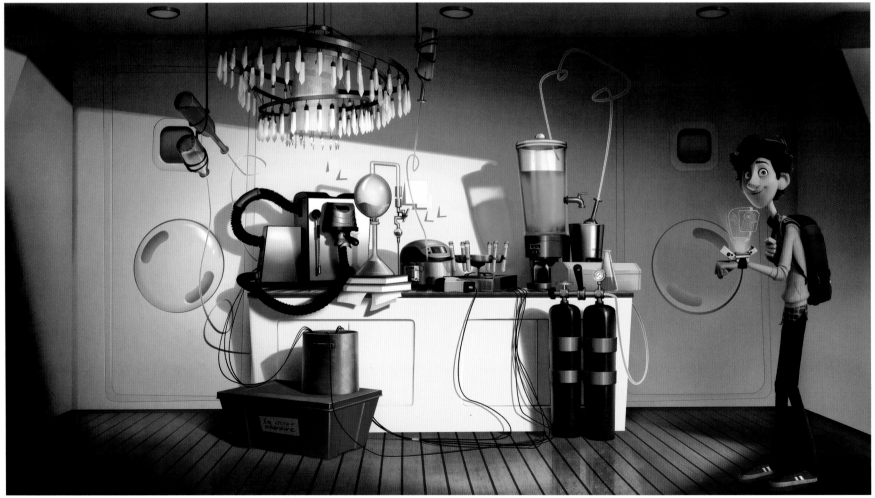

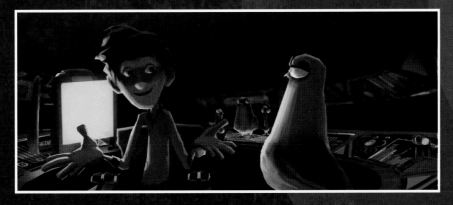

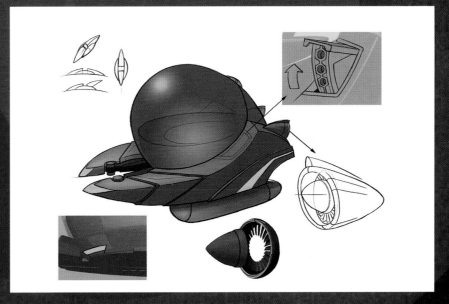

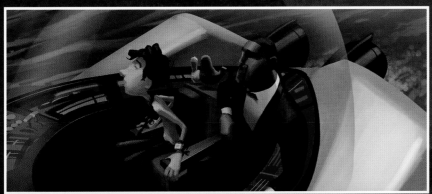

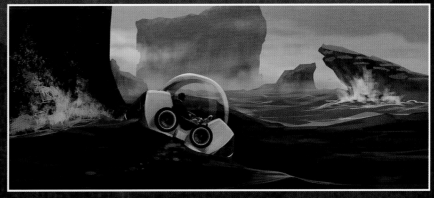

> "A submersible is typically bulky and purely functional. The challenge here was to redesign it to cater to Lance's sleek and contemporary sensibilities."
>
> *Sandeep Menon, Set Designer*

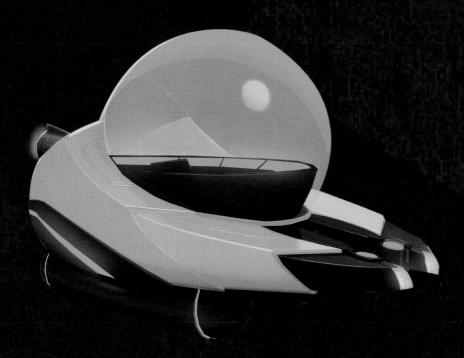

TOP LEFT: Walter and Lance in Minisub: color keys by Ron DeFelice

TOP RIGHT: Minisub Concept: design by Sandeep Menon

ABOVE: Walter and Lance Arrive at the Island: color key by Ron DeFelice

LEFT: Minisub Callout: design by Sandeep Menon, color by Hye Sung Park

BACKGROUND VEHICLES

"All the vehicles were caricatured right up to their breaking point. To capture the essence of each vehicle meant maintaining a consistent, cohesive style structure. Even for an average sedan, the window-to-body proportions were pushed quite a bit. In the sports cars those proportions went even further: lots of body and just a sliver of window."

Tyler Carter, Designer

RIGHT: SUV Callout: design by Jon Townley and Tyler Carter, color by Hye Sung Park

BOTTOM RIGHT: Car Seat Profile: design by Jon Townley

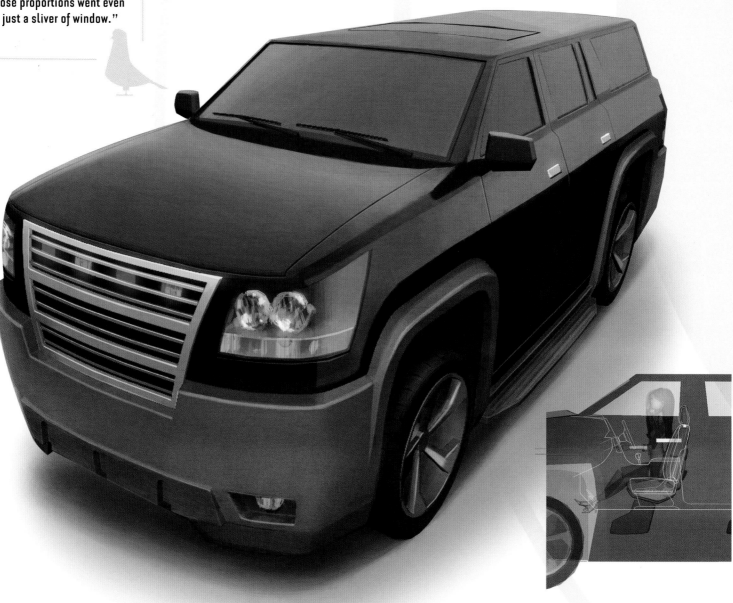

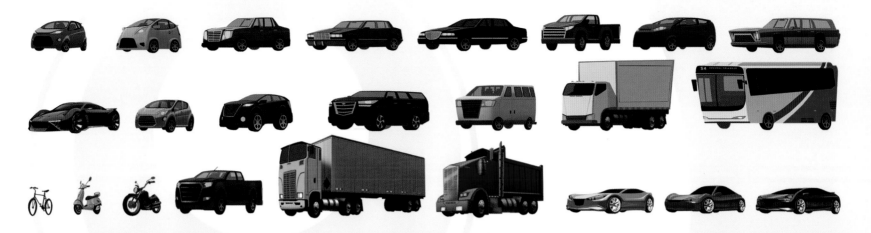

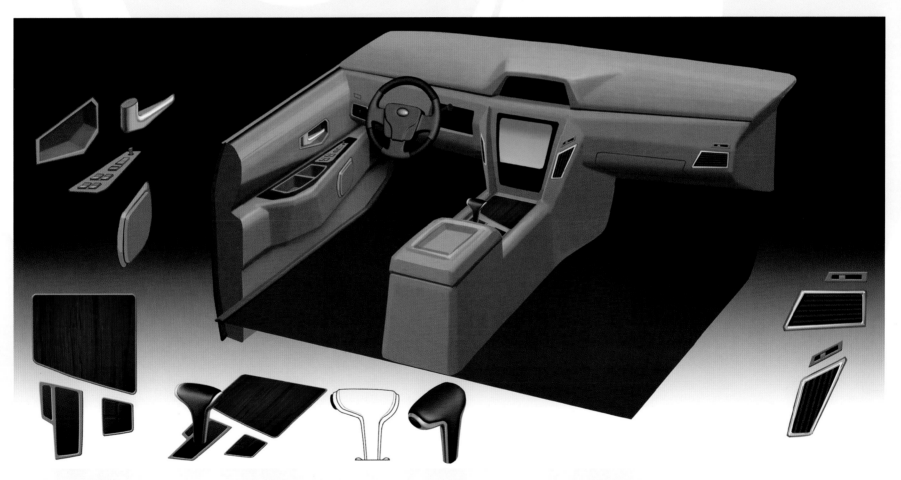

TOP: Background Car Lineup:
designs by Tyler Carter

ABOVE: SUV Interior: design by
Jon Townley

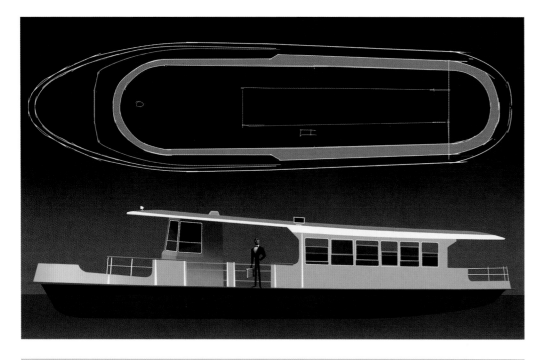

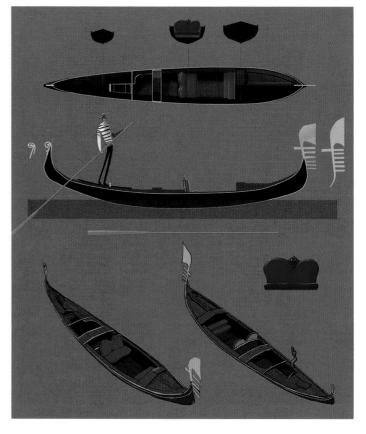

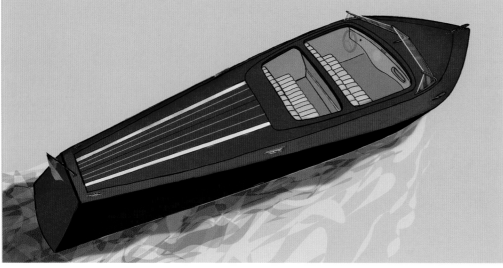

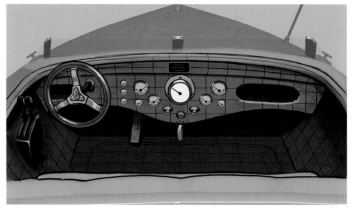

TOP LEFT: Tour Boat: design by Jon Townley

BELOW: Runabout Concept: designs by Kevin Yang

ABOVE: Runabout: design by Tom Humber

TOP: Gondola: designs by Jon Townley

ABOVE: Runabout Interior: design by Tom Humber

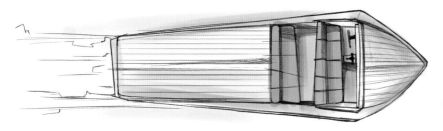

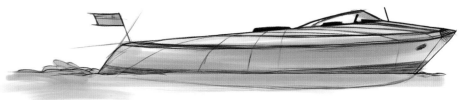

BELOW: Taxi Cab: design by Tyler Carter, color by Vincent Nguyen

RIGHT: Runabout Interior Concept: design by Kevin Yang

MIDDLE LEFT: Vespas: design by Tyler Carter, color by Vincent Nguyen

BOTTOM LEFT: Hatchback: design and color by Tyler Carter

BOTTOM RIGHT: Motorcycles: design by Tyler Carter, color by Vincent Nguyen

VEHICLES

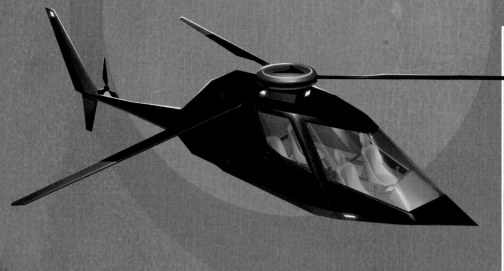
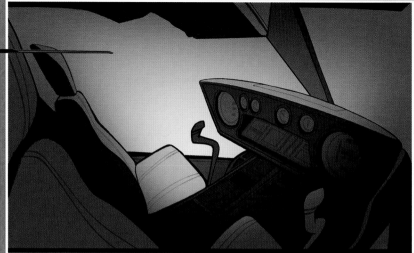
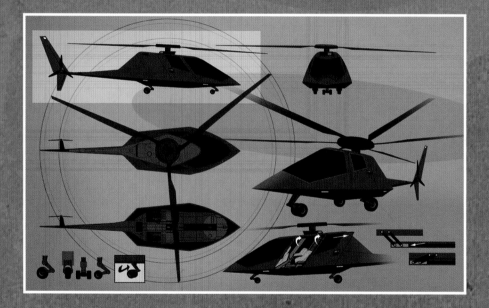
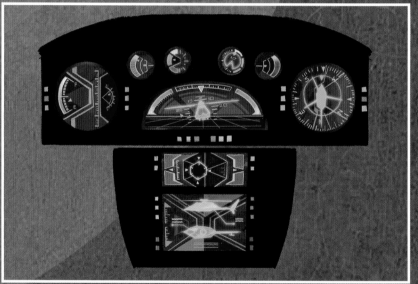
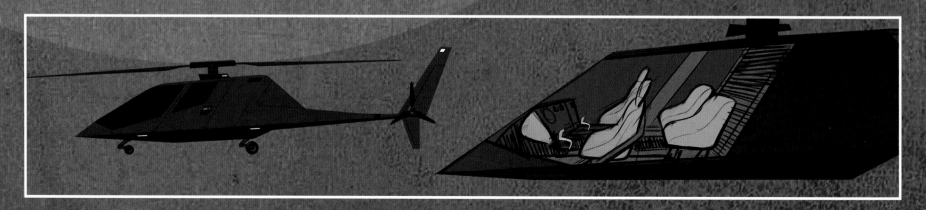

"The villains' vehicle shapes were based on sharp angles and acute trapezoids to give a sense of kinetic inclination. They were designed to feel like they are moving, even when at rest."

Tyler Carter, Designer

OPPOSITE TOP LEFT: Helicopter Callout: design by Tyler Carter, color by Peter Nguyen

OPPOSITE TOP RIGHT: Helicopter Interior: design by Tyler Carter

OPPOSITE MIDDLE LEFT: Helicopter Concept: design by Tyler Carter

OPPOSITE MIDDLE RIGHT: Helicopter Graphics: designs by Sandeep Menon

OPPOSITE BOTTOM: Helicopter Concepts: designs by Tyler Carter

RIGHT: Snow Bike Concept: designs by Tyler Carter

BELOW: Snow Bike Yakuza Moment: design and color by Tyler Carter

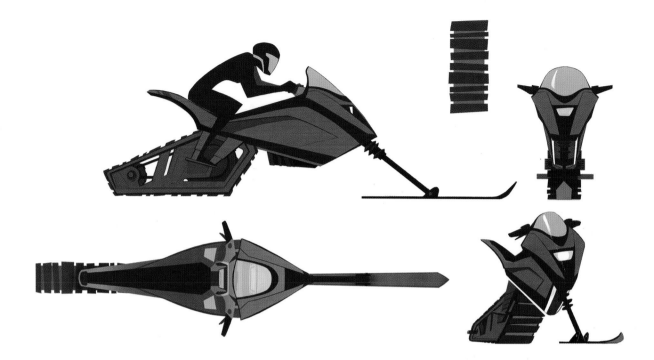

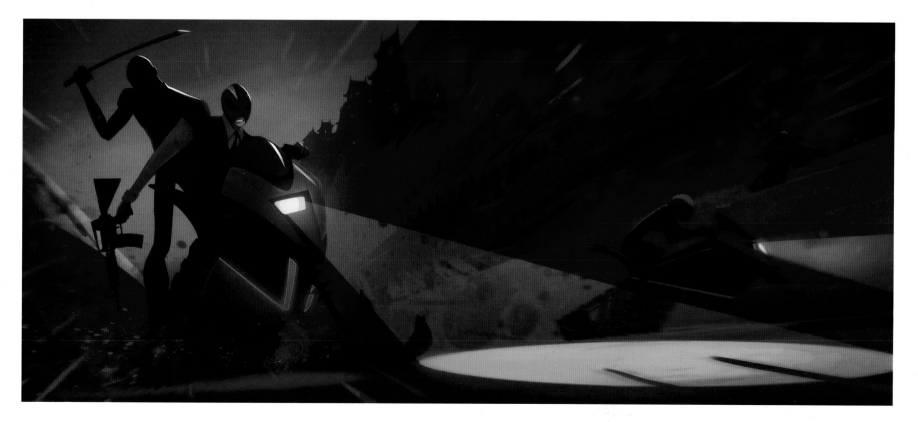

 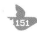

MOTION GRAPHICS

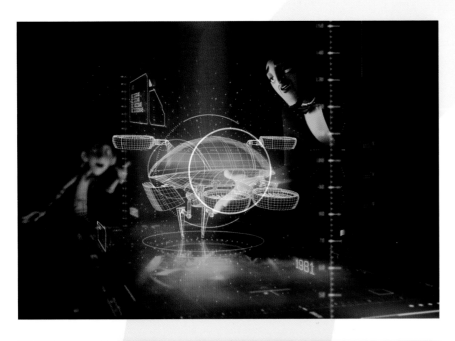

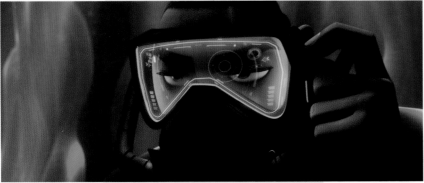

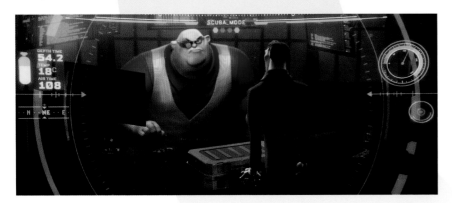

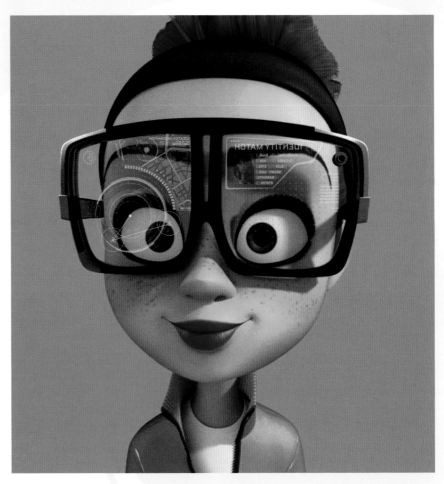

"My favorite aspect of motion graphic design (for film) is being able to inform the story telling process. Great motion design can help push a narrative and communicate story points more effectively to the viewer."

John Koltai, Motion Graphics Lead

THIS SPREAD: Motion Graphics: designs by John Koltai

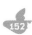

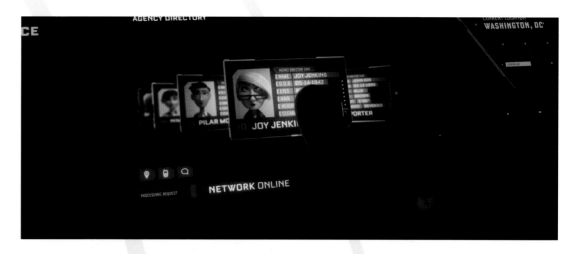

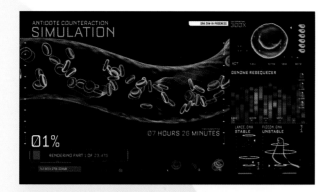

ANTIDOTE COUNTERACTION
SIMULATION

01%

07 HOURS 26 MINUTES

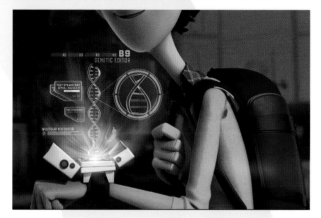

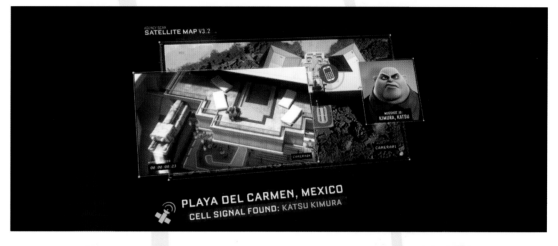

PLAYA DEL CARMEN, MEXICO
CELL SIGNAL FOUND: KATSU KIMURA

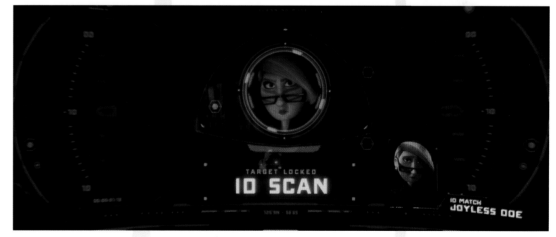

TARGET LOCKED
ID SCAN

ID MATCH
JOYLESS DOE

STYLE GUIDE

SHAPE

• UTILIZE THE "STEALTH SHAPES" WHEREVER POSSIBLE

LINE

• IN GENERAL, OBJECTS WILL BE COMPOSED OF SHAPES WITH ROUGHLY

3 STRAIGHTS ||| TO EVERY **1** CURVE)

• THIS RATIO IS THE DESIRED BALANCE BETWEEN SOFT AND HARD

PROPORTION

• WHEREVER POSSIBLE STRIVE TO CREATE **DISTINCT** BIG, MEDIUM AND SMALL SHAPES

BIG

MEDIUM

SMALL

TREATMENT

• THE OVERALL TREATMENT IS **80%** CARICATURED / **20%** REALISTIC

CARICATURE

100	90	80	70	60	50	40	30	20	10	00
00	10	20	30	40	50	60	70	80	90	100

REALISM

THE ART OF SPIES IN DISGUISE

THIS SPREAD: Style Guide: by Jason Sadler

FORM

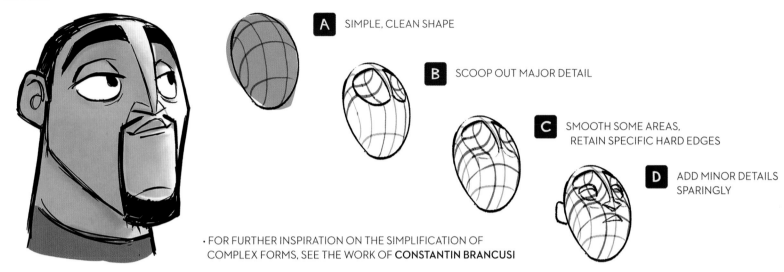

A SIMPLE, CLEAN SHAPE

B SCOOP OUT MAJOR DETAIL

C SMOOTH SOME AREAS, RETAIN SPECIFIC HARD EDGES

D ADD MINOR DETAILS SPARINGLY

· FOR FURTHER INSPIRATION ON THE SIMPLIFICATION OF COMPLEX FORMS, SEE THE WORK OF **CONSTANTIN BRANCUSI**

BOLD AND IMPLIED STRAIGHTS

· A SINGLE, DOMINATE **BOLD STRAIGHT** CAN STRENGTHEN AND ANCHOR A DESIGN

· **IMPLIED STRAIGHTS** WITH A SLIGHT BOW CAN SUBTLELY GIVE LIFE AND VITALITY TO A GRAPHIC SHAPE

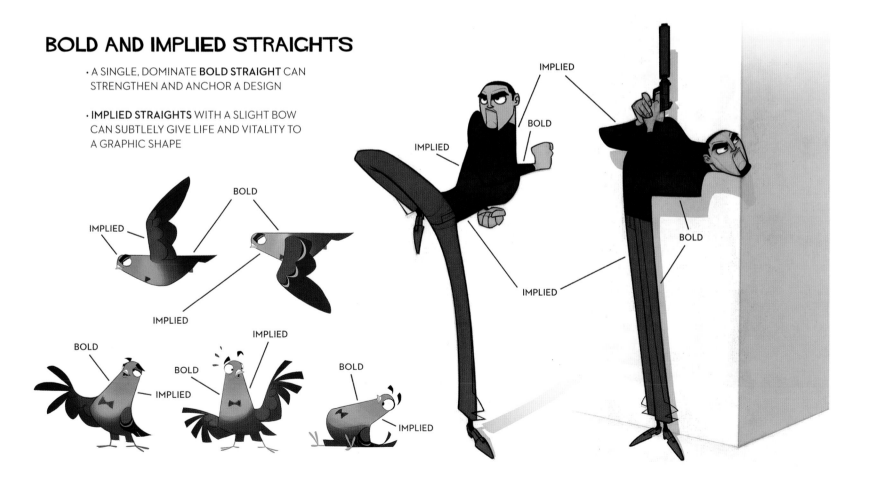

COLOR & LIGHTING STYLE

"As we discussed the look of *Spies in Disguise* with the directors, there were certain aesthetic qualities we wanted to instill that both played off the graphic designs of our characters and world, but also added texture and tangibility to each shot. This became the beginning of a conversation with the lighting team as they crafted the final look of the film."

Michael Knapp, Production Designer

USE DEPTH OF FIELD AND BOKEH TO ISOLATE CHARACTERS AND CREATE FOCUS. Not everything in frame should be in focus, and when our characters are in complex environments, this is a photographic way to simplify and focus a shot. Where appropriate, the use of bokeh adds a textural and graphic aspect all of its own.

EMPHASIZE THE "GRAPHIC" IN PHOTOGRAPHIC. Always look for opportunities to use light and shadow to emphasize silhouettes or to carve graphic shapes across the frame. Using camera exposure to let detail fall away in strongly lit or shaded areas is one way to accomplish this.

BOLD USE OF LIGHT AND SHADOW TO STRUCTURE SHOTS. In order to push the "photo-GRAPHIC" look, we wanted to rely less on fill lights which tend to soften the look of a shot, and really try to be conscious of how light shapes define characters or locations. The designs of our characters are pretty sculptural, and we wanted to emphasize their graphic qualities whenever possible.

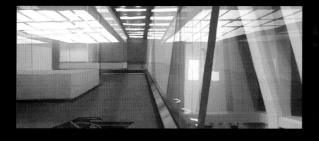
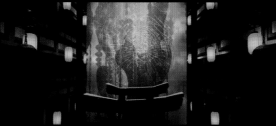
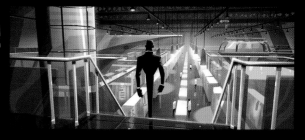

USE PRACTICAL LIGHTS TO DEFINE ENVIRONMENTS. Every good environment design has a lighting plan, but with so many urban or constructed locations in our film, we wanted to utilize practical lights in a way that reinforced the structure and perspective of the shots in which they were featured.

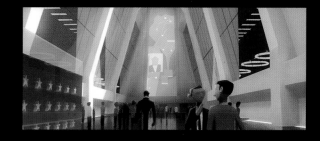

REFLECTIVE SURFACES ADD DEPTH AND TEXTURE TO LOCATIONS WHILE CREATING LIGHT ACTIVITY IN A SHOT. Looking at our favorite spy or action movies, we noticed a whole lot of reflective surfaces which really brought each frame to life. Whether glass, metal or polished marble, or wet asphalt for bright highlights to reflect off of, this was a crucial textural element for establishing the look of *Spies in Disguise*.

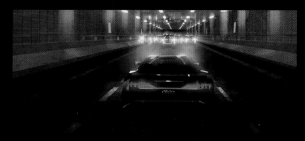

USE LIGHTING TO PAINT OUR CHARACTERS IN BOLD EXPRESSIONISTIC COLORS. Going hand in hand with how we were pushing the lighting, values and exposure in *Spies*, we also wanted to push the color in ways that both emphasized the emotional state of our characters, but also the color themes we had established. This helped establish the heightened look and really helped immerse the characters and the viewers in the scene.

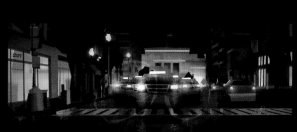

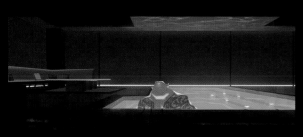

COLOR SCRIPT

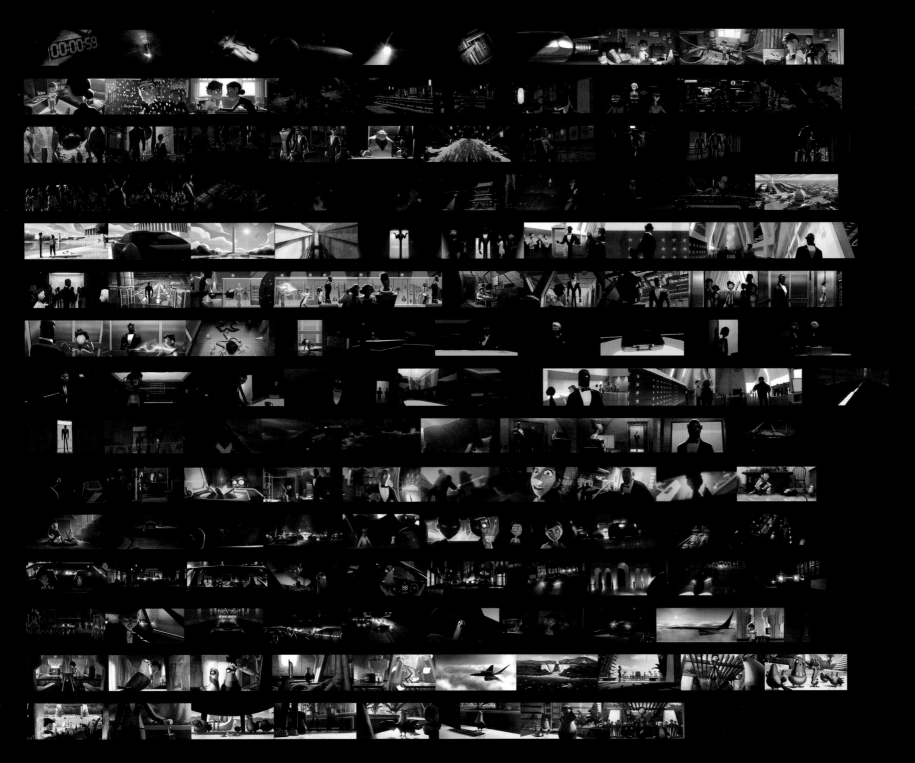

THIS SPREAD: Art Direction by Michael Knapp; Color Keys by Peter Nguyen, Hye Sung Park, Ron DeFelice, Tyler Carter and Vincent Nguyen

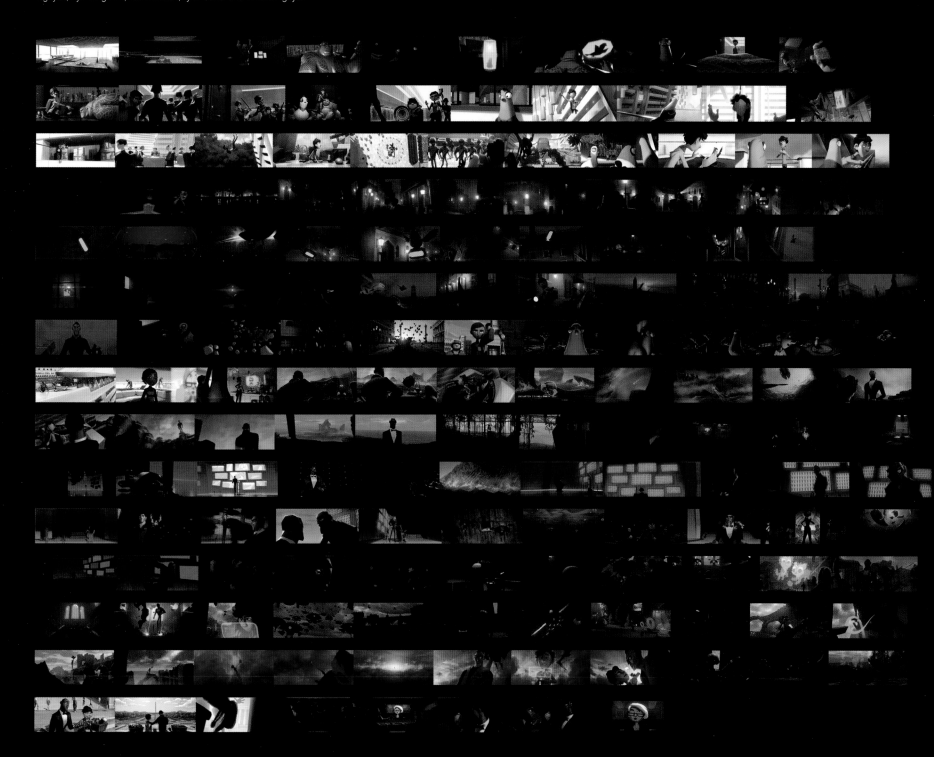

THE ART OF SPIES IN DISGUISE
ISBN: 9781785659669

Published by
Titan Books
A division of Titan Publishing Group Ltd
144 Southwark St
London
SE1 0UP

www.titanbooks.com

First edition: December 2019
10 9 8 7 6 5 4 3 2 1

Spies in Disguise ™ & © 2019 Twentieth Century Fox Film Corporation.
All Rights Reserved.

Did you enjoy this book? We love to hear from our readers. Please e-mail us at: readerfeedback@titanemail.com or write to Reader Feedback at the above address.

To receive advance information, news, competitions, and exclusive offers online, please sign up for the Titan newsletter on our website: www.titanbooks.com

No part of this publication may be reproduced, stored in a retrieval system, or transmitted, in any form or by any means without the prior written permission of the publisher, nor be otherwise circulated in any form of binding or cover other than that in which it is published and without a similar condition being imposed on the subsequent purchaser.

A CIP catalogue record for this title is available from the British Library.

Printed and bound in China.

ENDPAPERS, FRONT OUTSIDE:
Jim Jackson
ENDPAPERS, FRONT INSIDE:
Erin Humiston
ENDPAPERS, BACK INSIDE:
BJ Crawford
ENDPAPERS, BACK OUTSIDE:
Jim Jackson

RIGHT: The Flock at Dinner:
design by Aidan Sugano

ACKNOWLEDGEMENTS

Titan Books would like to thank the following:

Directors Troy Quane & Nick Bruno

Production Designer Michael Knapp

At Blue Sky Studios: Samantha Letzler, Caroline Qualey, Vandana Pulijaal, Sumire Takamatsu, Lindsey Connors

At Fox Animation: Melanie Bartlett, Ryan Gardner & Laura Baltzer

At Fox Consumer Products: Nicole Spiegel & Carol Roeder

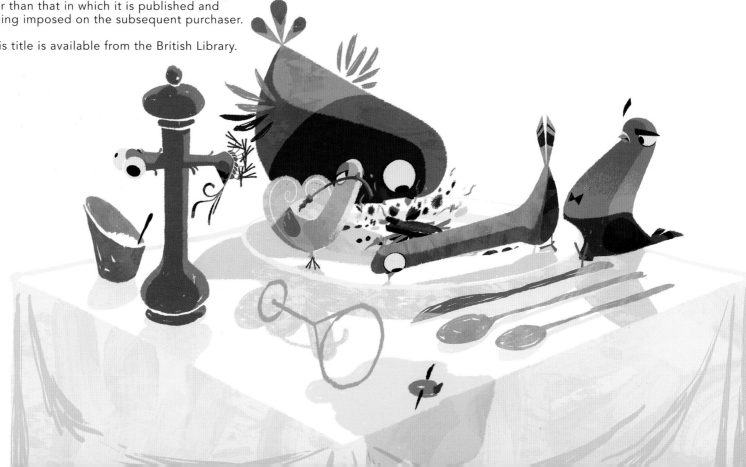